Assignments

PRESTEL

MUNICH · BERLIN · LONDON · NEW YORK

© The Press Photographer's Year 2006
www.thepressphotographersyear.com
Foreword © Tony McGrath

Prestel Verlag
Königinstrasse 9, D-80539 Munich
Tel +49 (89) 38 17 09-0 Fax +49 (89) 38 17 09 35
www.prestel.de

Prestel Publishing Ltd.
4, Bloomsbury Place, London WCIA 2QA
Tel +44 (020) 7323 5004 Fax +44 (020) 7636 8004

Prestel Publishing
900 Broadway, Suite 603, New York, NY 10003
Tel +1 (212) 995 2720 Fax +1 (212) 995 2733
www.prestel.com

Library of Congress Control Number is available; British Library Cataloguing-in-
Publication Data: a catalogue record for this book is available from the British Library;
Deutsche Bibliothek holds a record of this publication in the Deutsche Nationalbibliografie;
detailed bibliographical data can be found under: http://dnb.ddb.de

Prestel books are available worldwide. Please contact your nearest bookseller or one of the
above addresses for information concerning your local distributor.

Conceived by Tim Bishop and Dillon Bryden
Design SMITH
Victoria Forrest, Heather McDonough
Origination: Reproline Mediateam, Munich
Printing: Passavia, Passau
Binding: Conzella, Pfarrkirchen
Printed in Germany on acid-free paper.

ISBN 978-3-7913-3596-4/3-7913-3596-0

Assignments tsunami, sudoku, bush inauguration, iraqi elections, john paul ii, mg rover, charles & camilla, benedict xvi, super jumbo, labour party victory, liverpool 3-1, deep throat revealed, wacko jacko acquitted, harry potter, g8 summit, live 8, london win olympics, suicide bombings, de menezes, trafalgar 200th, space shuttle discovery, israeli withdrawal, hurricane katrina, ira disarms, ashes regained, bali bombs, pakistan earthquake, ipod nano, saddam's trial, leap second.

Th Pr ss Photogr ph r's . r

"Men wanted for hazardous journey. Low wages, bitter cold, long hours of complete darkness, safe return doubtful. Honour and recognition in event of success." So began the small ad placed by the great Polar explorer Sir Ernest Shackleton at the start of the last century to recruit volunteers for his trek to the South Pole. He could just as well have been inviting people to help design, set up and launch a new photographic competition.

What is it that is so unappealing about competitions? Do the winning images always seem so predictable? Why is it that so many of our finest press photographers never enter? It should be a time when we all get to see the very best of photography, to see the images properly displayed, and for them to be in a book that will last as a great record of an astonishing year.

What on earth can The Press Photographer's Year bring to the table that would be any different? A competition organised by press photographers for press photographers? Imagine just how ugly things could get: photographers choosing who should be the 'Greatest of Them All'.

So we asked members of the British Press Photographers' Association (BPPA) about why so many of them felt that competitions just didn't work. Well, they said, it could be straight for a start. We could know who will judge, that all entries would be seen by these judges and that those selecting don't have any vested interest in who wins, because the emphasis should be on the very best photographs, rather than the best photographer on the best newspaper.

And in an industry where published work ends up recycled next day, photographers wanted the presence and permanence that comes from touring exhibitions and a book, rather than a link to a coal-fired website. Quite a tall order, especially following impressive and established international competitions, with everything that multiple sponsorship, a large permanent staff, and years of experience, have created.

All this with two determined BPPA organisers who realised rapidly that they had better be happy with low wages, long periods of darkness and intense cold.

The first ray of light came with the sheer enthusiasm of so many photographers. Things began to heat up when Cari Bibb and Graham Smith of Canon Cameras, already major sponsors of the BPPA, pledged their support, long before we could really give them a clear idea of exactly how the competition would work. Without their backing, we would have had nothing.

Next we needed that jury: I worked for Tony McGrath for a brief two weeks as a stand-in deputy when he was halfway through his eleven-year career as the legendary picture editor of the *Observer*. Nothing got into the paper without his approval. He was famed for his temper, his determination, and his passion for great pictures. The weekly Saturday battle with the editor over the front page was a fight he rarely lost. When I went on to become a more permanent deputy on another paper some years later, my picture editor did what he was told, and cowered not only before our editor, but the chief sub editor. We gathered as many pictures as we could. We were terrified of being asked for something 'we didn't have'. Our power lay in

selecting who we assigned, but melted away deciding what actually went on the page. Living ten thousand miles away in Sydney proved no barrier to Tony accepting the role of chairman, showing again the enthusiasm for chasing the highest standards of press photography that has stamped his career. As Tony flew in from Australia, we were lucky to gather a distinguished panel of photographers or former photographers. BPPA founder John Downing has won Press Photographer of the Year nine times and founded the BPPA twenty-two years ago.

Stuart Nicol, who was the youngest staff photographer in Fleet Street in the early eighties and went on to gain a high coveted contract on *The Sunday Times*, left after a ten-year tenure as picture editor of the *Daily Record*, days before judging was due to begin. Bob Martin, the only British sports photographer on the staff of *Sports Illustrated* found that judging had to fall in the middle of the Winter Olympics, because of tight print deadlines. Rob Taggart, found himself suddenly transferred to a new role as commercial director of the Associated Press.

Tara Bonakdar, worked for IPG for seven years, before setting up on her own with the impressive mantra of refusing to see photography as a commodity that's to be pumped out and sold. The renowned jazz and arts photographer Allan Titmus joined the BPPA twenty-one years ago, and was at the very centre of our original Assignments books and exhibitions, the inspiration behind the recent Five Thousand Days project. Paul Sanders, made the rare transition from freelance to picture editor at *The Times*, in the time it takes many photographers to get their portfolios past reception.

As things were developing, we needed new technology that would let us not only receive entries, but keep in touch with all the entrants. Tom Scott and Colin Breame of Talking Pixels built a website that allowed photographers to upload their images in just the same way they do every day. Only it had never been done in a competition before, or on this scale. This really was a first. The entrants certainly did test it, with over half of the six thousand entries dropping within the last 24 hours of the deadline.

The result is this book, and a competition that *really* isn't about the winning but the taking part. It is about photography, and about creating an enduring record for a body of outstanding work. It is organised in much the same way as you would find in your daily newspaper. You'll see hard news first, both domestic and foreign, news features, then portraits and the arts, entertainment follows that, before ending with business and sport towards the back.

We owe much to our designer, Stuart Smith, the enthusiasm of Andrew Hansen of Prestel, the publishers, and the commitment of John Langley at the Royal National Theatre, who not only provided the Lyttelton Foyer for our opening exhibition, but also generously allowed our jury the space and time they needed in the theatre complex for the intensive two day judging process.

As for Dillon Bryden and myself, we could say that our Polar exploration has been more than made up for with the honour and recognition that these great images deserve. But our safe return? Now that really would be something.

tim bishop

contents

sean smith THE GUARDIAN
Detainees being taken for questioning by US troops
after a sweep north of the Euphrates at Rawah,
north west Iraq as Operation Steel Curtain draws
to a close. 21st November 2005.

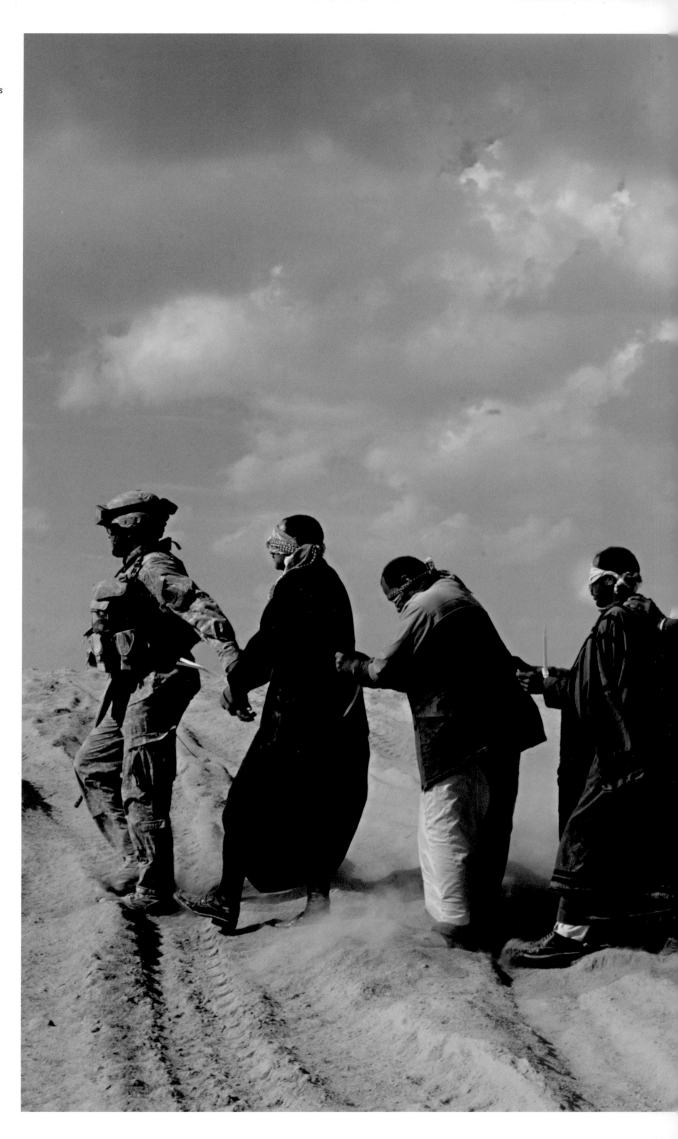

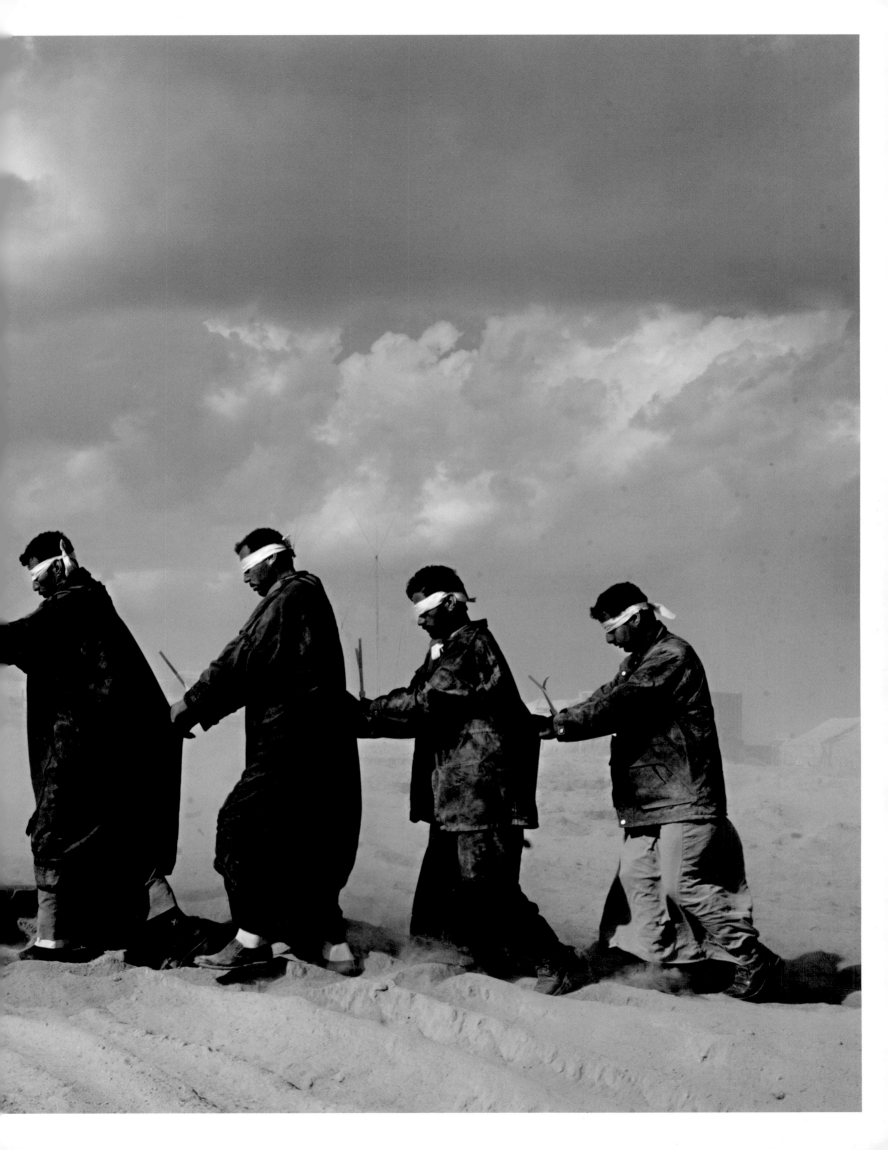

the deceptively simple art of the press photograph

tony mcgrath
chairman of the 2006 jury

Nowadays, anyone and everyone can and does take pictures. Right?

In a world full of phone cameras, throw-away cameras, digital cameras, film cameras, video cameras, even CCTV cameras, everybody is a photographer. Right?

Take the photographs on the following pages; most of them could have been taken by Joseph Average, given of course, the same privileges and access as the professionals. Right? Wrong!

In fact, one couldn't be more wrong. The following 157 images were chosen from a collection of more than 6,000 photographs, submitted by more than 300 professional photographers working in the media. They are as varied as a world that generates thousands of stories each day, depicting man's unending efforts to create, destroy, communicate, withhold, share, deny or fabricate the terms and conditions under which we live our lives. These images are a testament to that.

While the photographs reveal some fascinating aspects of the complexity of our society, they invariably cloak the difficulty of their making, and rightly so. It's not how the messenger arrives that should be of interest to the viewer, but the message he/she bears. That difficulty can be as relatively simple as a ruck of photographers being designated a restricted enclosure, from which they all try to capture the 'moment' as some 'celebrity' floats up yet another roll of red carpet amid a squadron of publicity managers, minders and personal assistants.

Or, it can be as chilling as the decision to move away from the protection of a solid structure in order to capture a crucial image during a fire-fight in Iraq thereby risking injury or death. But that is the photographer's problem and decision, not the viewer's.

Every picture in this book tells us a little about the life that flowed around us during the past year. Sometimes, the images may not be 'perfect' or, on occasion, when people wish to ignore the cruel reality of some aspects of life, they may have been deemed to be 'unacceptable' But truth should never be denied, particularly when words, both written and spoken, are today being used increasingly without challenge, to swamp and confuse the unwary, or deny inconvenient realities. The more words obfuscate, the more important becomes the truth of the photograph.

The following pages record events as they happened, without adornment or addition. They are for the most part, the plain unvarnished truth selected from a kaleidoscope of stories unfolding not only in Britain but also around the world. Even the images of subjects who willingly agreed to be photographed and in doing so allowed themselves to be placed in a situation not necessarily of their making, holds to a certain truth. The photographs are real, the questions many of them raise are real, the challenge is: are we, as viewers, still interested enough to respond to the questions raised by those images?

The pictures taken in the aftermath of the London suicide bombings are a reminder of that truth and a recognition that today all actions, taken for whatever reasons, and however distant, have reactions that can end up being as close as the passenger sitting beside you on the number 30 bus in the heart of London. The photograph on pages 12-13 taken by Matthew Rosenberg following the explosion that killed 13 passengers and injured many more is an excellent 'news picture moment'. Capturing as it does, only moments after the bomb went off, some of the stunned, bewildered, and injured passengers still standing amid the wreckage of the ripped-apart upper deck.

In the past we have viewed such atrocities from the comfort of our island fortress. Even after the destruction of the twin towers in New York, we continued hopefully and probably unconsciously to believe "it could never happen here". So it was a terrible wake-up call for everyone when the unthinkable happened. The bombings presented real problems for the media as a whole as it attempted to illustrate the immediate aftermath of the explosions. With the exception of the bomb on the bus, the other three explosions happened out of sight and below ground. However, as the bombs went off early in the morning, newspapers were in a good position to prepare their front pages and obtain the visual images vital to communicating what had happened.

But this time they would not be able to cloak the usage of powerful and disturbing images of the dead and dying under the 'anonymity of distance' - an unspoken but regular justification used by newspapers over the years to show the true reality of terrorism and war in far flung places like Iraq, Afghanistan and the Middle East.

The bus photograph graphically showed what happens when a bomb goes off in a bus, and while it did show survivors still on the bus, it was not close enough to show detail or evoke emotions usually connected with the sight of the suffering of others. What the newspapers needed was another more personal image, which would immediately resonate with the readers and hopefully communicate the horror of what had happened, mostly underground and out of sight.

The key picture to emerge was of a female survivor of the bombing, face covered by a white gauze burns mask, being guided away from a tube station entrance by a first-aid person. The picture presented the newspapers with an image that, while sparing them the need to delve deeper into the brutal visual truth of exactly what had happened, was still able to convey the full horror of the day's events. That photograph taken by Jane Mingay working for Associated Press (see page 17), has deservedly won First Prize 'Live News'

It is interesting to note, after a sweep of 437 newspaper front pages in 47 countries on the day following the attacks just under 75% used one or both of those two photographs to illustrate their stories and while more graphic

images were available, only one used an image of a dead victim.

The many other photographs in this book are as varied as life itself and brimming with the basic criteria required of the media photographer: information, education and entertainment. But the almost biblical image, by Sean Smith, of a single line of blindfolded prisoners, each with his hands tied with plastic restraints, holding on to the one in front as they stumble across the imprint of tank tracks in the sandy wastes of Iraq, says more in its detail than a hundred American media briefings could, or even want to convey. It confides to us the terrible truth that this is no 'ordinary' or conventional war, but a war being fought with smoke and mirrors - no front lines, no uniforms, and no enemy - until he pushes the button or pulls the trigger. Smith's photograph stands head and shoulders above the others, a magnificent photograph that communicates far more than that which exists on its surface and truly deserves the accolade 'Photograph of the Year' award. Smith ploughs an increasingly lonely furrow in a field that grows more difficult and smaller as other more frivolous aspects of the photographic media becomes more dominant.

At the other end of the spectrum we have the gentle and beautifully observed picture story by Peter Macdiarmid of Getty Images of the whimsical and uniquely British event known as 'Swan Upping' the annual counting of the Queen's swans on the upper reaches of the river Thames. Macdiarmid deservedly shared joint first prize in 'Photo Essay' with Nir Elias of Reuters, who excellently documented the removal by the Israeli Army of illegal settlers.

On page 74 the questions thrown up by the deceptively simple image of two pairs of eyes framed by the ubiquitous chador that leap off the page to challenge our preconceptions are: Where and why were these two women photographed? With no background information to help, the viewer can only surmise: Iran, possibly, or maybe Iraq, or any of a dozen Middle Eastern countries. But the revealed truth is so much closer to home.

Andrew Testa's truly disturbing photograph of 15-year-old Nobisa Begam on page 28 is a really powerful example of why photographers should continue the long and honourable tradition of seeking out and photographing difficult and confronting stories. Such images help remind us that, whatever questions are raised about the perceived shortcomings of our own domestic society (head coverings or no head coverings in school, etc.) others in the world live in far greater fear of their response to seemingly far more innocent questions.

Two wonderfully uplifting sports photographs appear on pages 124 and 129. The first, taken by Tom Shaw moments after the final ball was bowled at the end of the second Ashes test at Edgbaston, restores my faith and belief that sport still contains the seed of true sportsmanship.

The image shows, despite the fiercely contested nature of the series and despite the victory having only been achieved moments before, Andrew

Flintoff's sportsmanship and compassion for the defeated, young and broken Australian fast bowler, Brett Lee.

The second, by Eddie Keogh captures a moment that is as rare as it is funny, particularly when one realises that it was taken during a soccer match (professional soccer and humour have not intentionally shared a bed for a long, long time) and it's a Champions League match and Bayern Munich have just scored their second goal against Arsenal.

*

Photographers working in the media are rarely represented fairly, not only by their own news print industry (the exception being when they win awards and their employers grasp the opportunity for a little self-promotion) but especially by television and screenwriters. So it is not surprising that the general public's impression is formed by the lazy under-researched scribblings of those who should, and in many cases do, know better.

It really should come as no surprise if the behaviour of photographers sometimes falls below what others perceive as the 'acceptable' standard when they are repeatedly placed in virtual cages, or in inappropriate positions, and then expected to carry out their function of recording an event to which, in many cases, they have been invited.

It will also come as no surprise to any working photographer reading this that on so many occasions over the years, photographers has been treated in a less than even-handed way, particularly when the Metropolitan police were involved. While aware that the press in the United Kingdom have no official or legal rights above those of the general public, one would imagine that in this most visually dependant age, a more enlightened approach might have been taken many years ago by those who had the power to do so.

However, at last, after more than twenty-five years of sporadic attempts by the representatives of the photographic media, and driven by the Trojan efforts of the BPPA representatives, celebrations are due: the Metropolitan police have finally issued a document setting out clear and simple guidelines for their officers to follow in their dealings with working photographers. Those guidelines, which will be welcomed by all photographers, will of course take time to penetrate the helmets of some London bobbies, but penetrate they will because, though they are referred to as 'guidelines', they are not intended to be ignored at the whim of an individual police officer.

*

When the digital era arrived, I'm quite sure many working photographers were relieved at the prospect of having so much more control over the initial editing

of their photographs. They expected far less mauling of their hard crafted images by picture editors, sub editors or layout people who just didn't know, or worse, didn't care about the material as long as they could find a photograph that could be levered, hacked or hammered into some predetermined space. Also, given that there was no longer any requirement for the photographer to return to the office to process the material, he/she would have much more time to shoot and, of course, edit without people looking over their shoulder and demanding to see the contact sheets.

Unfortunately, working digitally has turned out to be a double-edged sword. True, it did indeed free up lots more time, and yes, photographers would by and large only transmit pictures they thought really worked. However, Picture Desks saw things from a different perspective. With less time used up travelling and processing, photographers completed their assignments sooner and that of course meant they would be in a position to cover more assignments (much better value for the employer's buck). Also, with the ability of picture editors, sub editors and layout people to see images punched through to their screens almost immediately, from any given event by multifarious agencies, it allowed them to make up their minds *earlier* rather than *later* and so deadline times were brought *back*, not pushed *forward*, as photographers had expected. As a result it soon it became a question of not "what have you got" but depressingly, "have you got the AP/PA/Reuters/Getty landscape/upright of him/her doing xyz"?

With photographers rushing from one assignment to the next they lost the opportunity their physical presence in the office had traditionally given them to 'sell' their chosen image to the Picture Editor who, in turn, would carry the passion, if not the belief, of the photographer all the way to the editor's office.

The Digital era has also been accompanied by the resurgence of a photographic disfigurement, which in the past was confined mostly to the lower media orders and badly designed magazines. The curse (confusing convience with design) is carried by layout people who seem to feel it is okay to hack a chunk out of an image, slap on a slab of colour without any thought as to how it resonates with the photograph and then type the caption or extended caption on top. The idea that the words might be accommodated underneath or beside the photograph by the simple method of slightly reducing its size doesn't seem to occur to them. Nor does it occur to them that although a large amount of space is being devoted to the image (the case in mind was a double page spread) the name of the author of the photograph might also deserve a commensurate credit rather than the *vertical* 2 pt. credit on side of the picture that the photographer received.

So the question I ask is: who is there to protect not only the integrity of the photograph but the photographers as well?

It should be the Picture Editor but sadly, in most cases, this does not seem to be the case. Picture Editors, whether revered or reviled, have an even more important role to play today, by acting as the intelligent, independent, visual conduit between the image-maker and the reader, thus enabling the reader access to not only the best images a photographer can offer but making sure they are seen in the best possible light.

Sadly, just about all newspapers have lost the individual photographic identity that they prided themselves on in the past; a quality appreciated both by the readership and those working on various pictures desks.

That lack of identity is caused not by the photographers newspapers employ, but rather by Picture Editors who refuse to understand the role their position demands; and that is to stand up and fight for their photographers' photographs and resist pressure from further along the editorial conveyor belt to settle for the easy 'what's first what fits' philosophy.

As long as those who command Picture Desks behave like picture gatherers, while photographers are desperate for them to behave like Picture Editors, readers will be deprived of the individual style and choice they expected and received previously from a range of daily and Sunday newspapers in the United Kingdom.

Despite these problems, this book of photographs is a wonderful testament to the resilience and commitment of the Press Photographer in pursuit of individual excellence.

matthew rosenberg

At 8.50am on 7th July 2005 three explosions on the London Underground forced early morning commuters onto city buses to get to their destinations. At 9.47am a suicide bomber detonated himself in the rear of the packed number 30 bus in Tavistock Square. Driver George Psaradakis (far right) stumbles from his stricken bus and into the devastation surrounding it. In total 56 people were killed and 700 injured in what are believed to be the first suicide attacks in Western Europe.

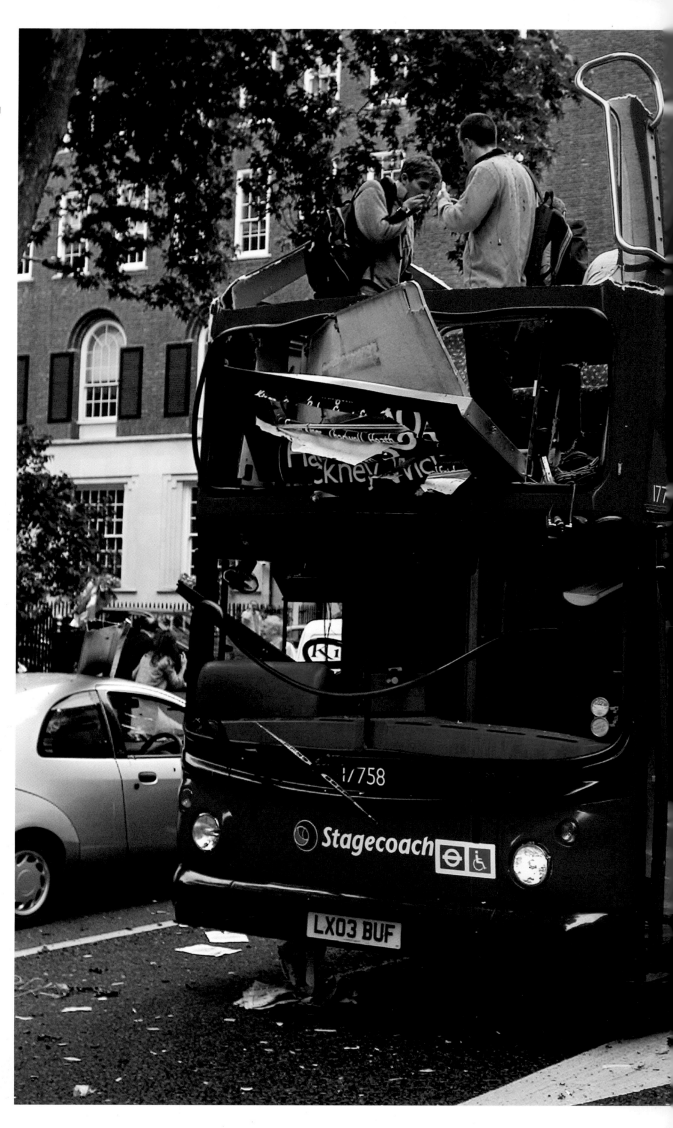

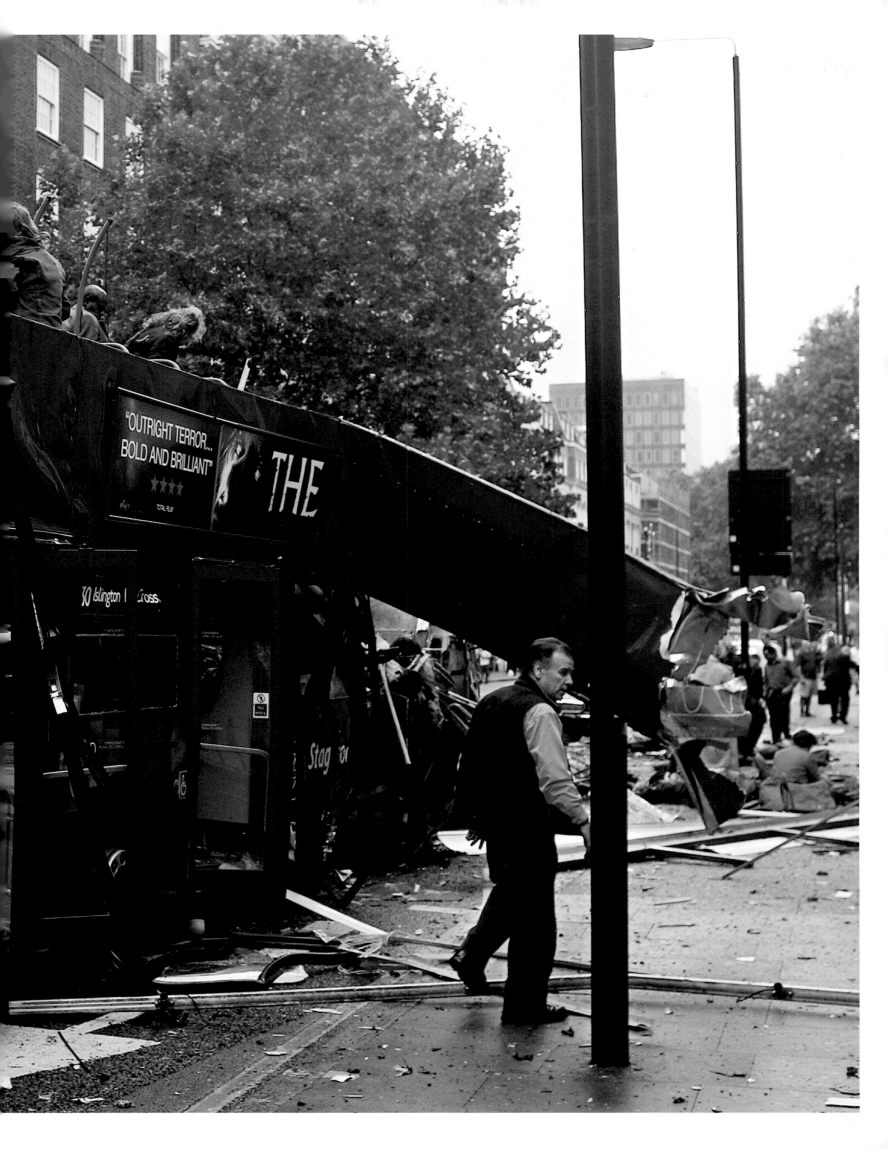

14

matthew rosenberg
Londoners run as the explosion of packed number 30 bus rocks Tavistock Square. Explosions on the Underground forced early morning commuters onto city buses to get to their destinations. 7th July 2005.

sion touhig
British police forensic officers gather evidence around the destroyed number 30 bus in Tavistock Square, London. 10th July 2005.

adrian dennis AFP
Blood is splattered 10 metres high on the wall of the British Medical Association near to where the terrorist bomb exploded on a bus in Woburn Place and Tavistock Square in London. 8th July 2005.

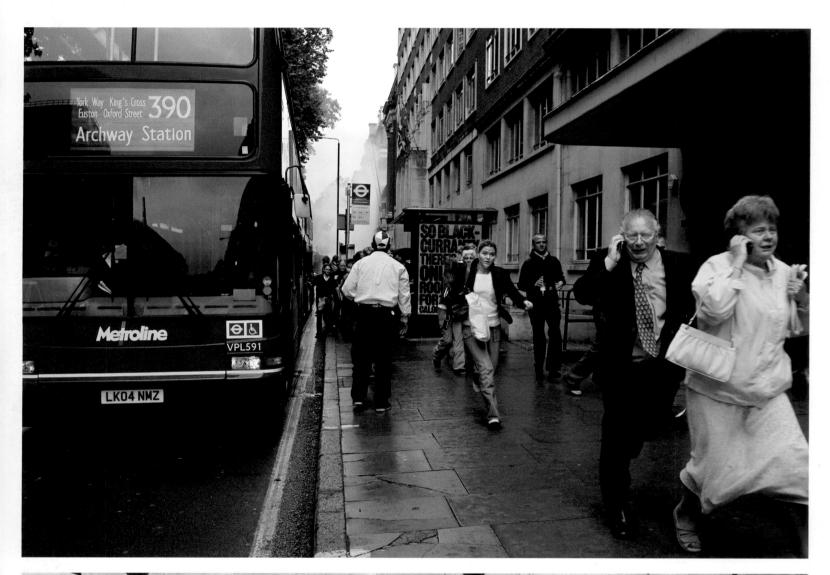

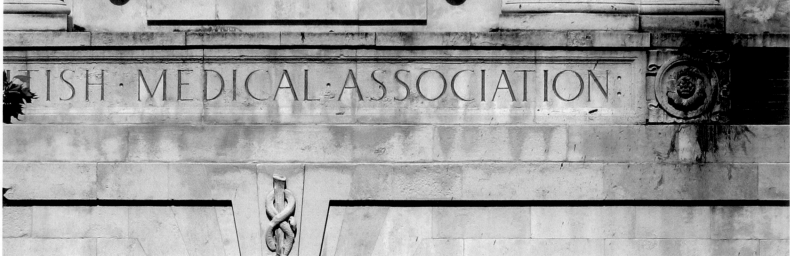

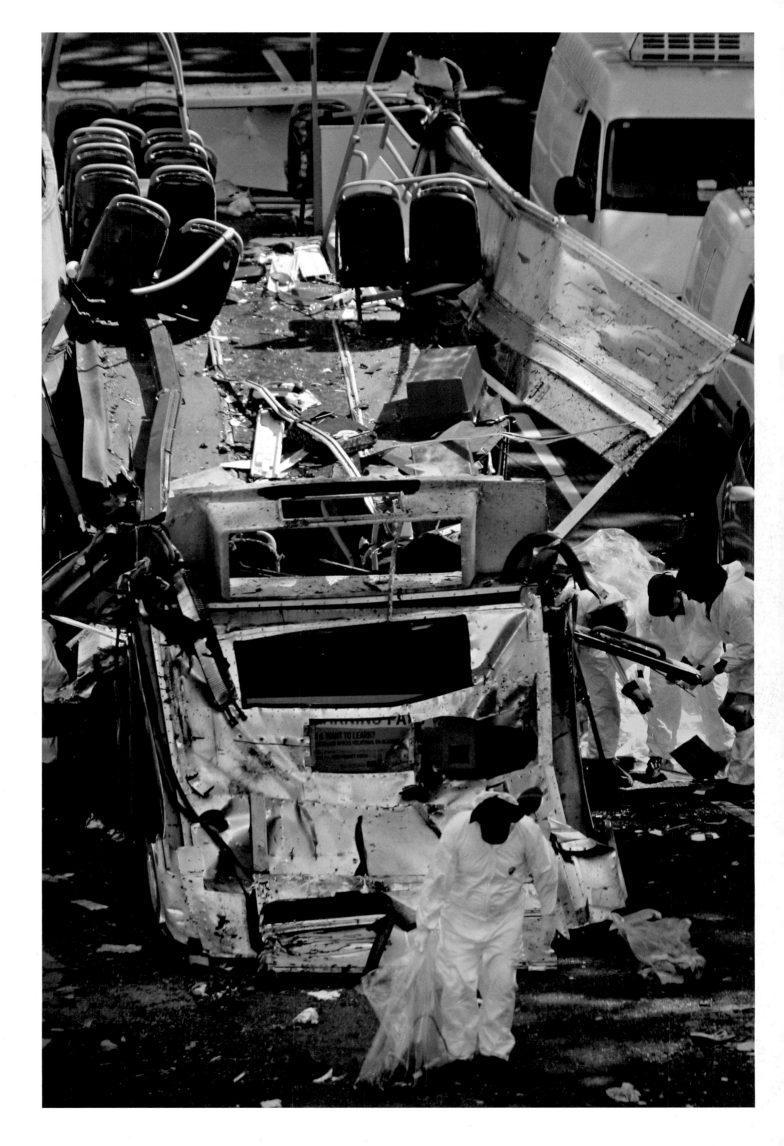

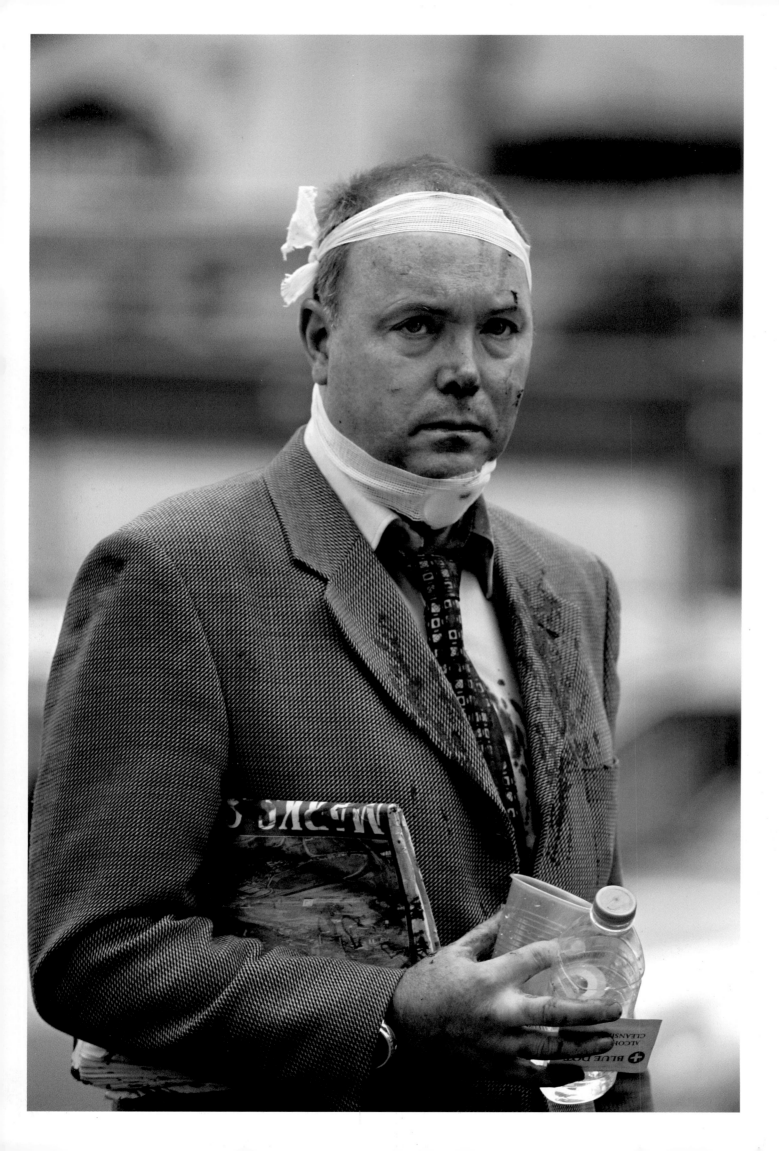

edmond terakopian PA
Walking wounded leaving the scene of the explosion at Edgware Road Underground station. 7th July 2005.

**first prize: live news
jane mingay** AP
Tube Passenger Davinia Turrell is led to safety by fellow passenger Paul Dadge having escaped from the blast at London's Edgware Road Underground Station. 7th July 2005.

sion touhig
Home made posters of missing victims put up by friends and relatives on a wall outside Kings Cross Underground Station in London. Tube trains were blown up as part of a multiple terrorist bombing attack which targeted the public transport system and claimed over 50 lives. 11th July 2005.

timothy allen
The funeral of Anthony Fatayi-Williams who died in the Tavistock Square bus bomb. 23rd July 2005.

andrew parsons PA
Ruby Gray who lost her father Richard Gray in the July Bombings, with her mother Louise. She is holding a posy she is going to give to the Queen before a special service at St Paul's, London, in memory of all the victims of the July Bombings. 1st November 2005.

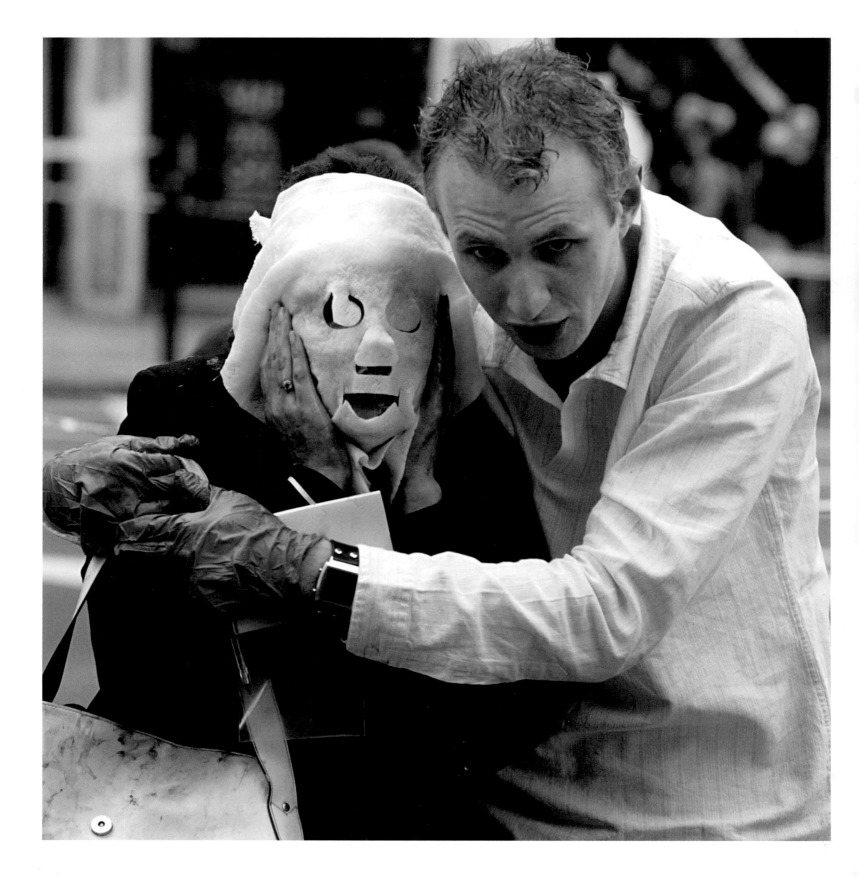

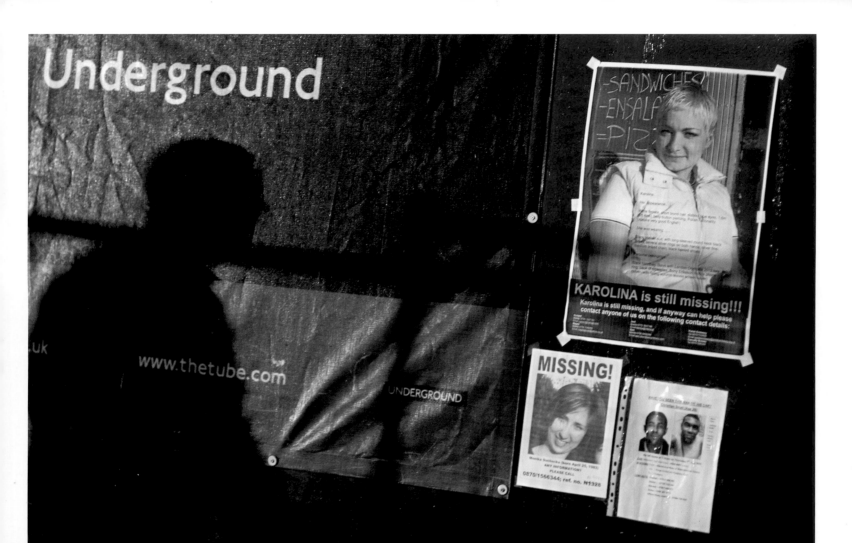

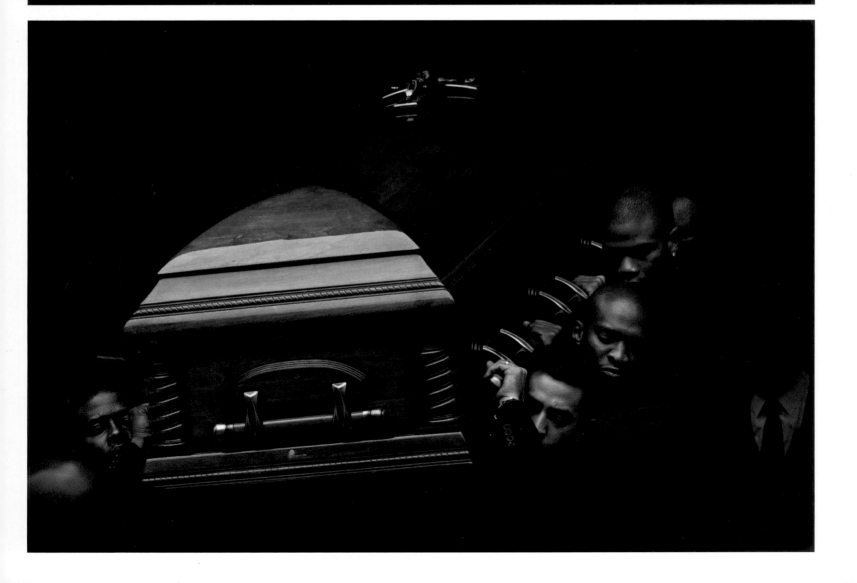

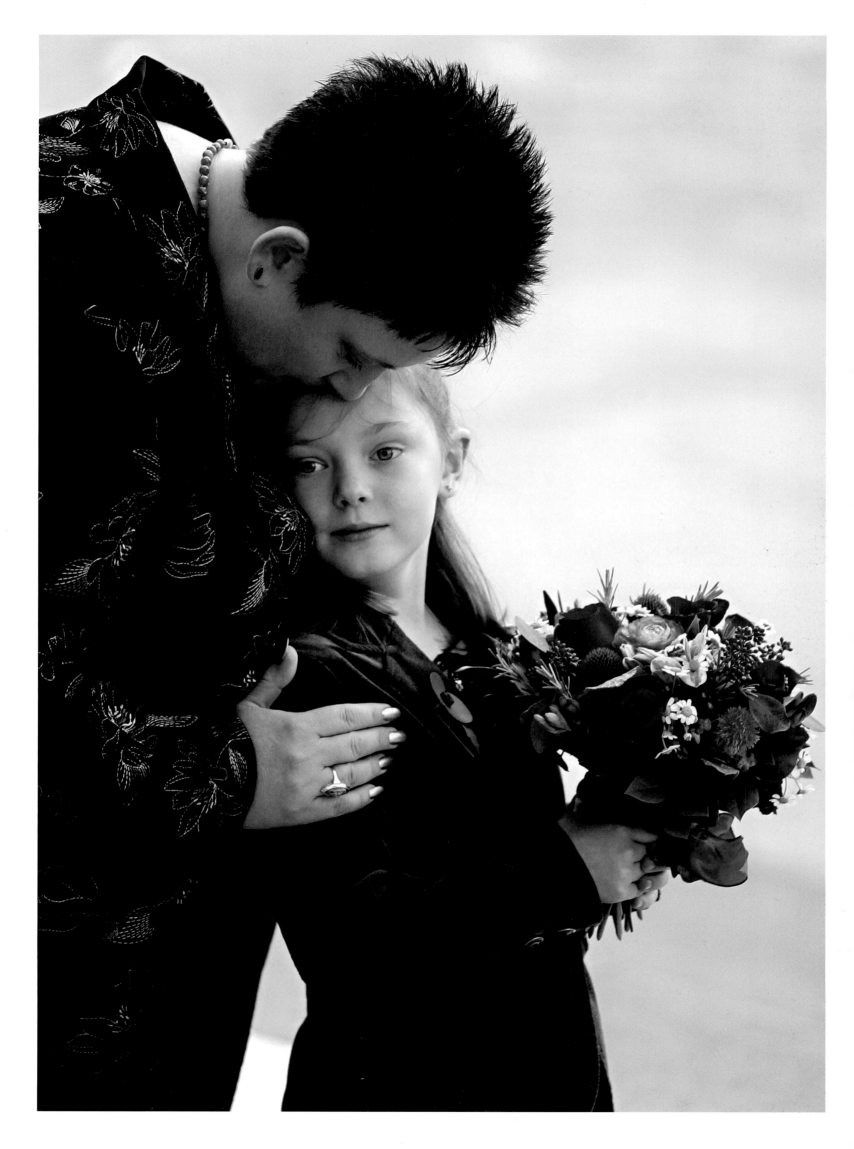

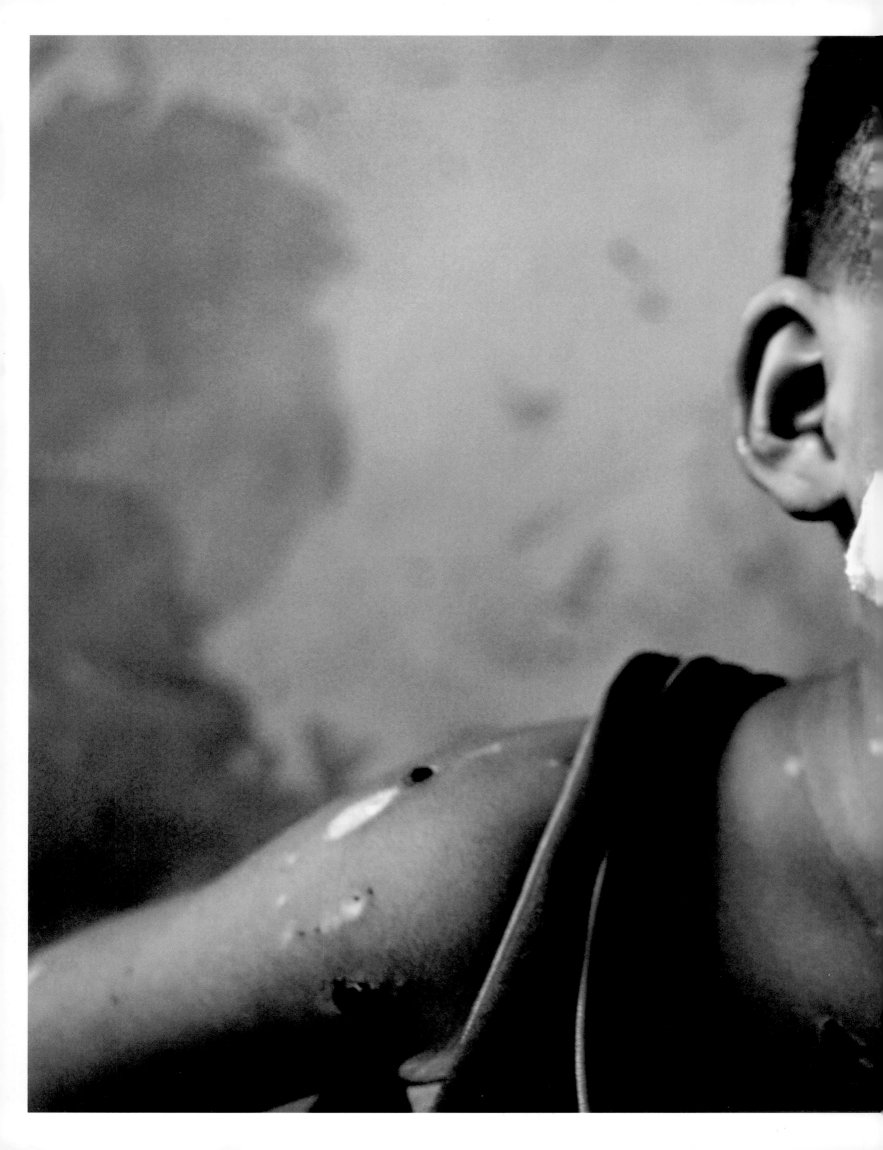

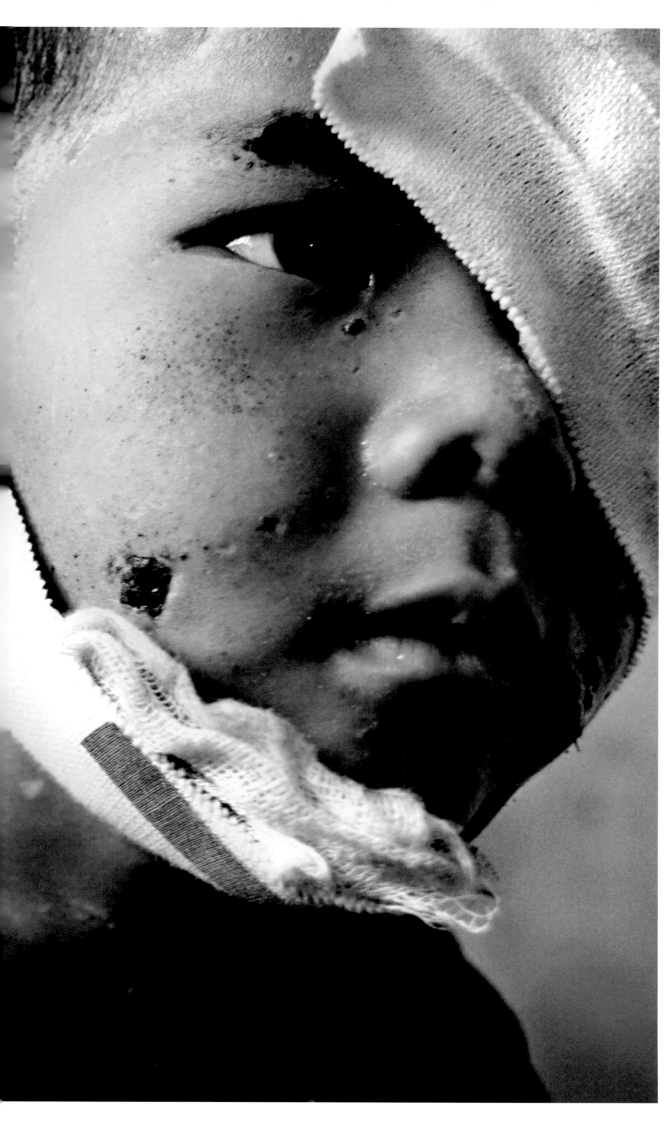

andrew mcconnell
Of the two million tons of explosives dumped on Laos during the Vietnam war, the cluster bomb was the most deadly, it accounts for half the unexploded ordnance in the ground today, and continues to claim innocent victims on a daily basis. Six-year-old Konglan La is one of the lucky ones, most do not survive a blast that sends 300 ball bearings tearing through everything within a 100 metre radius. One piece destroyed Konglan's left eye, another passed straight through his body puncturing a lung. Sadly this is a regular occurrence in a country still living with the legacy of a war that ended 30 years ago. Russian Hospital, Vientiane, Laos. 27th March 2005.

dan chung THE GUARDIAN

An injured girl is tended by medical staff in the makeshift hospital set up in in Muzaffarabad's Neelum stadium in Pakistan-administered Kashmir. The huge earthquake which had a magnitude of 7.6 and claimed an estimated 90,000 lives, and made more than 3 million homeless. 11th October 2005.

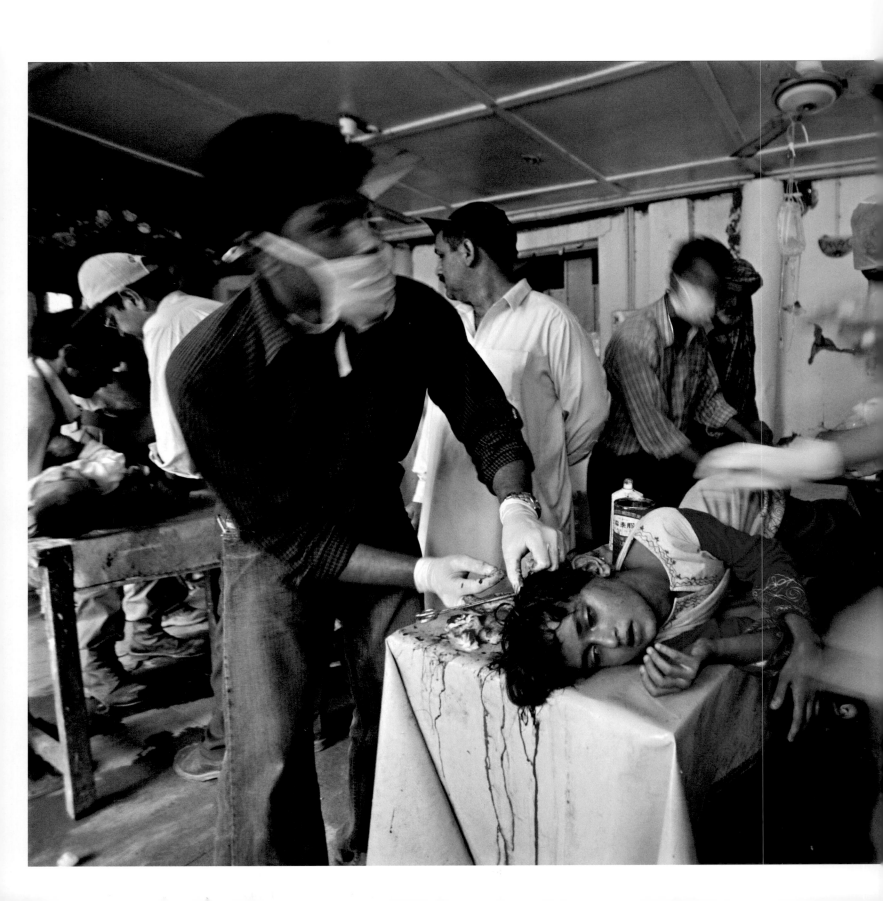

dan chung THE GUARDIAN
New arrivals on the temporary helipad at the Neelum stadium which was turned into a makeshift hospital after the huge earthquake. Muzaffarabad in Pakistan-administered Kashmir. 11th October 2005.

richard mills THE TIMES
A Turkish rescue team working in Muzaffarabad give immediate first aid to Iqbad, a Pakistani man who they brought out alive from a bank that collapsed during the earth quake. 9th October 2005.

john ferguson DAILY MIRROR
The aftermath of Hurricane Katrina in the state of Mississippi. Klin town resident Mark Vallery sits outside his home, rifle at the ready, to protect his house from looters. September 2005.

stewart cook IFAW
Floods in New Orleans after hurricane Katrina displaced thousand of people. Many had to leave their pets behind after being told they couldn't take them on transports out of the city or be able to keep them in shelters. Many animal rescue charities worked in toxic water on boats or by wading on foot to rescue pets from homes and those that were roaming the streets before they starved or died of thirst. Jim Boller approaches a scared dog that is guarding it's home. September 2005.

hazel thompson
Prisoners sleeping on the floor, in their cramped cell in a jail in Metro Manila.

There are an estimated 68,000 children in Philippine adult prisons throughout the course of a year. Some as young as 9. Most are illegally detained in prison for trivial offences and many are held on mere suspicion with long delays in the justice process.

The youngsters are subject to sexual abuse by the guards and other prisoners. The cells are overcrowded with prisoners having to stand while others sleep on the concrete floor. Diseases spread quickly and the children are most vulnerable. In flooded and damp cells with little light, stifling heat and no fresh air, the children's health is being affected. An adult prison is no place for a child. July 2005.

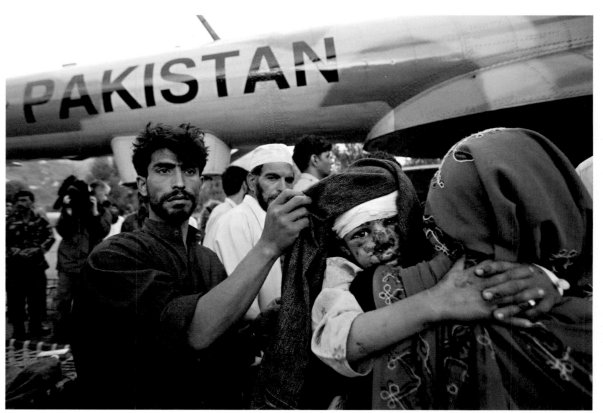

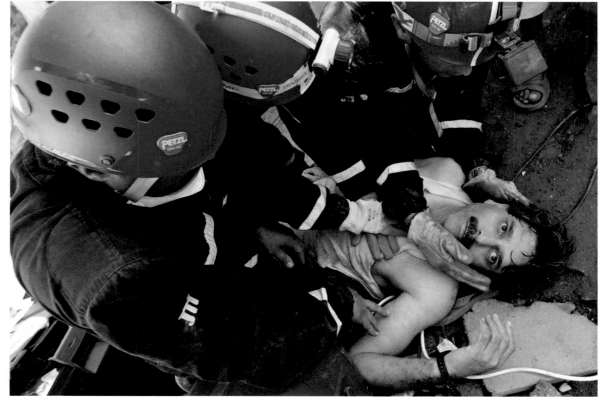

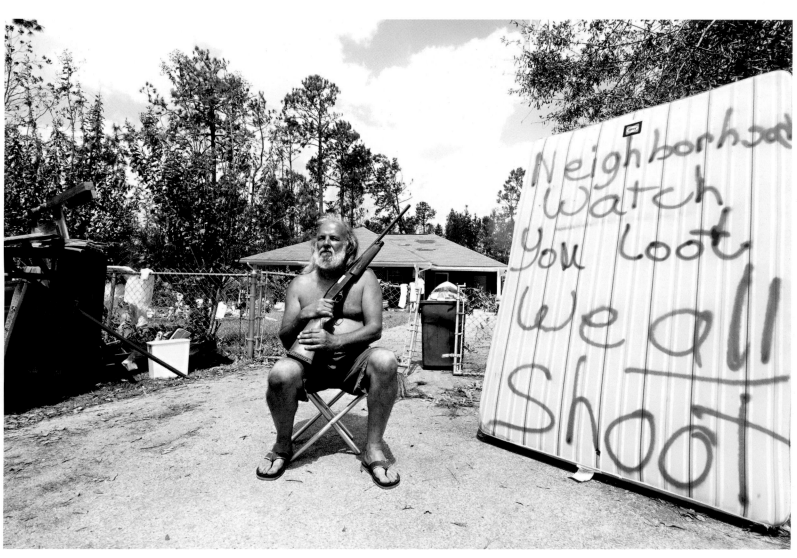

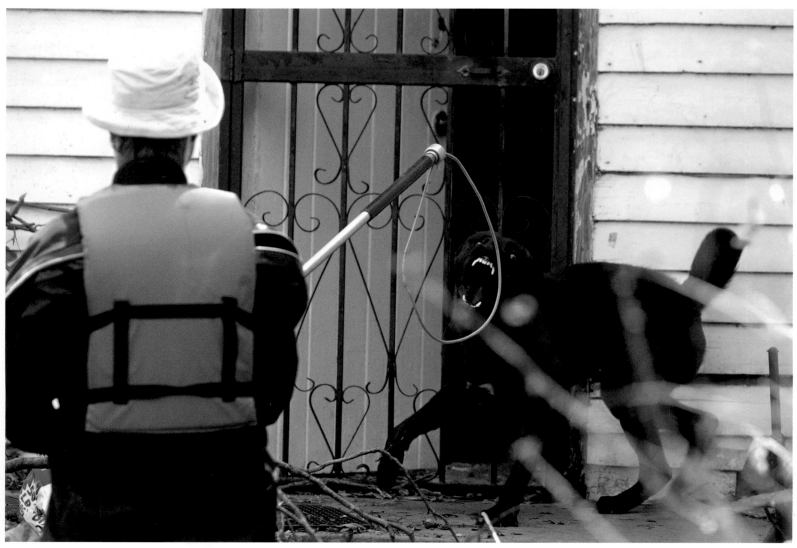

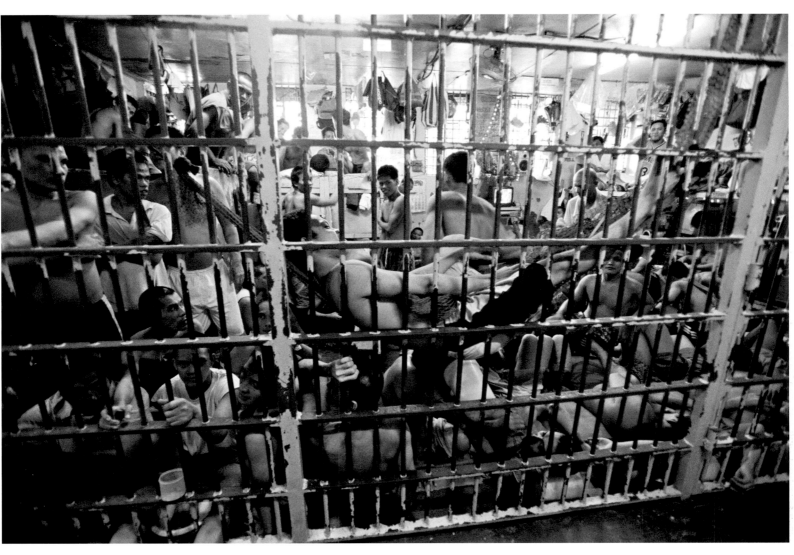
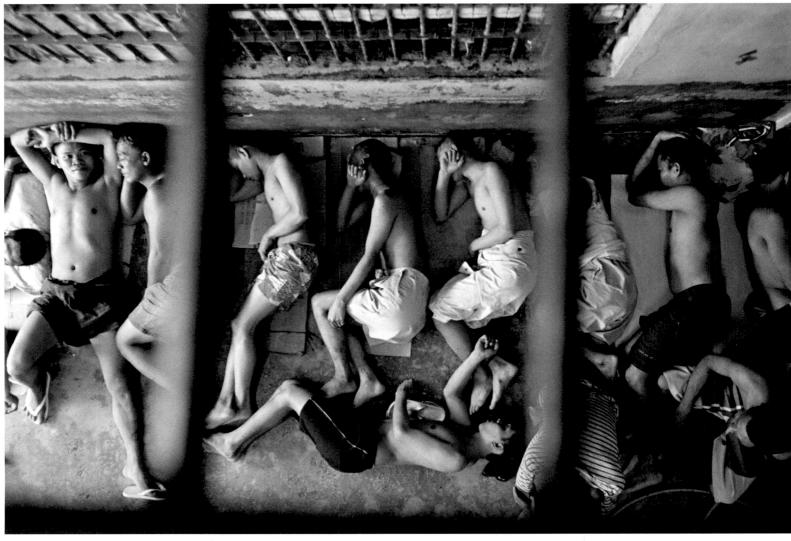

heathcliff o'malley
On 11th July 2005 the 610 coffins carrying the
remains of recently identified victims of the
Srebrenica massacre were buried, coinsiding
with the tenth anniversary of the greatest war
crime committed in Europe since World War Two.
Here politicians shake hands in greeting at the site
of a secondary mass grave on a hill shortly before
the ceremony . Long chains of men passed the
coffins from one to another and then were carefully
placed in their graves where mothers daughters
and sons caught a glimpse of their loved ones
enshrouded remains for the last time. At Srebrenica
an estimated 7,414 men and boys were murdered by
Bosnian Serb forces.

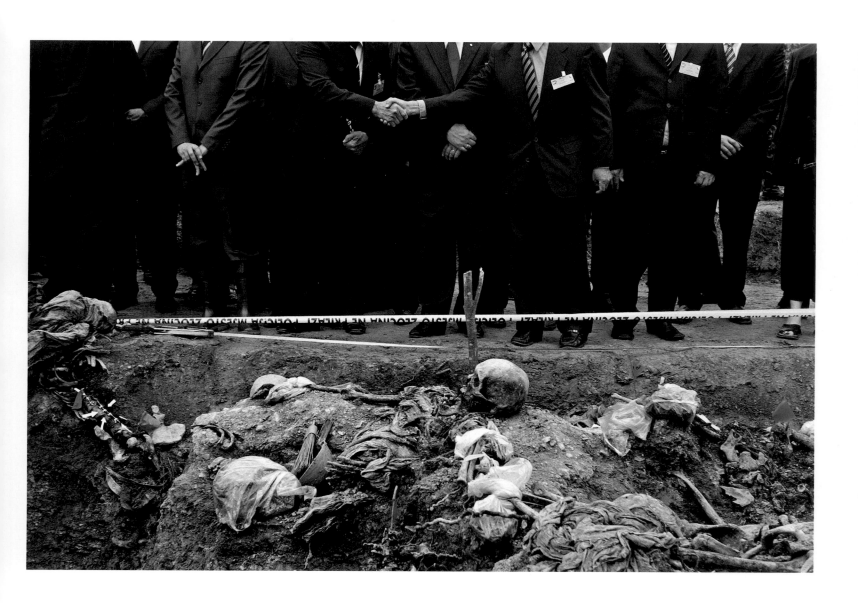

27

andrew testa PANOS
A young boy prays over one of nearly 600 coffins
that were placed in the Battery Factory in Potocari,
Bosnia in preparation for their burial on the IIth July,
the tenth anniversary of the Srebrenica massacre.
9th July 2005.

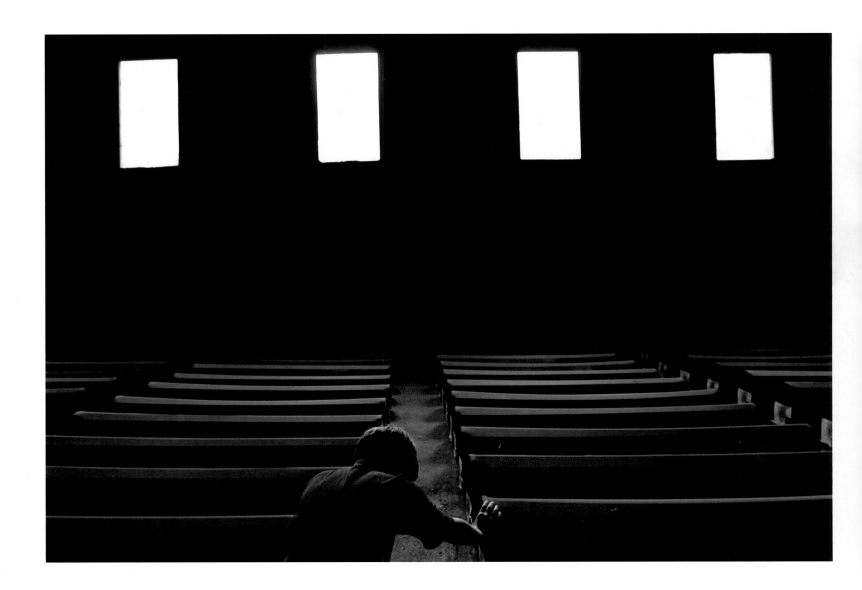

28

andrew testa PANOS

Since 1967 in Bangladesh, acid has been used as a weapon. It is usually thrown in the victims face or on the body. It is mainly used against women, often when they refuse the sexual advances of men, or an offer of marriage. In recent years it has also been used as a result of land disputes. The Acid Survivors Foundation began helping victims in °1999, and now runs a hospital in Dhaka that provides medical help to the victims. The Government has recently made acid attacks punishable by death in an attempt to stop its use, as yet, no death sentences have been carried out. Nobisa Begam who is 15 years old. Photographed three days after acid was thrown in her face for refusing a marriage proposal. June 2005.

stuart freedman PANOS

Potamienne Komezusenge, 37, plays with her youngest child. A school teacher, she was infected by her husband and left to bring up their children alone. He is buried in the back garden, marked by a wooden cross. She says "As long as I feel strong, I feel OK emotionally ... sometimes there is stigma here ... but the biggest problem is money. My salary is 22,000 Rwandan Francs a month and I have my children. Because I can't breastfeed, I have to buy the youngest special powdered food and it is like I am working just for him. Am I angry at my husband? How can you be angry at one you cannot see ...". Kibayi, Rwanda. November 2005.

stuart freedman PANOS

Saidi Ruhimbana, 40 comforts his wife Anastasie Hwamerera, also 40. Both have AIDS but Anastasie is very sick. Saidi says "These days things have changed. We both need medicine and our savings have gone because of this. Even some of the children had to stop school because we could no longer afford to send them ... I was a builder but now I can't lift anything heavy. In fact from my land I have to give a percentage of my crop to my debtors." Kibileze, Rwanda. November 2005.

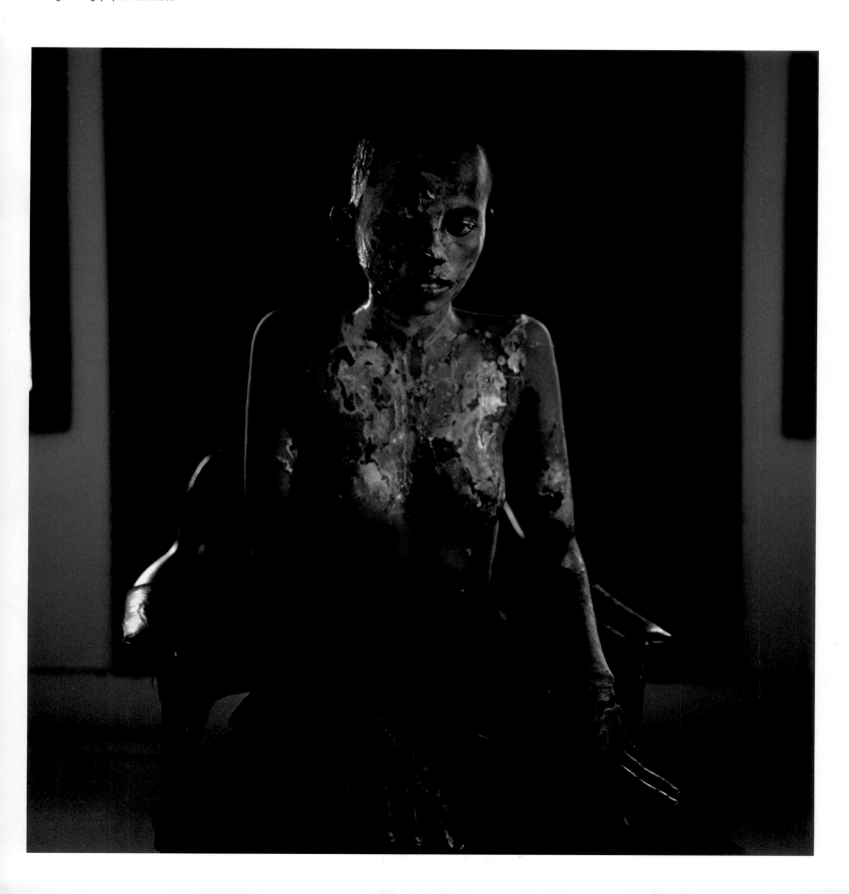

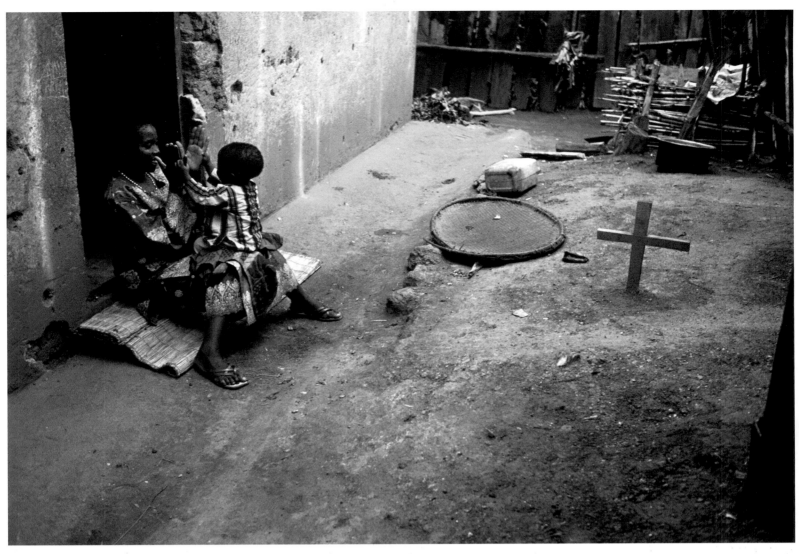
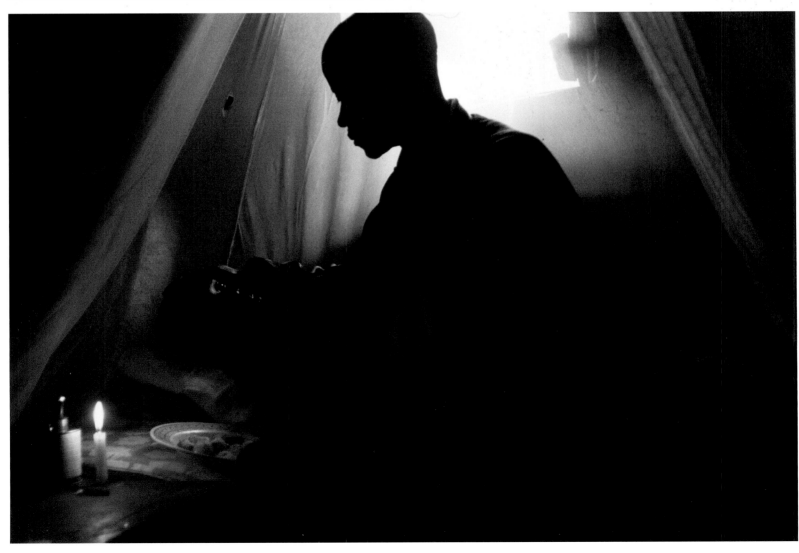

peter macdiarmid GETTY IMAGES
Smoke rises from the a fire at the Buncefield fuel
depot which started a week earlier after a massive
explosion near Hemel Hemstead, England.
18th December 2005.

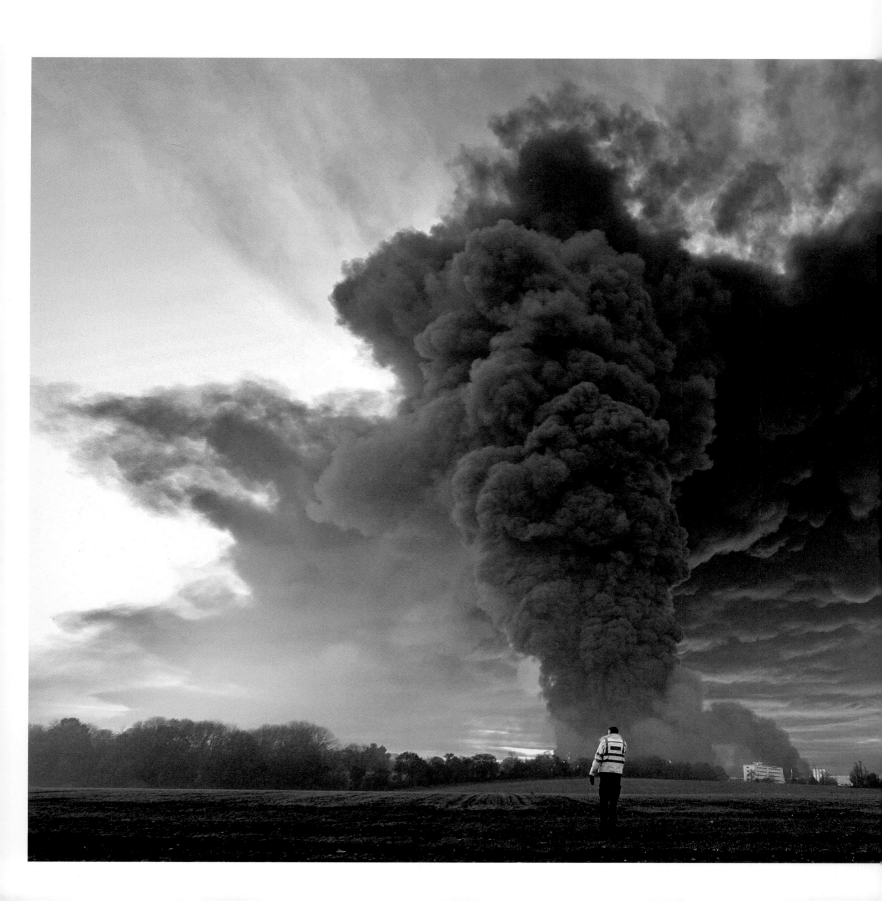

christopher furlong GETTY IMAGES
As the sun sets over Hertfordshire balls of fire
continue to erupt as secondary explosions occur
at the Buncefield oil depot near Hemel Hempstead,
England. The explosions are being treated
as accidental, scotching rumours of any terrorist
link. 11th December 2005.

jack hill
Flames from the fire beyond a cottage near to
Buncefield Oil storage depot, Hemel Hempstead,
Hertfordshire. 12th December 2005.

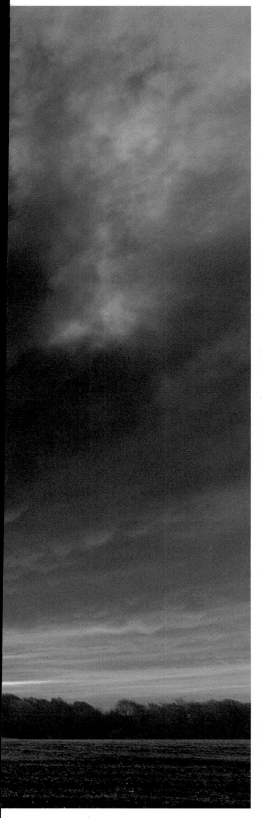

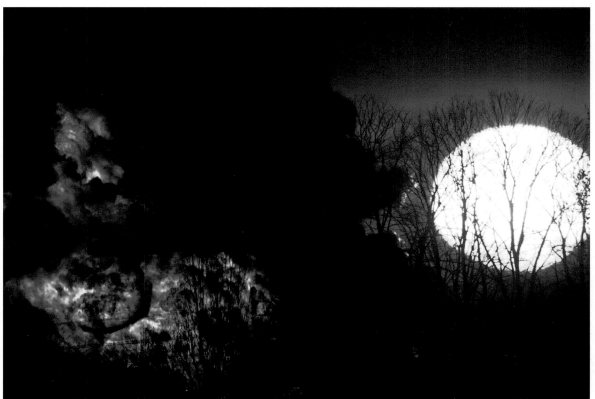

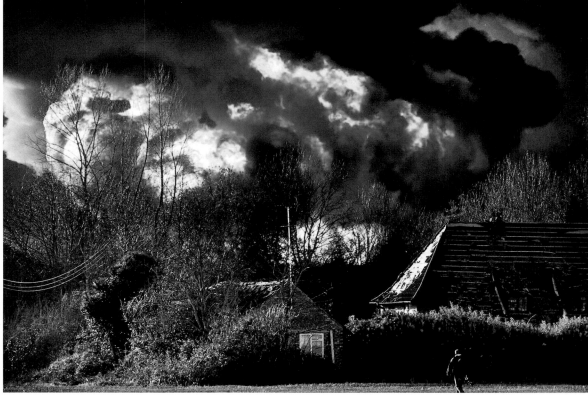

first prize: news

richard austin
With the countdown to the ban on hunting the
remarkable moment when John Stone of the Devon
& Somerset Stag Hounds was butted off his horse
by a startled red deer stag on Exmoor in Somerset.
The stag fled the scene and lived to fight another
day, whilst John Stone suffered a few bruises but
was otherwise unhurt. 1st February 2005.

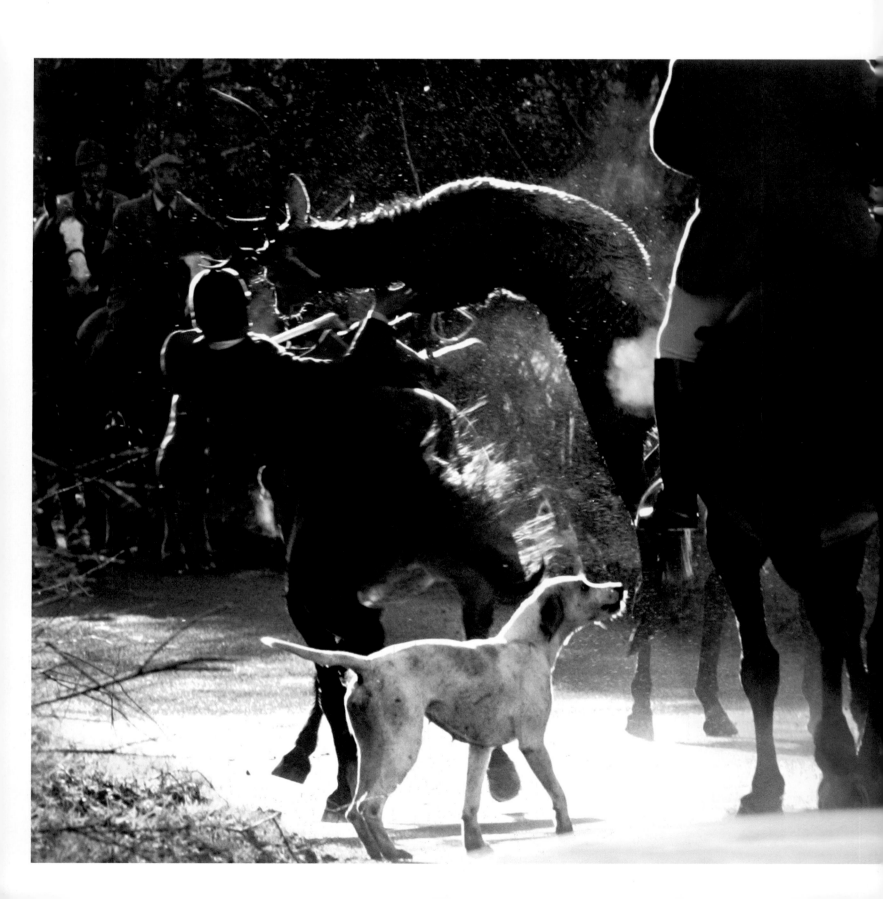

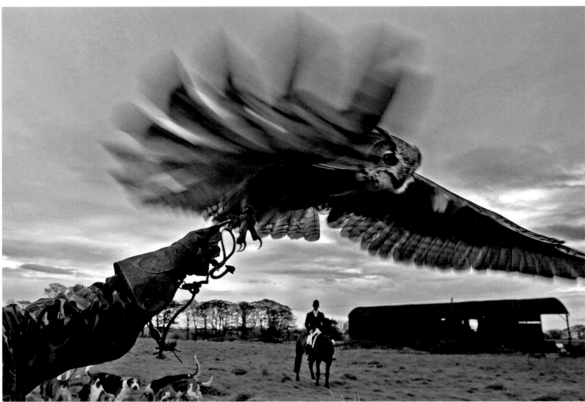

jeff j mitchell REUTERS
A member of the South Durham Hunt holds up a
Turkmenian Eagle Owl in Sedgefield in northeast
England. Hundreds of hunts are expected to ride
out on Saturday to mark the start of the fox-hunting
season in England and Wales, in spite of a ban on
hunting with dogs. Some hunts will take a hawk
or other hunting bird with them as a way around the
ban which still lets hounds chase and flush out foxes
as long as they do not kill them. 5th November 2005.

abbie trayler-smith
Hounds from The Royal Artillery Hunt in Wiltshire
tearing apart the 125th fox they've caught this
season. This was their last legal hunt as the ban
on hunting dogs in England and Wales came into
effect the next day. 17th February 2005.

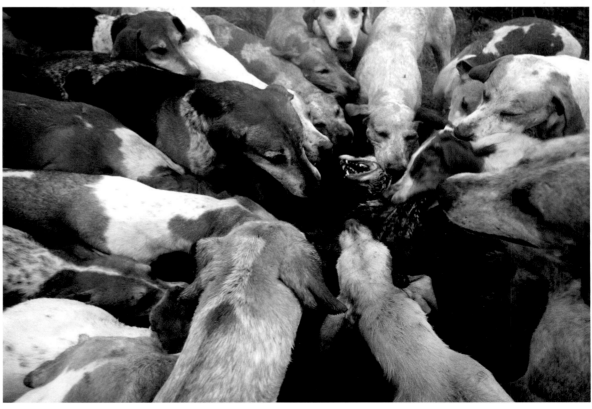

peter macdiarmid GETTY IMAGES
Swan Uppers row on the river Thames during the
Swan Upping ceremony on 18th July 2005 on
the River Thames South West of London. Swan
Upping is the annual census of the swan population
on stretches of the River Thames in the counties
of Middlesex, Surrey, Buckinghamshire, Berkshire
and Oxfordshire. It takes place during the third week
of July each year. This historic ceremony dates from
the 12th century, when the Crown claimed ownership
of all mute swans. At that time swans were regarded
as a delicious dish at banquets and feasts.

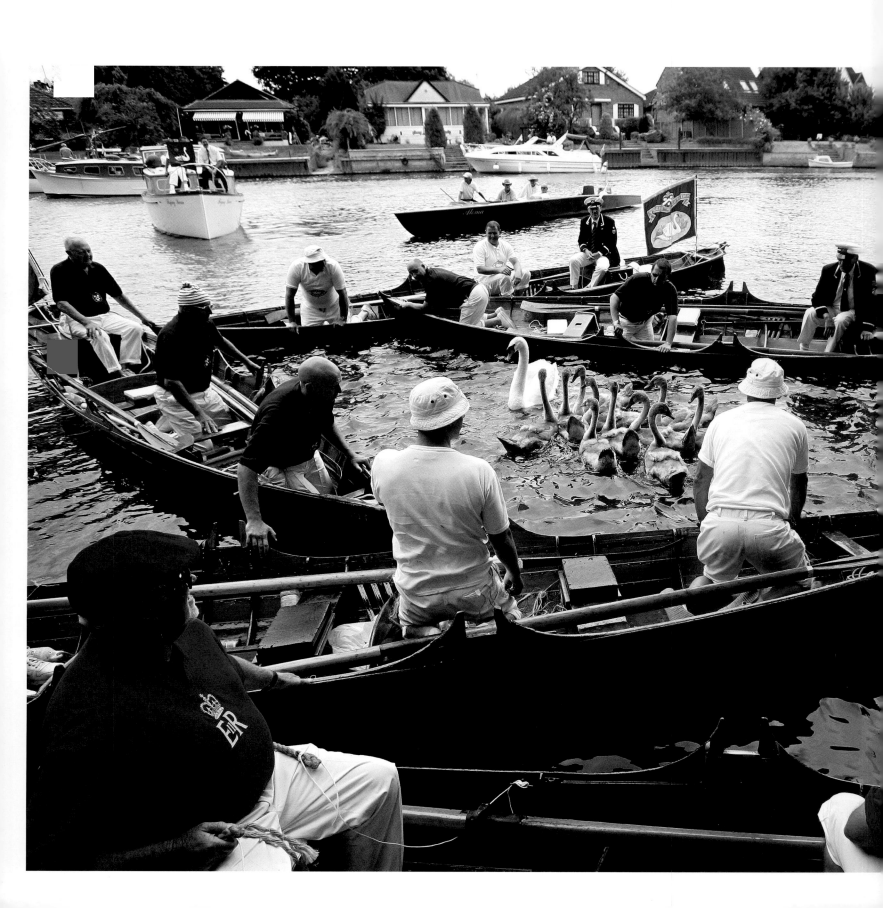

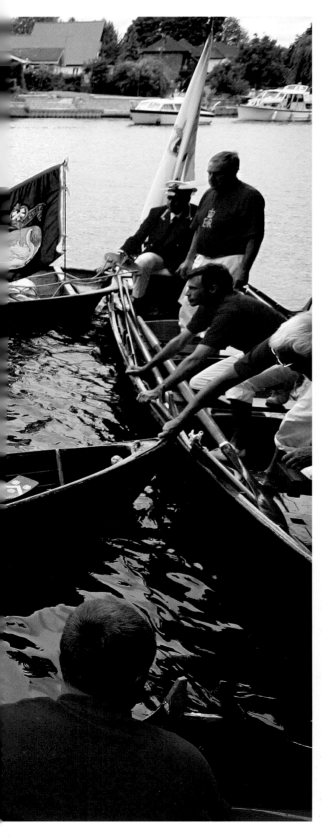

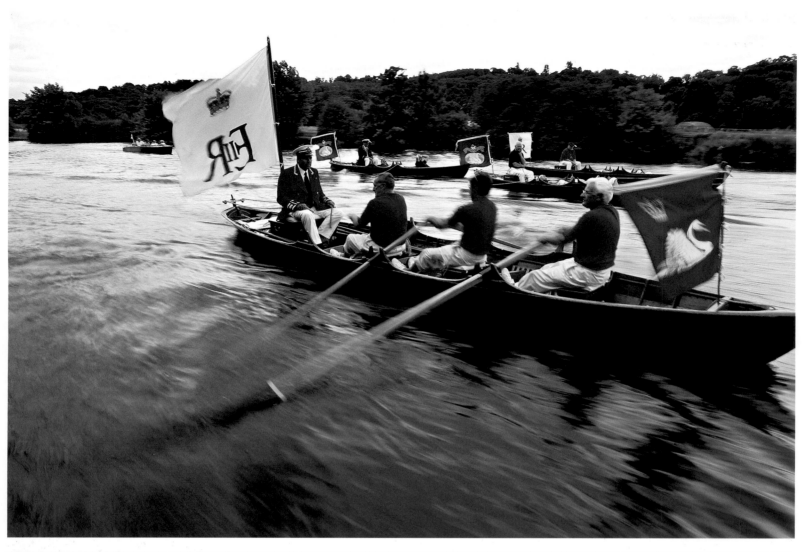
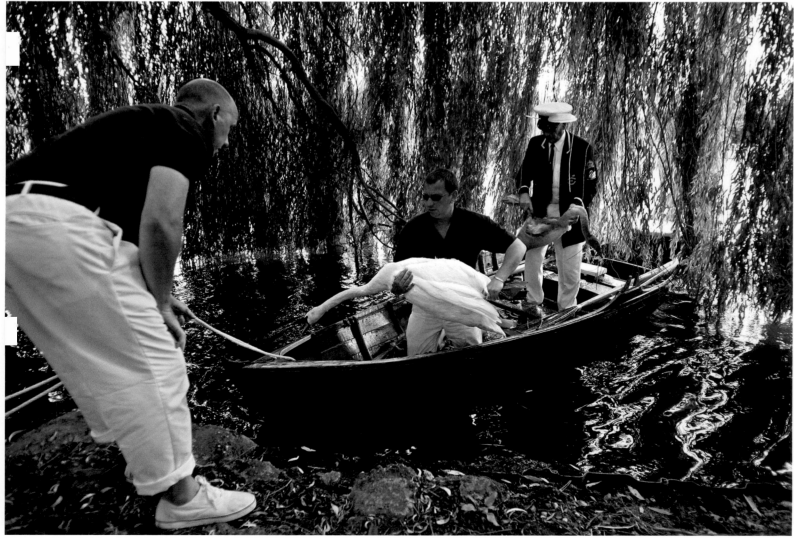

peter macdiarmid GETTY IMAGES
Today, the Crown retains the right to ownership
of all unmarked mute swans in open water,
but the Queen only exercises her ownership
on certain stretches of the River Thames and
its surrounding tributaries.

This ownership is shared with the Vintners'
and Dyers' Companies, who were granted rights
of ownership by the Crown in the 15th century.
Nowadays, of course, the swans are no longer eaten.

In the Swan Upping ceremony, the Queen's Swan
Marker and the Swan Uppers of the Vintners' and
Dyers' livery companies use six traditional Thames
rowing skiffs in their five-day journey up-river.
The officials wear traditional scarlet uniforms and
each boat flies appropriate flags and pennants.

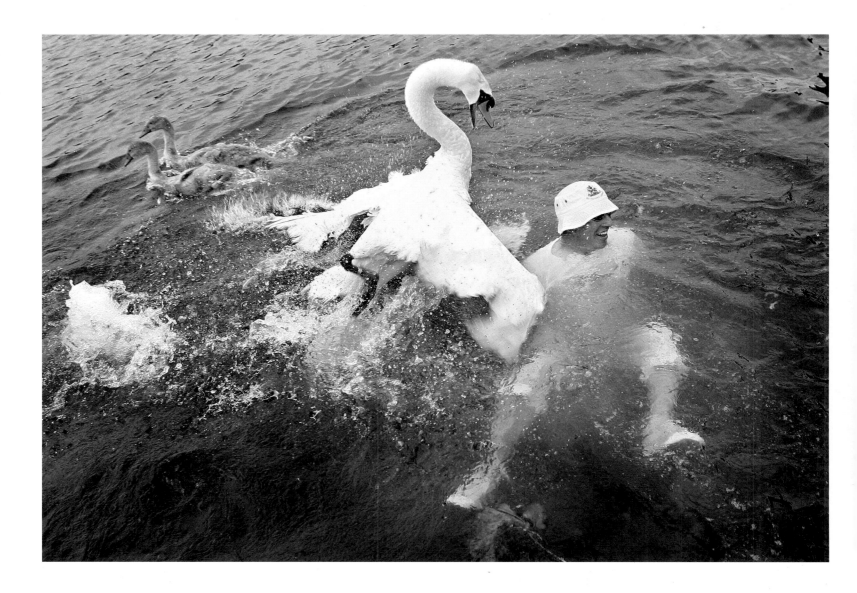

graham barclay BLOOMBERG NEWS
The face of Viktor Yushchenko, the Ukrainian
president who suffered Dioxin poisoning 'at the
hands of a third party' according to his doctor
in Vienna. 17th October 2005.

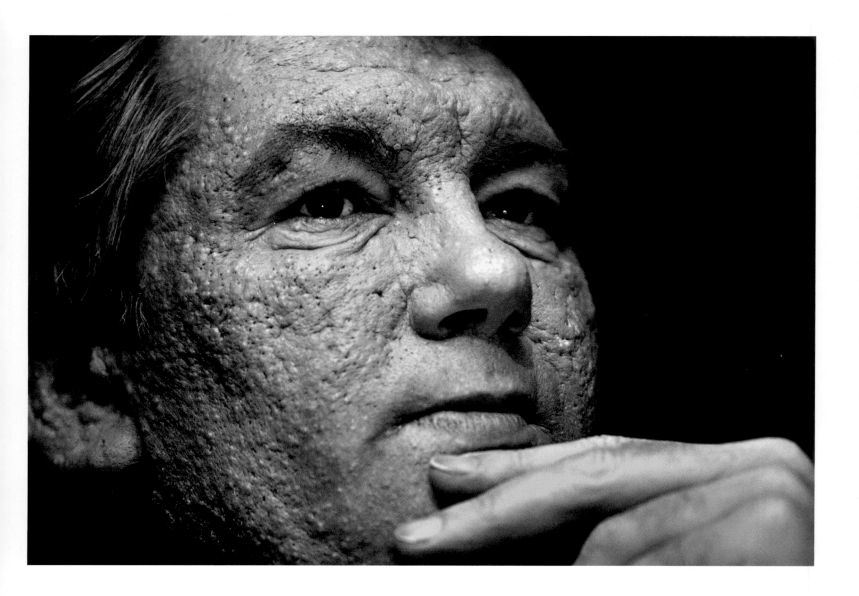

toby melville REUTERS
The shadow of Britain's Prime Minister Tony Blair
is cast behind Chancellor of the Exchequer Gordon
Brown as they take questions during a General
Election news conference in central London. With
Labour winning an historic third successive general
election, Brown was still left uncertain as to when
Blair would hand over the party leadership to his
Chancellor. 25th April 2005.

andrew parsons PA
Conservative Party Leadership Contender Ken
Clarke leaves the Imperial Hotel, Blackpool,
on his way to the start of the Conservative Party
Conference. 3rd October 2005.

paul rogers
Conservative candidate Boris Johnson canvassing
in St Andrews Road, Henley on Thames during the
General Election. 18th April 2005.

andrew parsons PA
Sandra Howard cuddles her husband, the Leader
of the Conservative Party, Michael Howard after
announcing in his speech at Roehampton University
he will step down as the leader when a suitable
replacement is found, after losing the General
Election to Labour. 6th May 2005.

david sandison THE INDEPENDENT
Charles Kennedy takes a moment to himself in the
Imperial Hotel in Blackpool, as he finds himself
under pressure from his party and the press, during
the 2005 Liberal Democrats Conference. He went
on to resign in January 2006 after admitting to
having an alcohol problem. 20th September 2005.

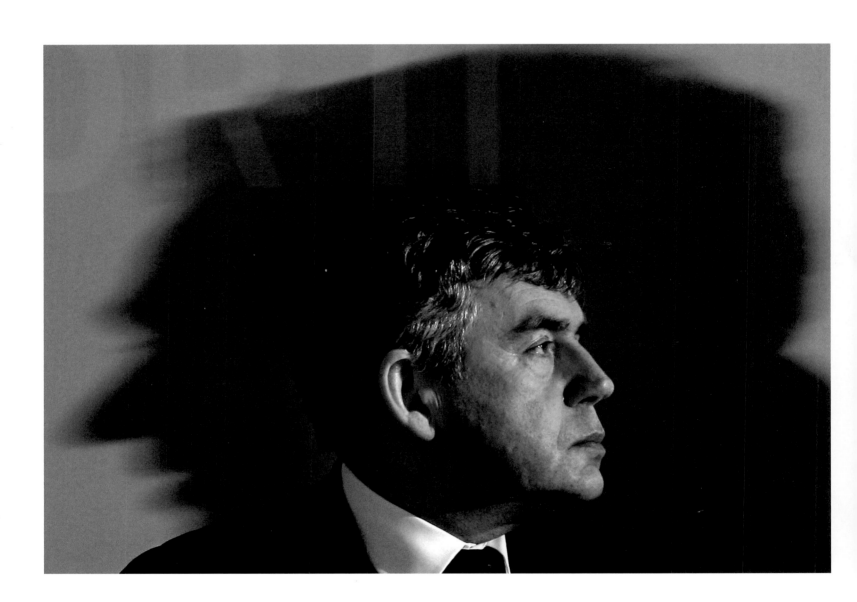

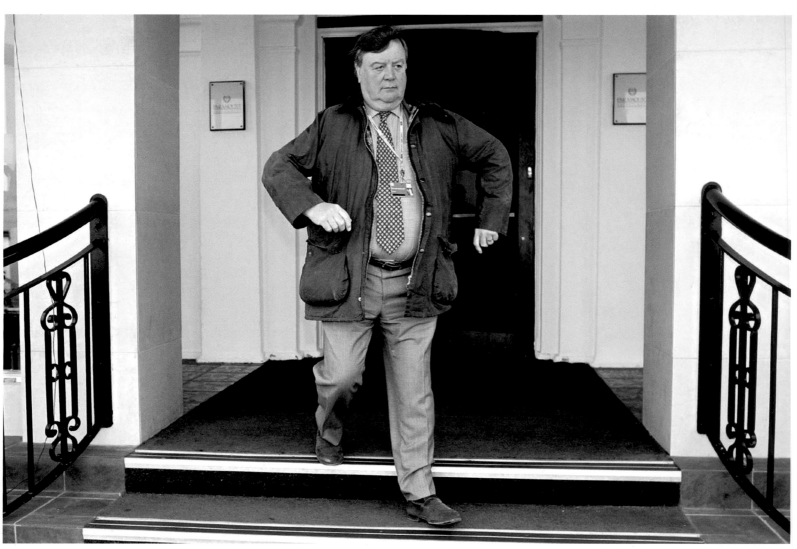

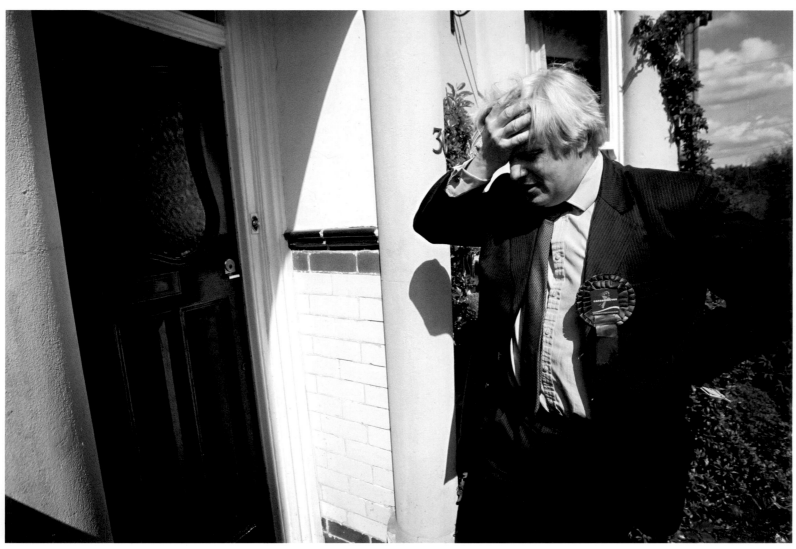

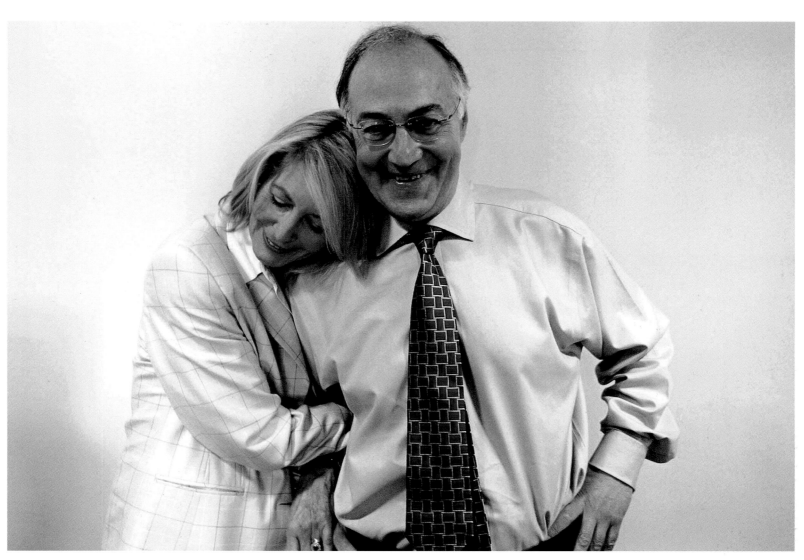
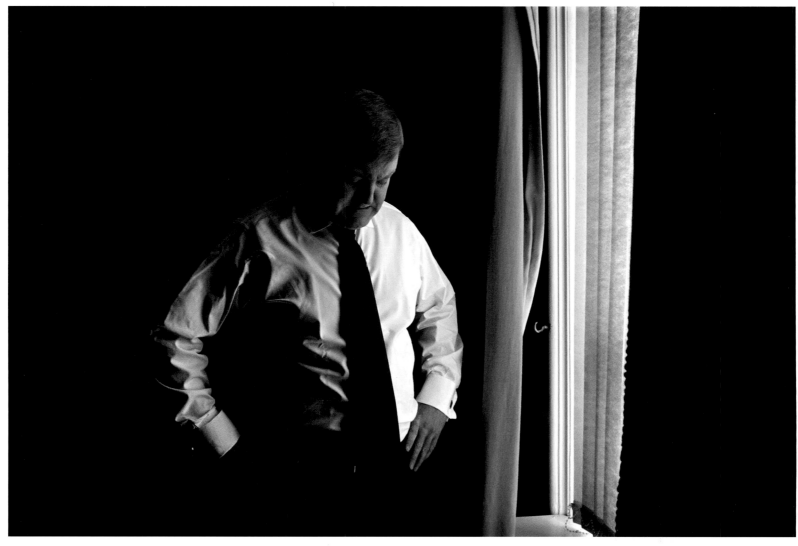

jeremy selwyn EVENING STANDARD
Tony Blair in contemplation at the G8 summit in
Gleneagles moments after being told the news
about the terrorist bombs that exploded in London
that morning. 7th July 2005.

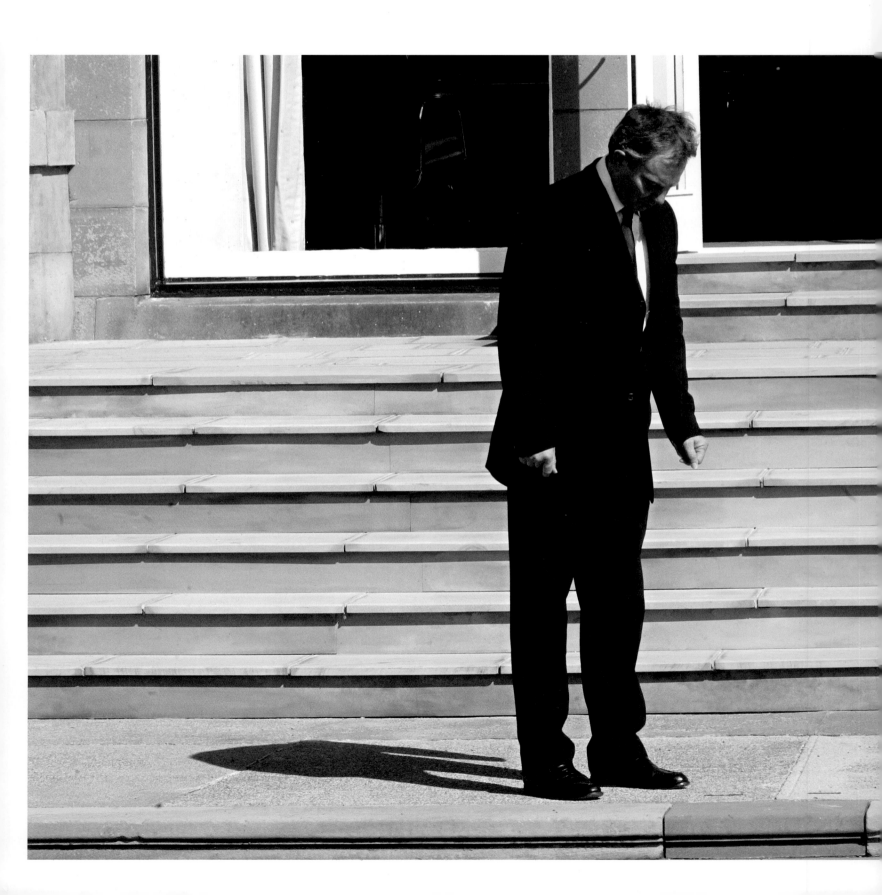

kieran doherty REUTERS
Respect Party leader George Galloway is
congratulated by his supporters on arriving in
Brick Lane, east London after winning the Bethnal
Green and Bow constituency seat in the General
Election. Britons have grudgingly returned Prime
Minister Tony Blair to power for a third time,
according to an exit poll of voters, but with a vastly
reduced mandate after a bruising election campaign
dominated by Iraq. 6th May 2005.

andrew parsons PA
David Blunkett leaves the House of Commons
Wednesday after resigning as Work and Pensions
Minister. 2nd November 2005.

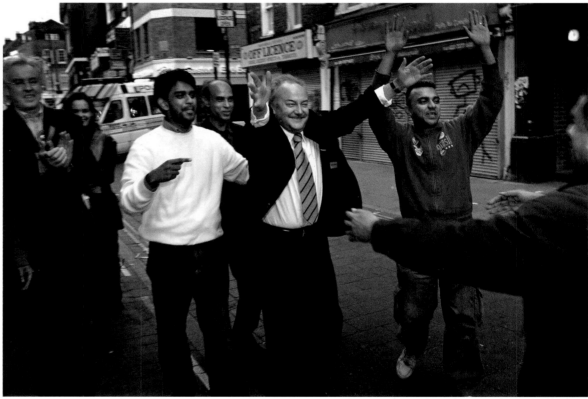

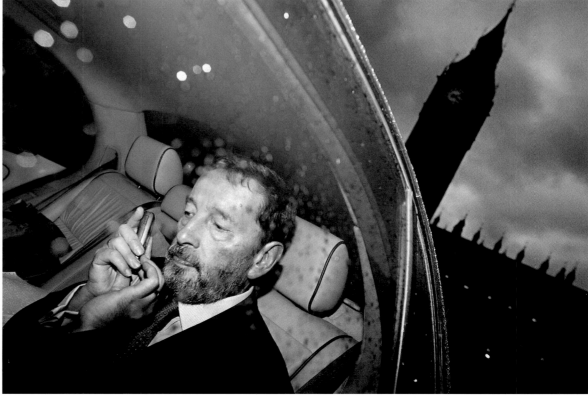

dylan martinez REUTERS
Police clash with protesters in Auchterarder near
the Gleneagles Hotel where the G8 summit is being
held in central Scotland. Thousands of anti-G8
protesters marched on the heavily fortified Scottish
hotel on Wednesday where world leaders, under
pressure to tackle climate change and poverty
in Africa, were due to meet. 6th July 2005.

wattie cheung
The results of a peaceful encounter with
anti-G8 protesters. Police come away with
colourful additions to their riot-shields as they
wait in Edinburgh city during the G8 conference
at Gleneagles. 4th July 2005.

wattie cheung
During the G8 conference in Gleneagles, protestors
converged onto the streets of Scotland in Edinburgh
and Glasgow to make their voices heard. The
Scottish Police were backed up by colleagues
from all over the UK and the bill ran into millions
of pounds for the Scottish Government. Anarchy
and riots were expected with the protesters who
came from around the world but in the summit
passed off relatively peacefully without serious
clashes that were predicted. 2nd July 2005.

dylan martinez REUTERS
Pope John Paul II blesses the faithful from his suite
at the Gemelli hospital in Rome. The Pope normally
reads a short address, then a prayer known as the
'Angelus' before delivering his blessing to the
crowds in St. Peter's Square, but was unable to
do so following emergency treatment for flu-induced
breathing problems. 6th February 2005.

dylan martinez REUTERS
A huge crowd of pilgrims, along with dignitaries
and religious figures, attend the funeral of Pope
John Paul II in the Vatican's St. Peter's Square. The
poor and the powerful of the earth rubbed shoulders
to say their last goodbye to the Pope on Friday as the
Vatican staged one of the most momentous funerals
in history for the Polish Pontiff. 8th April 2005.

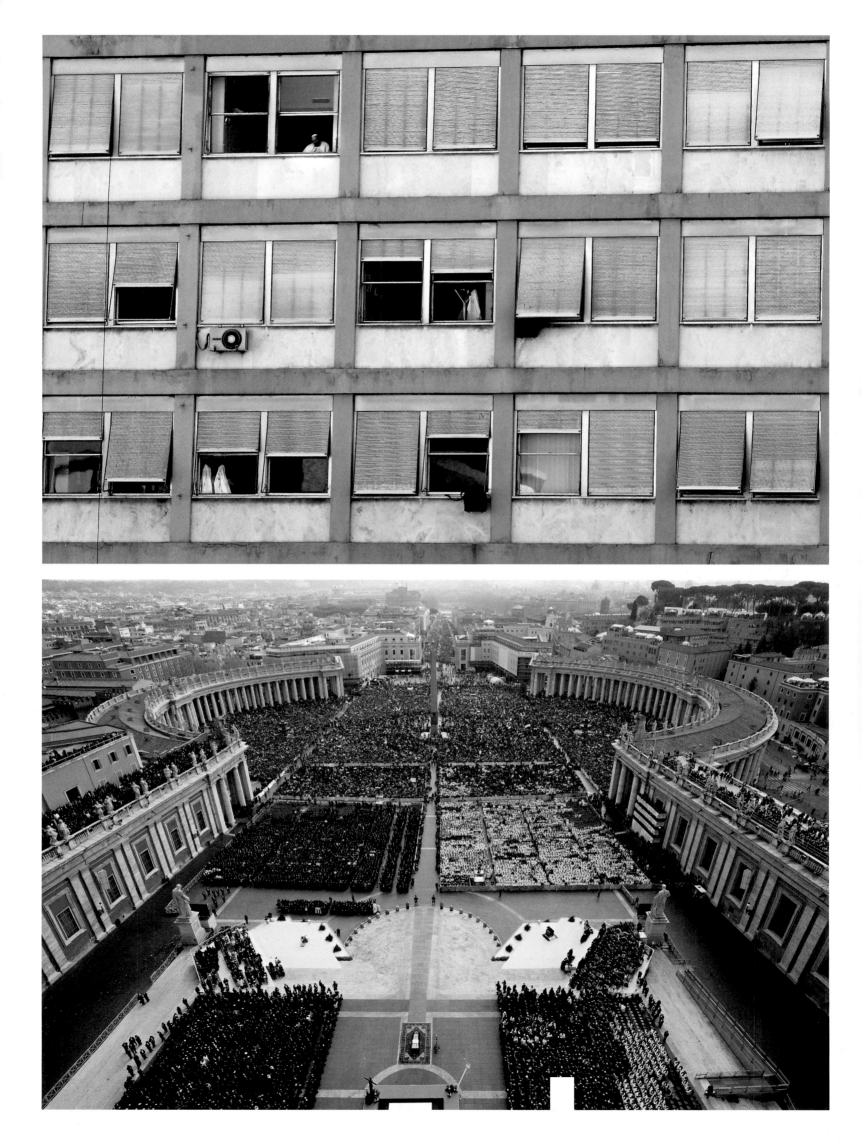

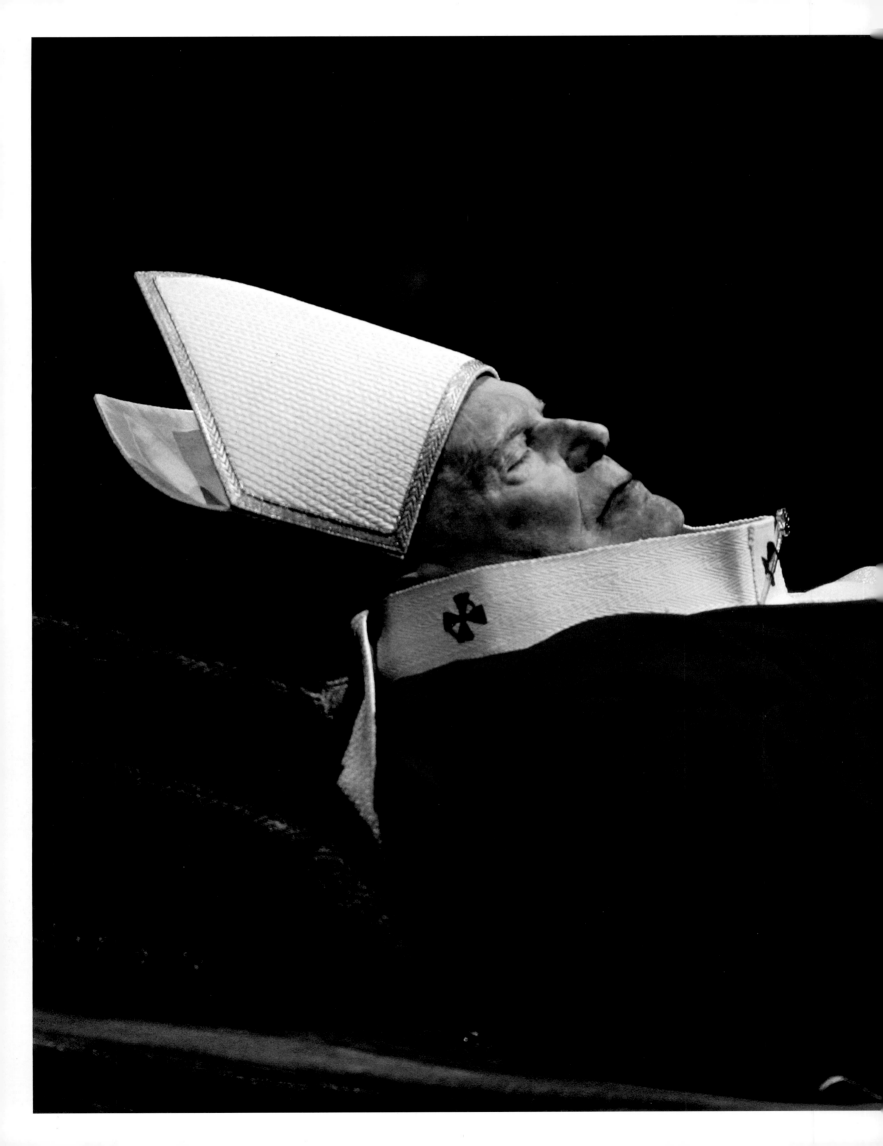

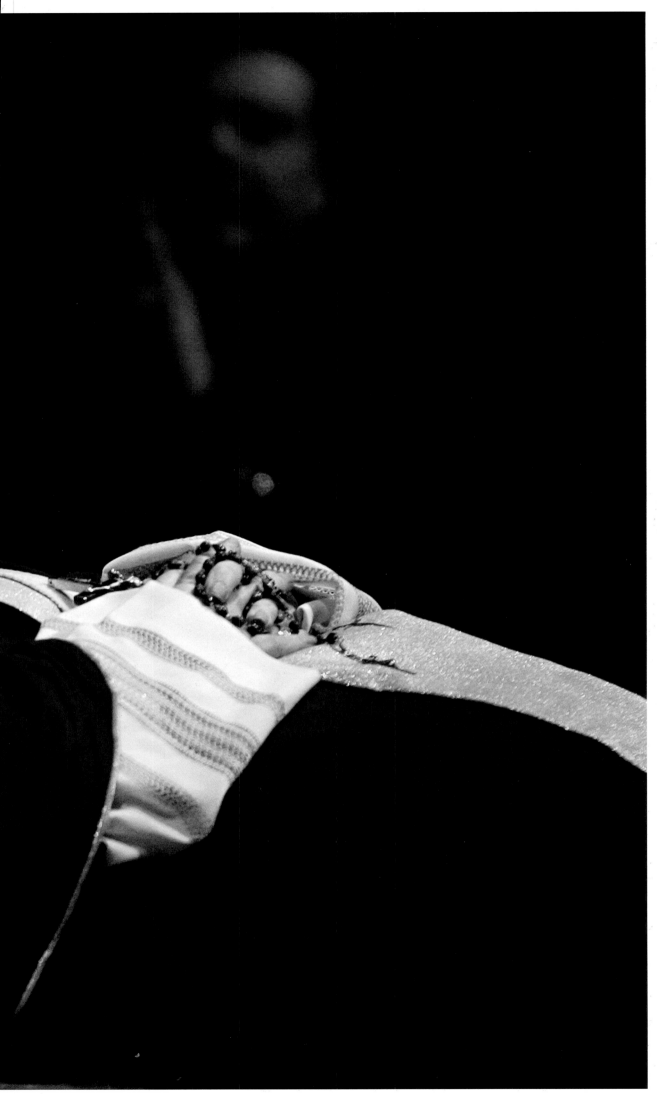

peter macdiarmid GETTY IMAGES
The body of Pope John Paul II lies in state in
St. Peter's Basilica in the Vatican City. The Pope's
body was on view to the faithful until the funeral
ceremony on 9th April 2005.

nir elias REUTERS
Israeli special evacuation forces arrive to the
rooftop of the synagogue in the Jewish Gaza Strip
settlement of Kfar Darom, inside a container just
before taking over the place. Israeli troops using
cranes and water cannon battled protesters on
the rooftop of a Gaza settlement synagogue as
they assaulted the last bastions of resistance to
evacuation of the occupied strip. 18th August 2005.

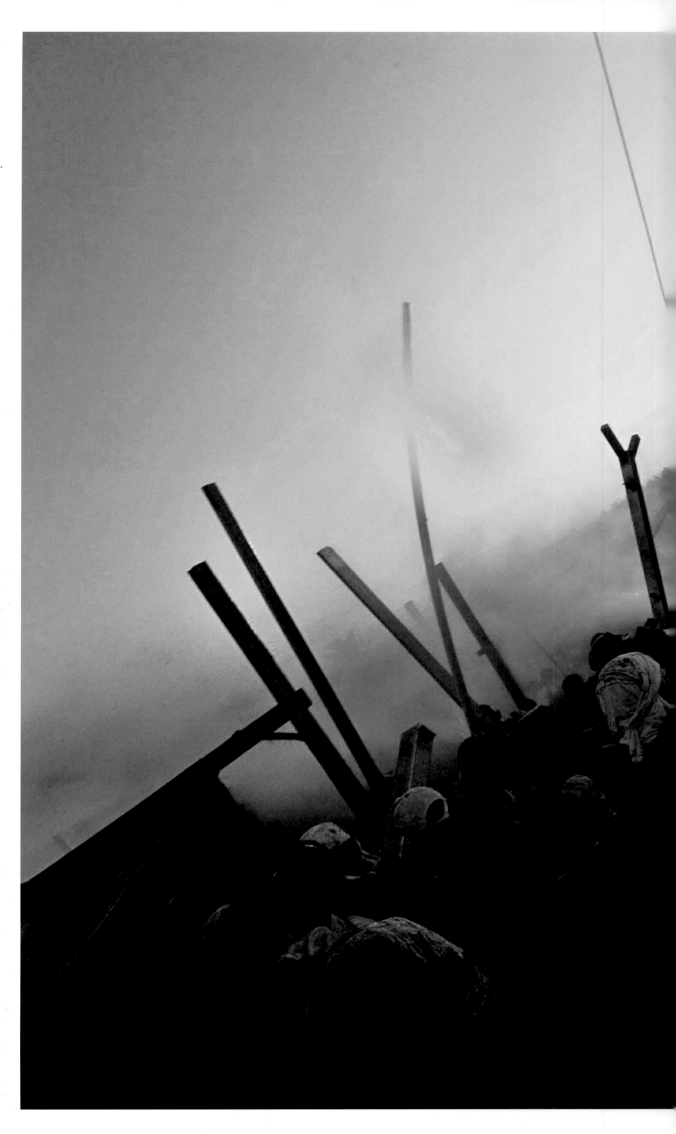

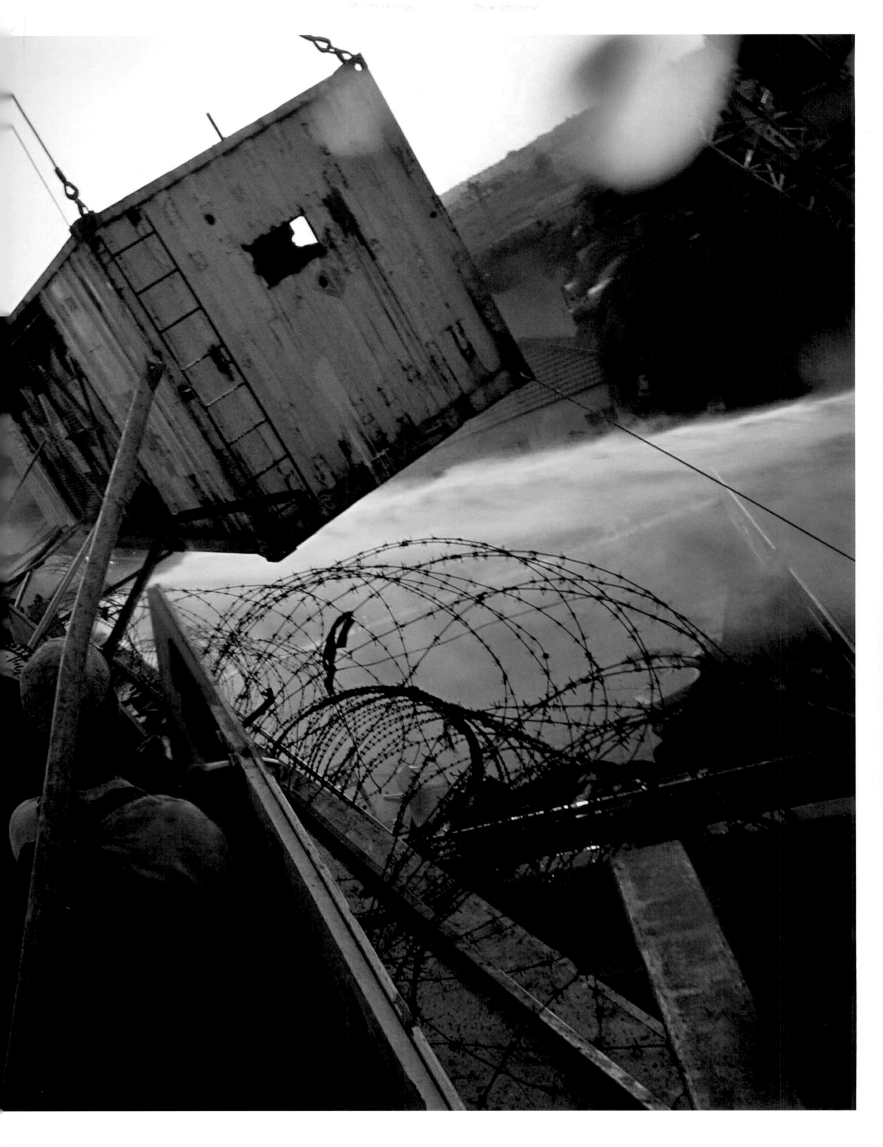

nir elias REUTERS
Emanuel (L), An Israeli opponent of Israel's
disengagement plan from Gaza, embraced by
a special evacuation policeman after the force took
over the roof top of the synagogue in the Jewish
Gaza Strip settlement of Kfar Darom in Gush Katif
settlements bloc. 18th August 2005.

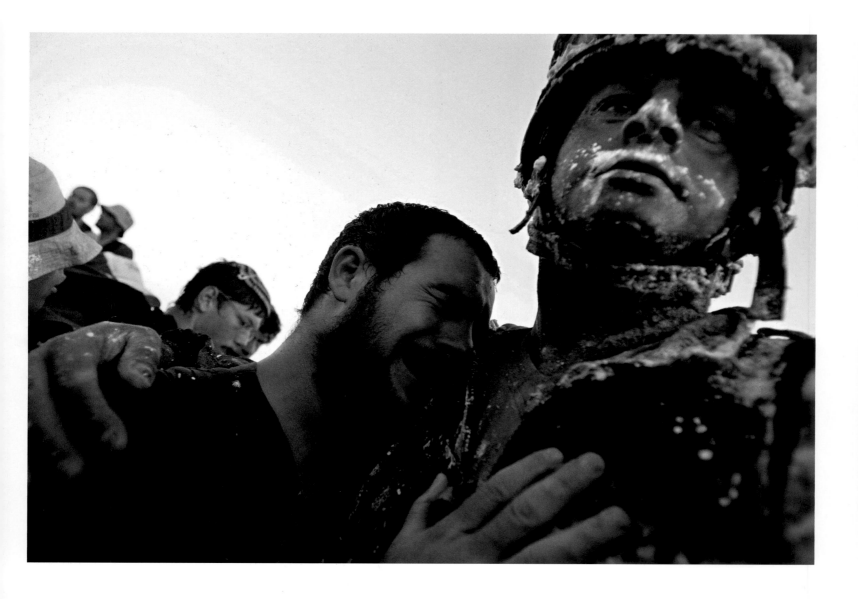

nir elias REUTERS

Israeli opponents of Israel's disengagement plan from Gaza, scream as they speak with a special evacuation policeman after the force took over the roof top of the synagogue in the Jewish Gaza Strip settlement of Kfar Darom in Gush Katif settlements bloc. 18th August 2005.

nir elias REUTERS

Israeli settlers and opponents of Israel's disengagement plan, dance at the end of a special prayer for ending Tisha B'Av fast day commemorating the destruction of the biblical Jewish Temples 2,000 years ago, outside a Synagogue at the Jewish Gaza Strip settlement of Kfar Darom in Gush Katif settlements bloc. 14th August 2005.

nir elias REUTERS

Israeli opponents of Israel's disengagement plan from Gaza wait on the roof top of the synagogue in the Jewish Gaza Strip settlement of Kfar Darom as a special evacuation police unit arrives inside a container to evacuate them. 18th August 2005.

nir elias REUTERS

Israeli special police force, arrest two opponents of Israel's disengagement plan from Gaza, as they push them inside a container on the rooftop of the synagogue in the Jewish Gaza Strip settlement of Kfar Darom in Gush Katif settlements bloc. 18th August 2005.

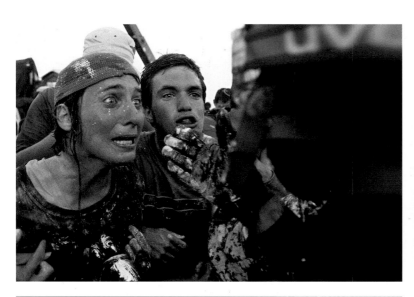
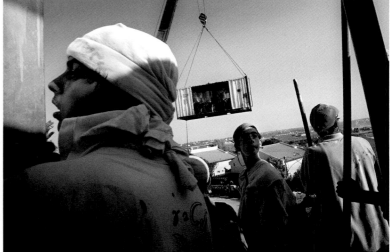
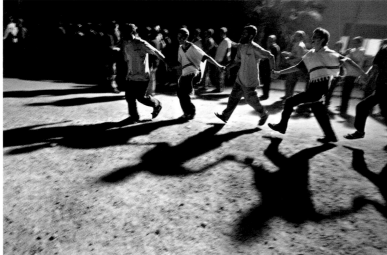
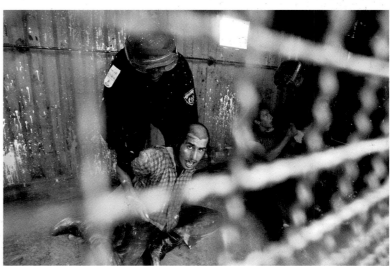

54

cate gillon THE SCOTSMAN

After the tsunami. A legionnaire fights the flames of a burning grounded boat in the market area of Meulaboh. The fire was spread after wind carried the flames from burning piles of debris throughout Meulaboh.

The French Foreign Legion, limited emergency services and locals, worked together in an attempt to control the fires across the town.
Meulaboh, Aceh, Indonesia. 23rd January 2005.

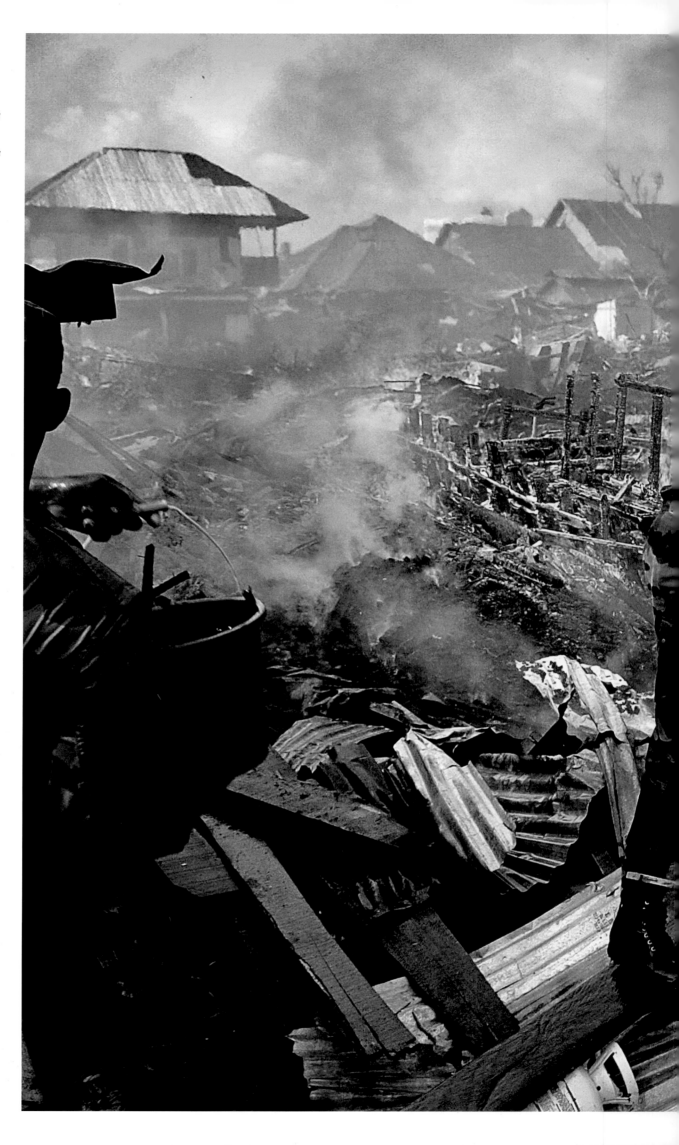

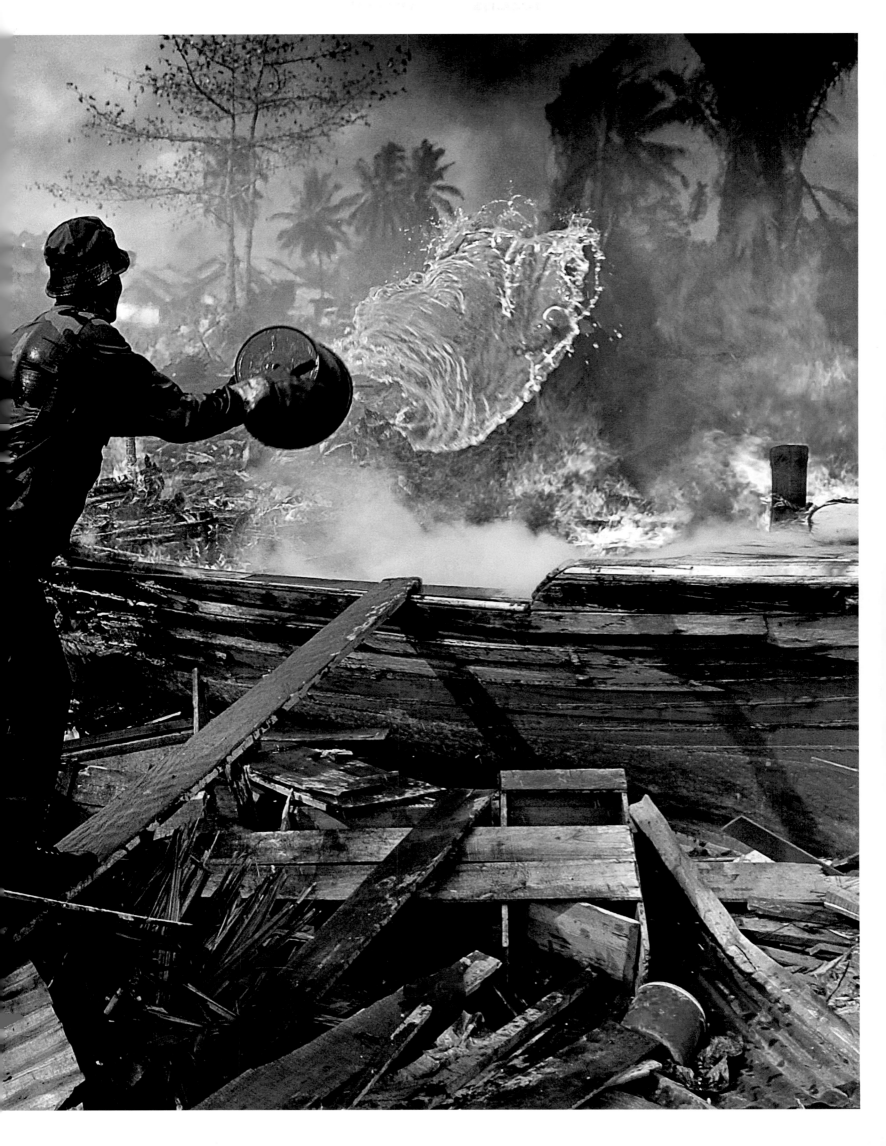

teri pengilley SAVE THE CHILDREN
A child scrambles over destroyed railway tracks in Ambalagoda, nr Galle, Sri Lanka. In the background rescuers begin a recovery operation, where a bus with at least 50 people on board has been buried. A newlywed couple are also buried in their taxi nearby. 1st January 2005.

clara molden
A family have tea in the shade of a large fishing trawler which has been swept inland by the Tsunami and destroyed part of their house. The village, which was one of the worst hit parts of the Thai coast, suffered badly from the effects of the Tsunami because, in addition to loss of life and devastation of homes, the trawlers of the fishing community were swept inland. As a result the remaining members of the fishing community were unable to provide food for themselves through fishing, or earn an income, until the large boats were repaired and moved back out to sea. Ban Nam Khem, Phang Nga Province, Thailand. 12th January 2005.

adrian fisk
The Tsunami annihilated the sea front of the small town of Nagapattinam in south India. In this area of India 7,000 people alone were killed. On the sea front are the remains of a house, so much care had gone into the beautifully painted flower pots, chaos surrounded everything and the crows appeared like carrion of death whilst the sea seems strangely calm and innocent. 1st January 2005

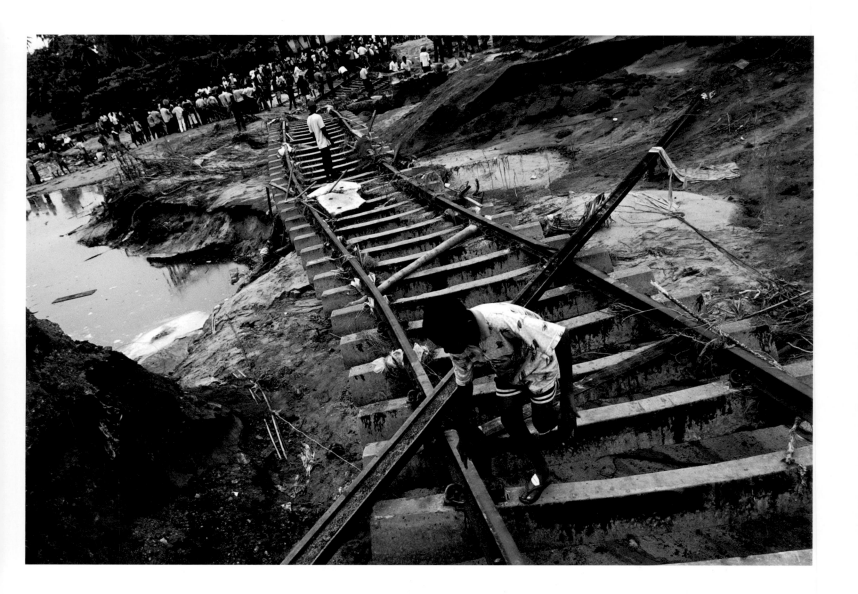

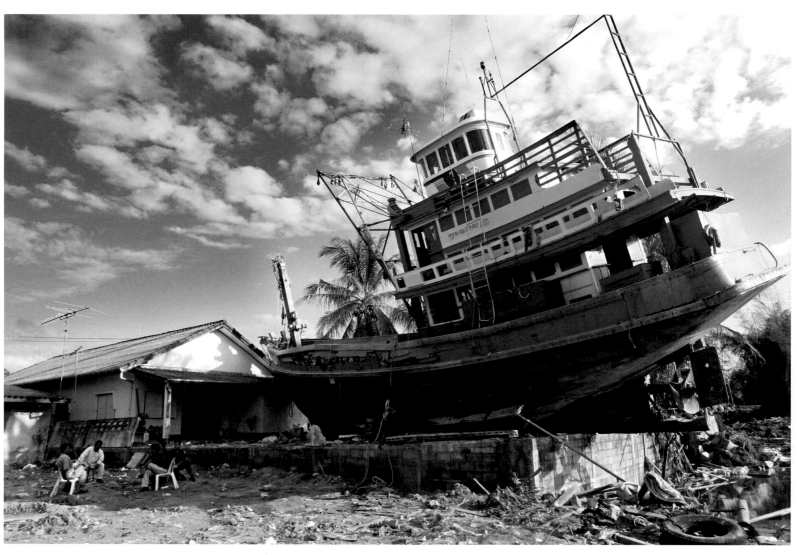
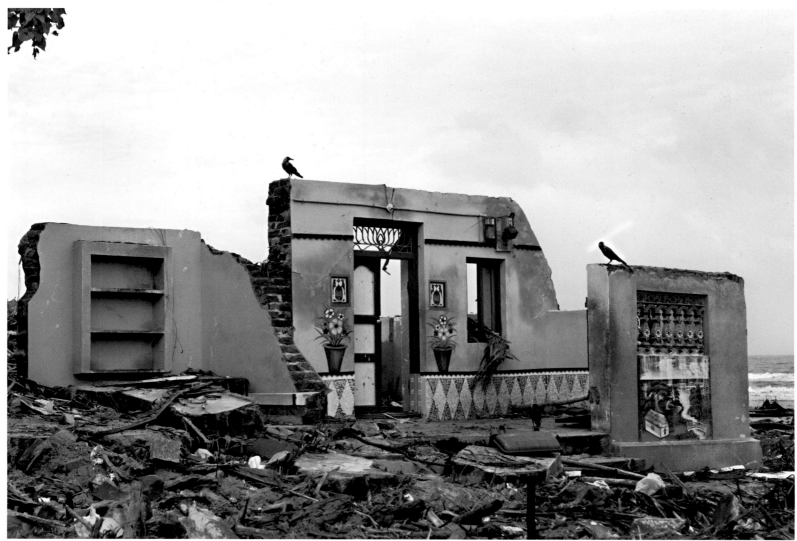

justin sutcliffe

Mahyudin Jamil stands on what remains of his
family home in Lohk Nga down the coast from
Banda Aceh. The full force of the tsunami wiped
the whole town off the face of the earth. He was out
fishing when the wave hit the town and miraculously
survived only to get home and discover that he had
lost his wife and five of their seven children.
Ist January 2005.

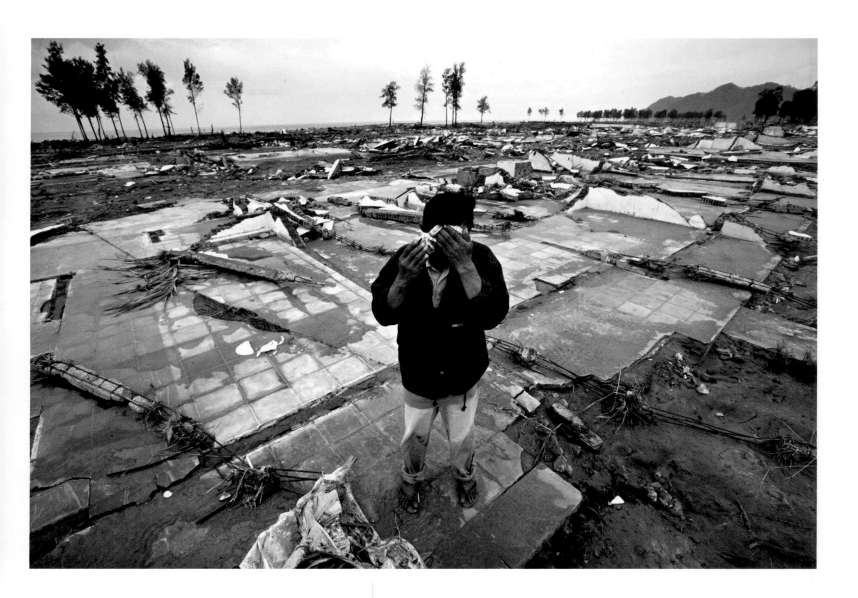

peter nicholls THE TIMES
Bodies of children lie next to those of adults in mass graves for victims of the recent tsunami, in the town of Ban Muang, on Phuket island. 4th January 2005.

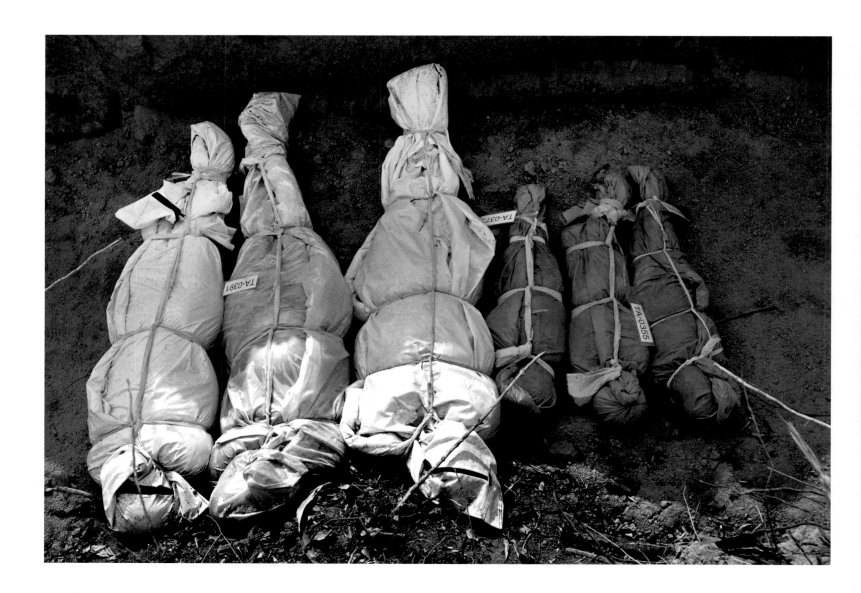

abbie trayler-smith
A woman weeps for the daughter that slipped from her arms as the wave crashed over the bridge she was standing on during the tsunami. Ule Lhue district of Banda Aceh, Indonesia.
18th January 2005.

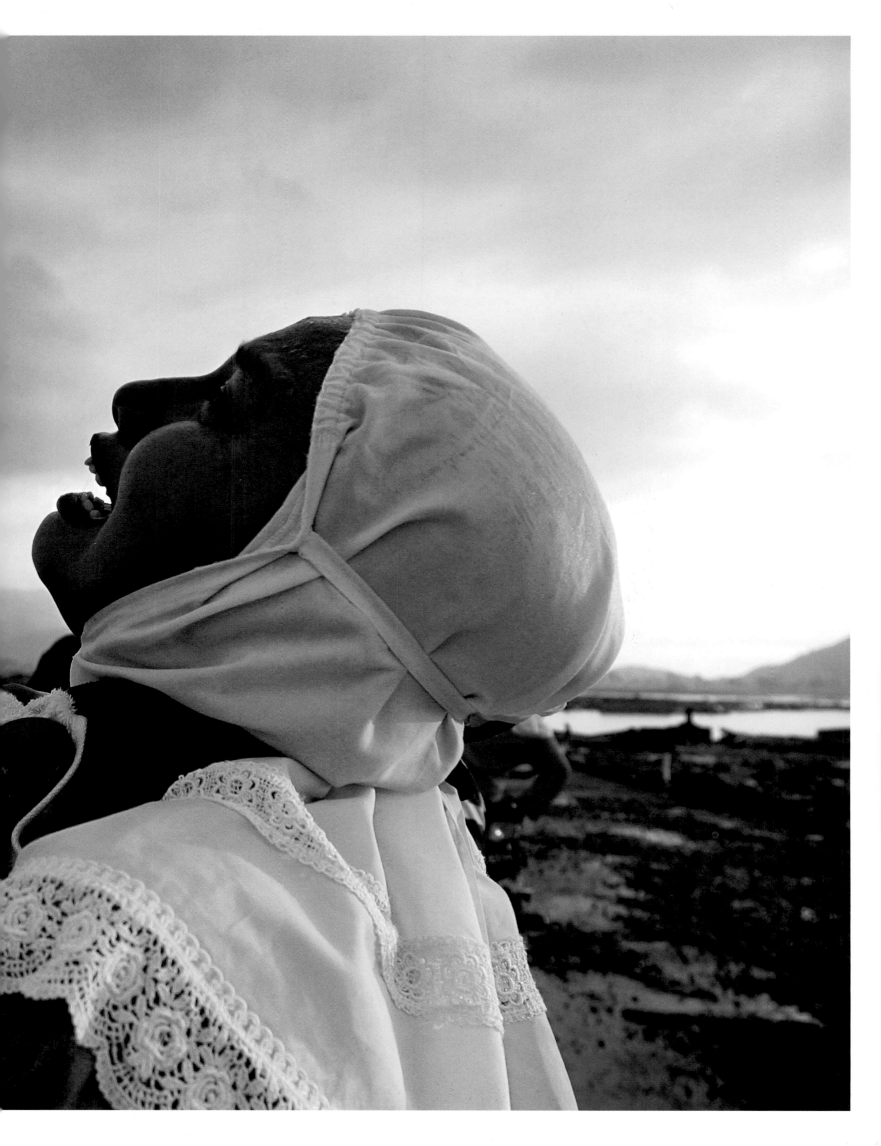

simon c roberts NB PICTURES

Russia claims the distinction of being the coldest
country in the world. It has twice as much territory
above the Arctic Circle as Canada, ten times as
much as Alaska, and fifteen times as much as
Norway, Sweden, and Finland combined. Day after
day, the coldest spot on the globe is usually
somewhere in Russia. Not surprisingly, the lowest
temperature ever recorded outside Antarctica was in
Russia. One third of Russia's population live and work
in inhospitable climatic conditions where air
temperatures average -30 degrees Celsius. Northern
European Russia runs from the Gulf of Finland to the
Arctic Barents Sea.

Winter in this northern territory finds a region
shrouded in darkness nearly 24 hours a day, a
phenomenon known as Polyarnye Nochi, or Polar
Nights. Between mid-December and mid-January
the sun does not come up and there is only a faint
glow of light visible around midday. The period of
polar nights is reportedly very taxing on the human
body and can trigger depression in many people.

Soviet-style apartment blocks in Murmansk.
12.00 noon. January 2005.

simon c roberts NB PICTURES

A Soviet mural of a soldier holding a gun and waving
a flag painted on the side of an apartment block in
Murmansk. 3.30pm. January 2005.

simon c roberts NB PICTURES

The icy grave of an American warship the "Daniel
Morgan", which was torpedoed by the Germans
and sunk on 7th May 1942 sits rusting alongside
another boat in the Barents Sea just outside
Murmansk. 2pm January 2005

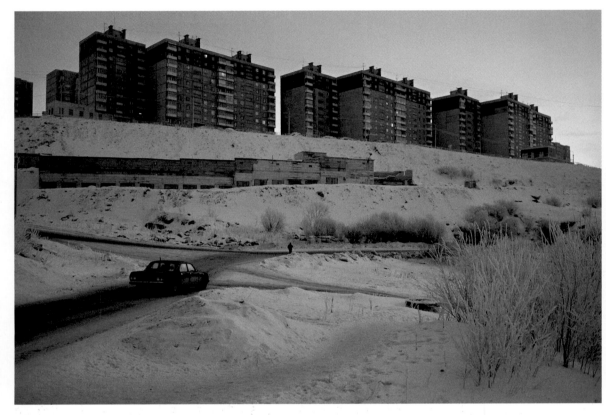

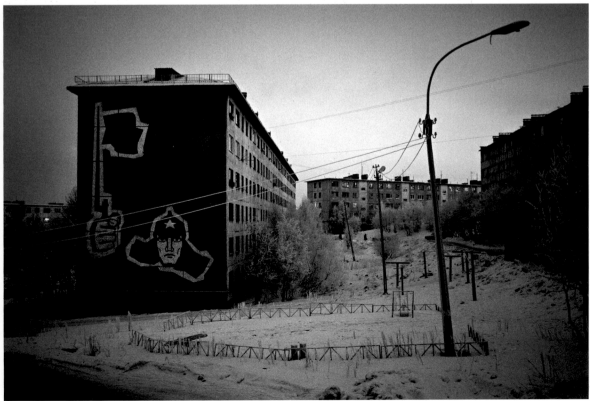

sean smith THE GUARDIAN
North west Iraq refugees leaving Ubaydi.
25th November 2005.

sean smith THE GUARDIAN
Ubaydi North West Iraq. US troops took over the
town yesterday as part of an ongoing offensive
against 'insurgents' in the N.west. residents had
to flee the town. All men of military age were
detained. November 2005.

steve pennells
Britain's elite Royal Marines work on their tans in the
searing Iraq heat, surrounded by watchtowers and
protected by the fortified walls of the British military
base in Umm Qasr, southern Iraq. 23rd July 2005.

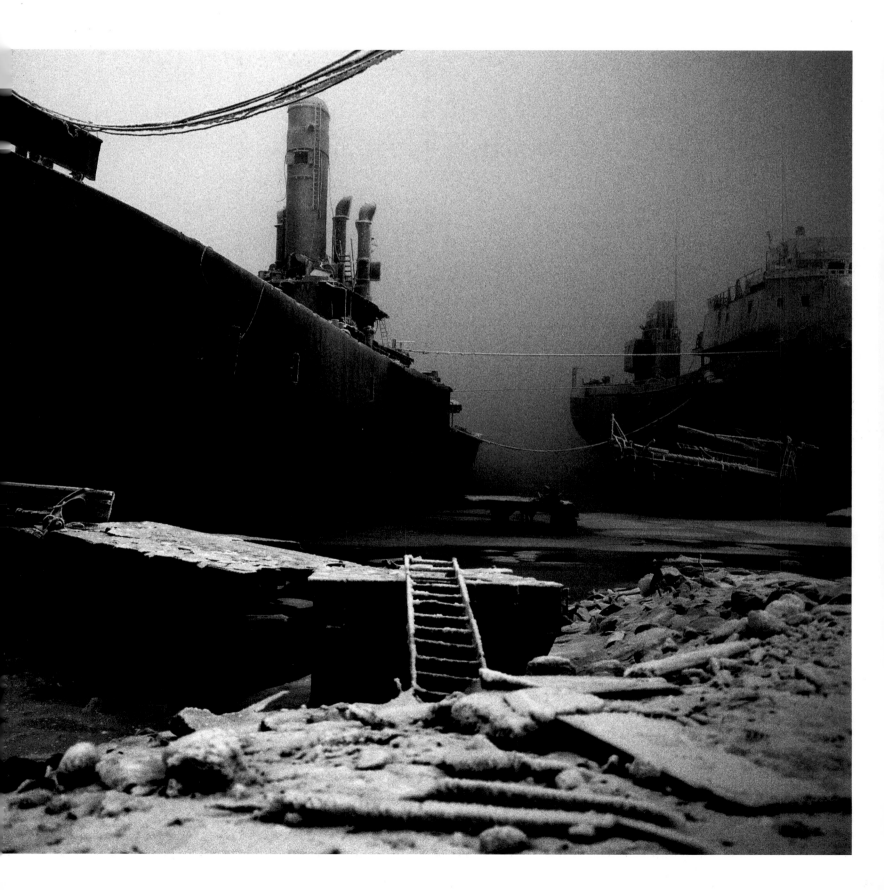

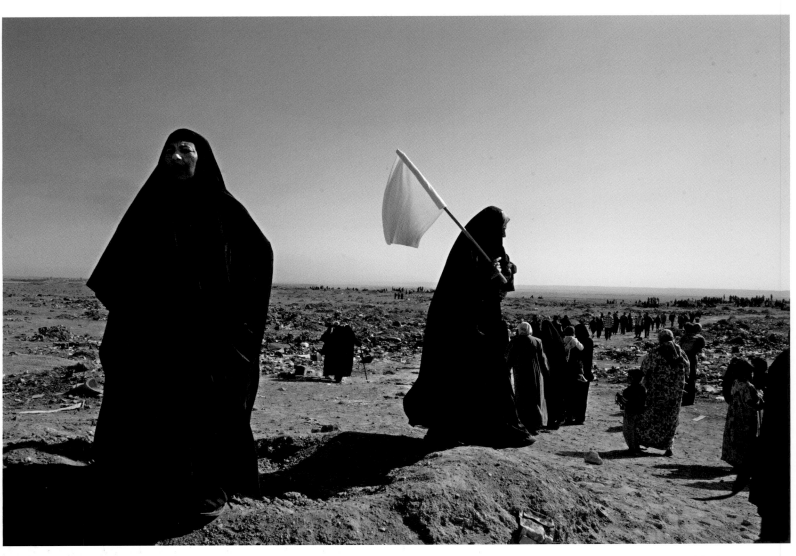

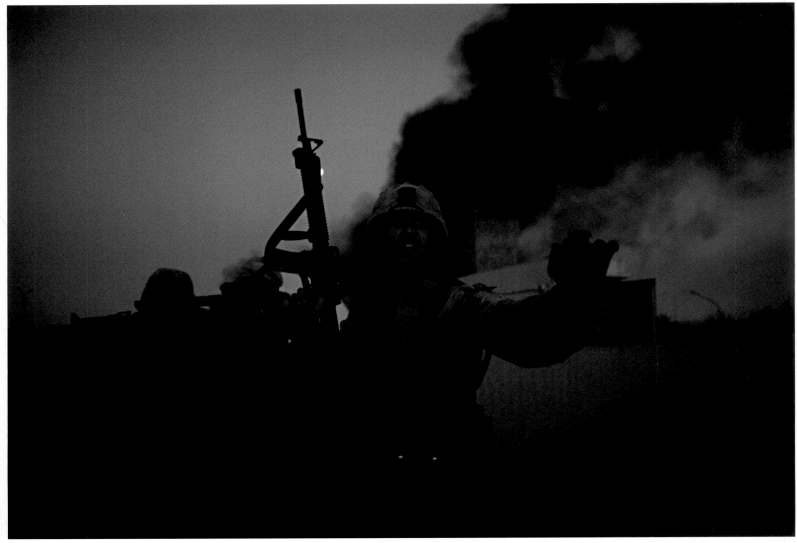

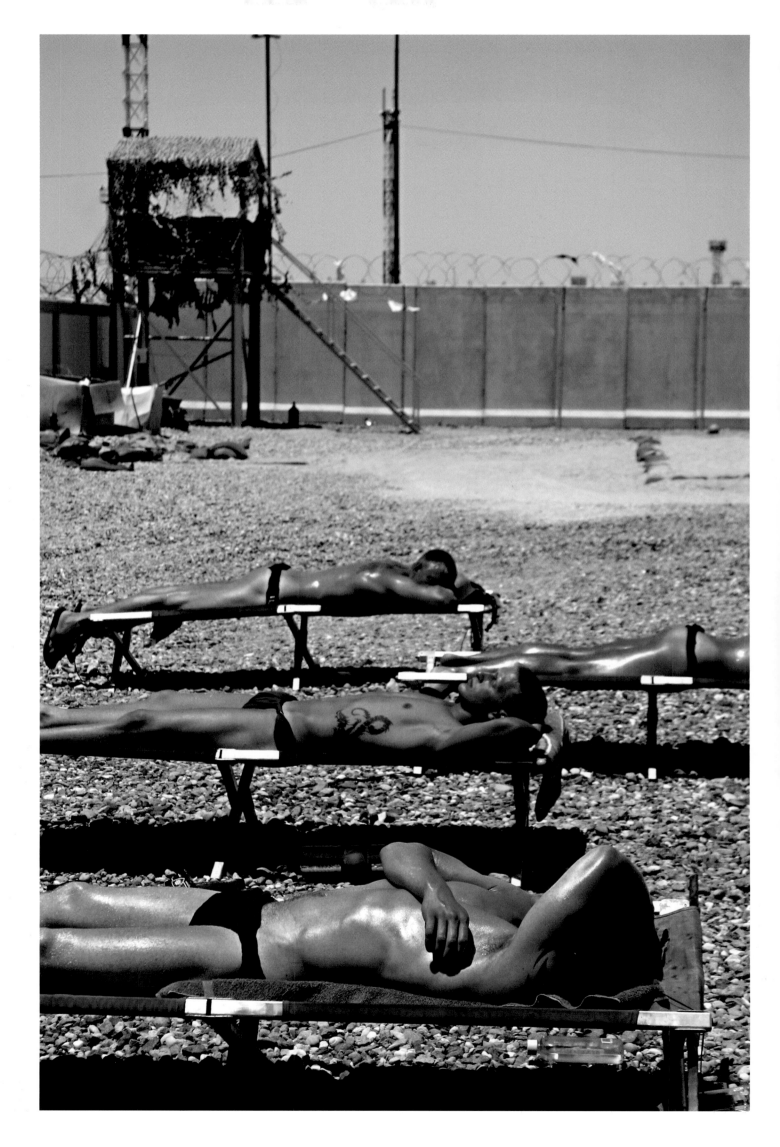

timothy allen
Jeanette Hall from Spring Creek, Nevada, showing her pedestal mounted Appaloosa horse that went on to win a third place in the professional division at the World Taxidermy Championships held in Springfield, Illinois, USA. March 2005.

timothy allen
World Taxidermy Championships. Springfield, Illinois, USA. March 2005.

timothy allen
World Taxidermy Championships. Springfield, Illinois, USA. March 2005.

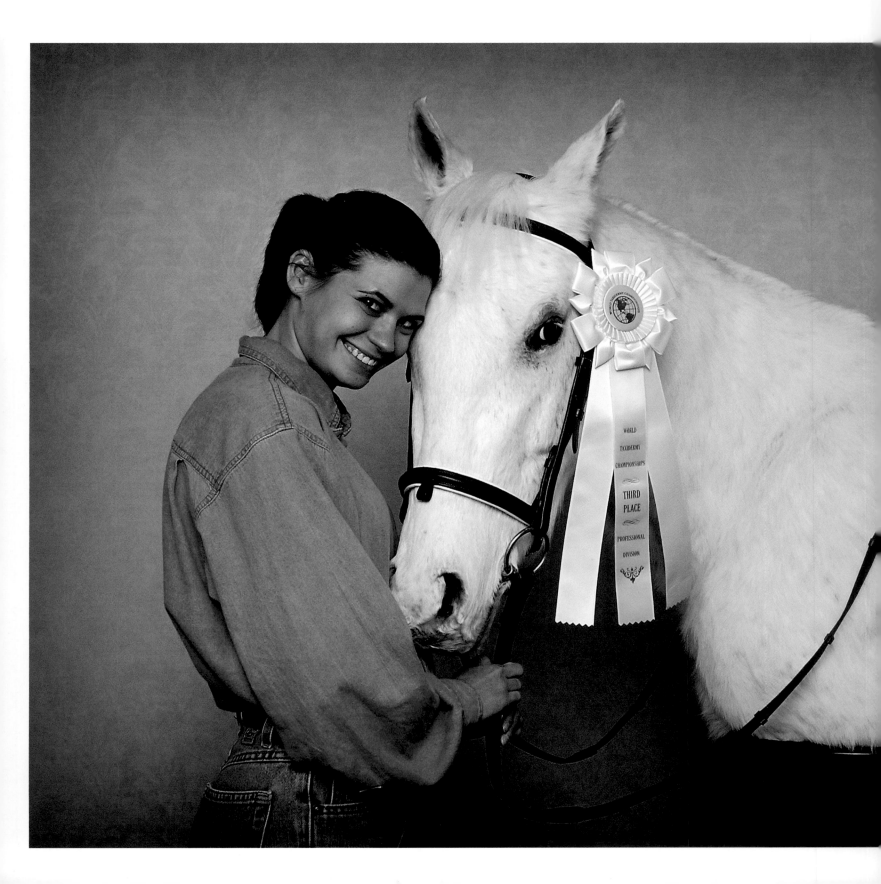

dwayne senior SUNDAY TIMES
Glastonbury festival goers attempt to salvage their belongings after torrential downpours flooded parts of the site. 24th June 2005.

sang tan
A monk pushes out lanterns onto river Thames at Battersea Park in London in a memorial ceremony to commemorate the 60th anniversary of the tragic atomic bomb dropped on August 9, 1945 on the Japanese city of Nakasaki which killed about 70,000 people. 9th August 2005.

fiona hanson PA
Poppies are dropped from the roof of Buckingham Palace towards crowds in London's Mall who have gathered to see the Royal family on the palace balcony as they mark the 60th anniversary of the end of World War II. 10th July 2005

rosie hallam
The very last "routemaster" bus service in London, on the 159 route from Marble Arch to Streatham Hill arrives at Streatham bus station for the very last time. 9th December 2005

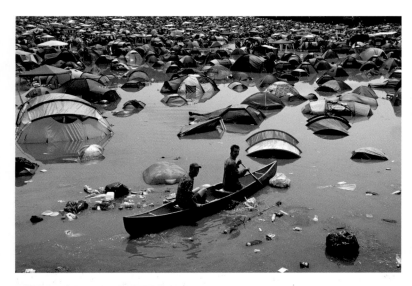

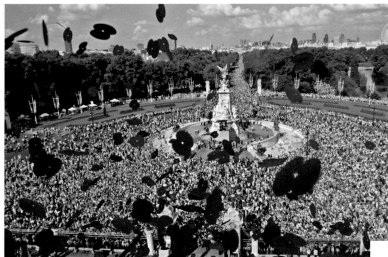

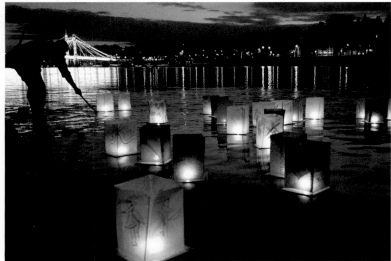

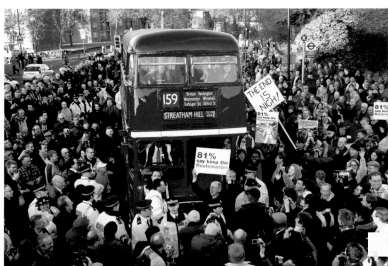

scott robertson MOD POOL

The Battle of Britain Flypast pass over the Mall and Buckingham Palace with one million poppies dropped by the RAF's last remaining Lancaster bomber during National Commemoration Day, the centrepiece of the 60th Anniversary of World War II anniversary commemorations and the culmination of Veteran's Awareness Week, a national project aiming to raise awareness of veterans' issues and mark their lasting contribution to society. 10th July 2005.

kieran dodds EVENING TIMES

The Maxillo-Facial prosthetics unit at the Glasgow Southern General hospital is the 2nd largest of its kind in the world. They produce prosthetic eyes, ear, noses as well as titanium skull parts for patients across the UK. 22nd July 2005.

niall carson PA

A group of Crested Macaques more used to tropical rainforests in Indonesia, huddle for warmth in Dublin Zoo. The primates are endangered in their own land due to hunting and the clearing of their native habitat, sometimes even taken when very young as pets by the local population. 30th December 2005.

lewis whyld SWNS

A girl releases a lantern at Takua Pa football stadium in Phang Nga, Thailand, during a memorial service for those killed in the Asian Tsunami. 10,000 candles were lit and 2,000 lanterns were released into the air during a ceremony to honour and release the dead, and to help the living heal. 19th January 2005.

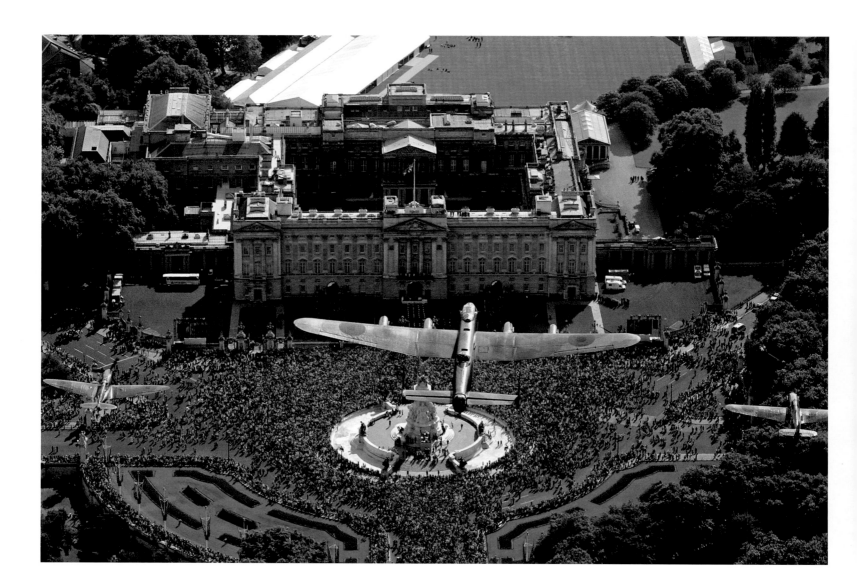

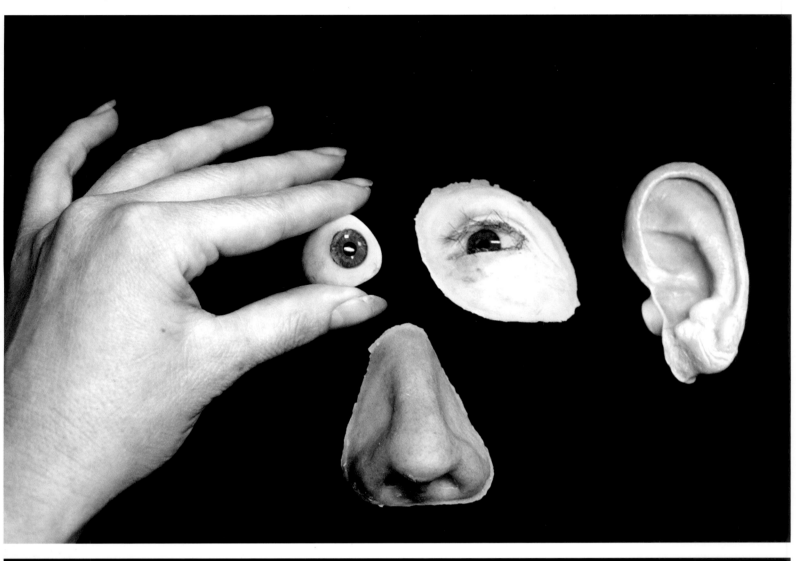
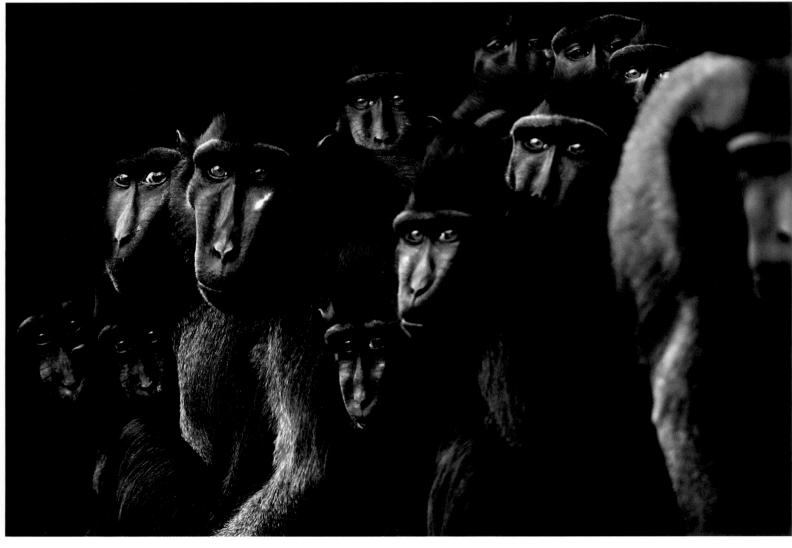

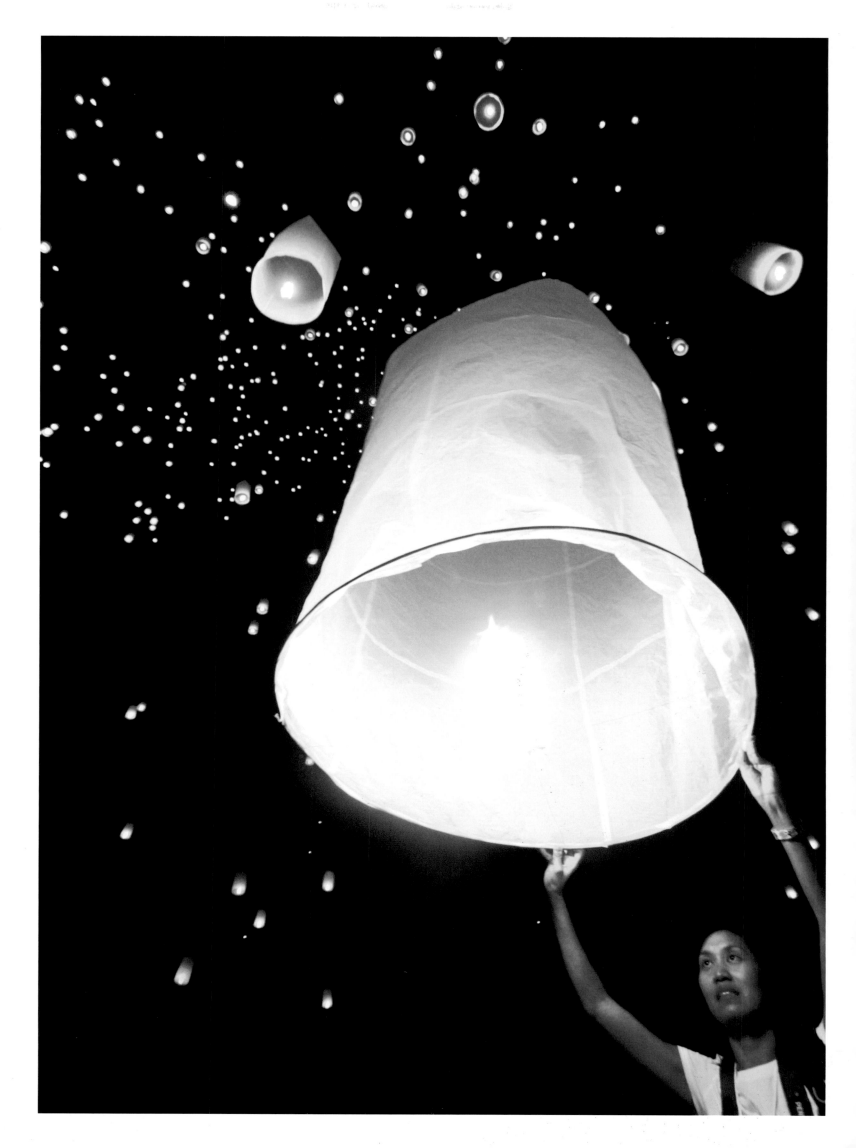

72

rosie hallam
The "Victory in Europe" reunion at the Imperial War Museum in London. WWII veterans Fred Hallett, RMC (r) and David Hutchings, 3rd British Division are given a cup of tea from a NAAFI truck outside. 4th May 2005.

edmond terakopian PA
A rehearsal for a series of projections onto the front of Buckingham Palace that show life in war-time Britain, part of the WWII 60th Anniversary Commemorations. 2nd July 2005.

sang tan
A horse from the Queen's Household Cavalry bolts and falls, throwing the mounted trooper to the ground, during the daily Changing of the Guard ceremony at Horse Guards Parade in London. 14th November 2005.

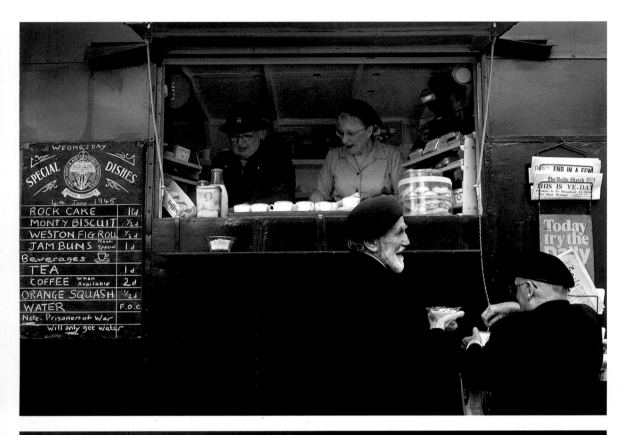

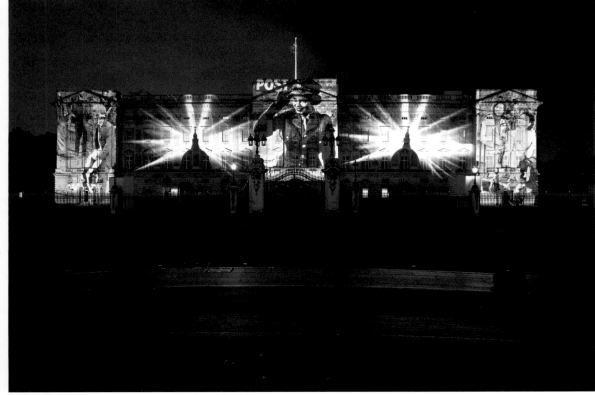

first prize: news features
eddie mulholland DAILY TELEGRAPH
Supporters and family members of British muslim
Babar Ahmad protested outside Bow Street
Magistrates Court in central London about the
decision by a judge to grant an extradition order.
I7th May 2005.

john d mchugh AFP
A model showing clothes by Indian designer Manish
Arora at the Natural History Museum in London on
the first day of London Fashion Week.
18th September 2005.

timothy allen
Mark Shelto , the former contorversial minister of
Union Chapel leads the Islington churches
procession to St. Mary's on Easter Sunday.
25th March 2005.

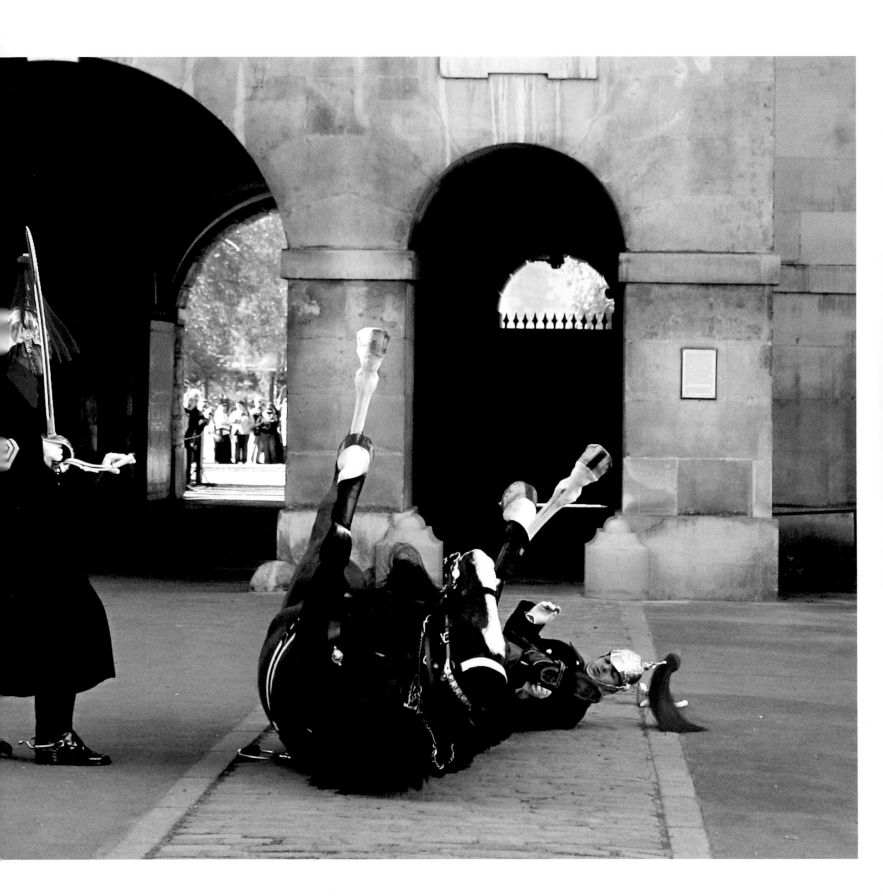

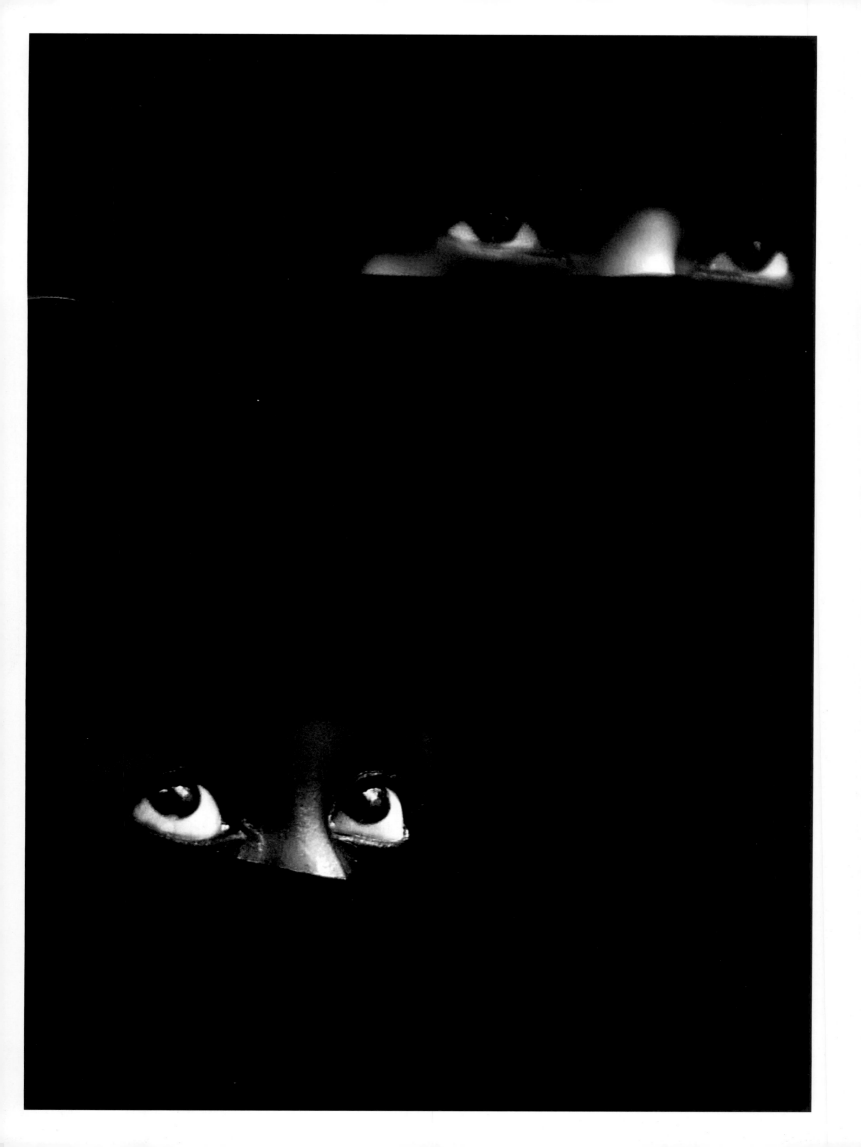

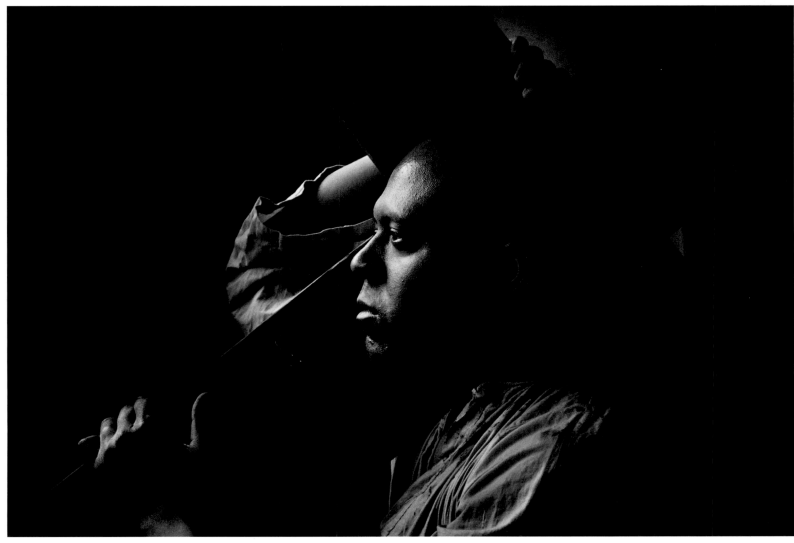

dave hogan GETTY IMAGES
Bono addresses the crowd at the Edinburgh
Live 8 concert at Murrayfield Stadium. The free
gig, labelled Edinburgh 50,000 - The Final Push,
was organised by Midge Ure alongside Bob Geldof,
and coincided with the G8 summit to raise
awareness for the Make Poverty History campaign.
6th July 2005.

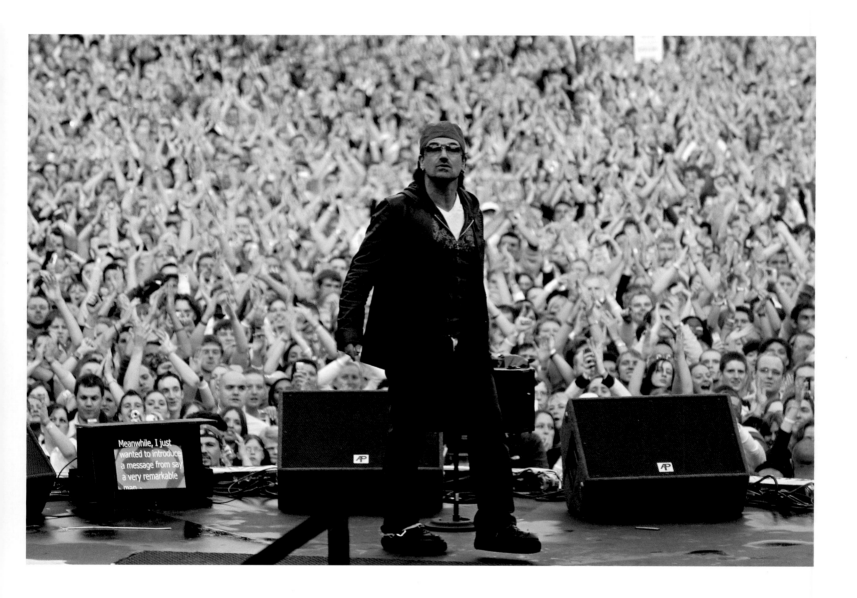

dave hogan GETTY IMAGES
Bob Geldof aboard a train departing for Edinburgh.
Geldof headed for Scotland as part of the Long Walk
to Justice with other key organisers and supporters
of Live 8 and Make PovertyHistory campaign.
2nd July 2005.

timothy allen
Gwyneth Paltrow and her daughter Apple in the
crowd at the Hyde Park Live8 concert in London.
2nd July 2005.

dave hogan GETTY IMAGES
Sir Elton John (l), Sir Paul McCartney (c) and
Coldplay's Chris Martin are seen backstage at
"Live 8 London" in Hyde Park, London 2nd July 2005.

bob johns EXPRESSPICTURES.CO.UK
One man and his dog try to sneak a view of the
Live 8 concert at Hyde Park underneath the solid
12ft fencing erected all around the concert.
2nd July 2005.

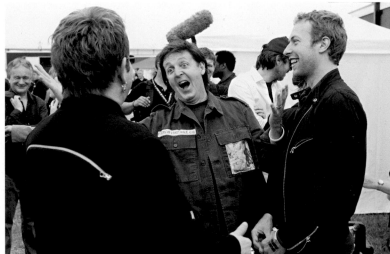

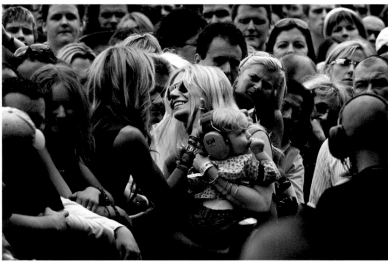

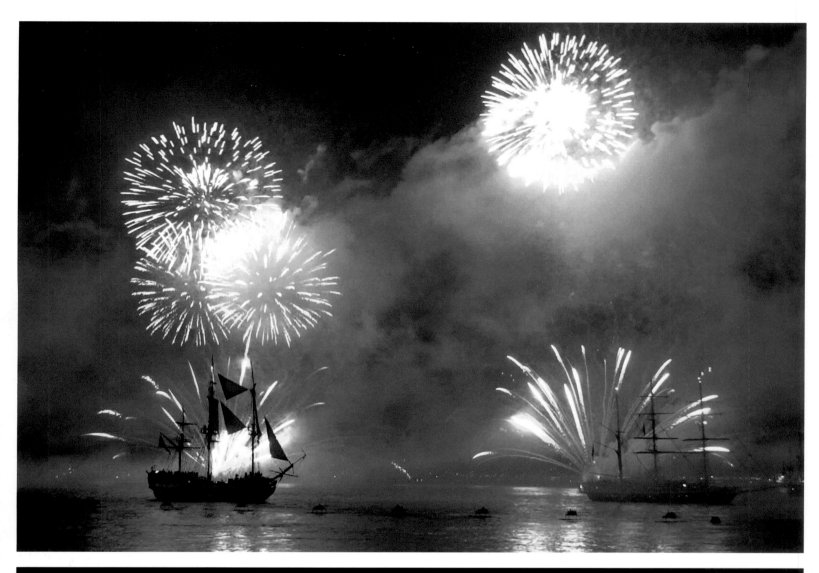

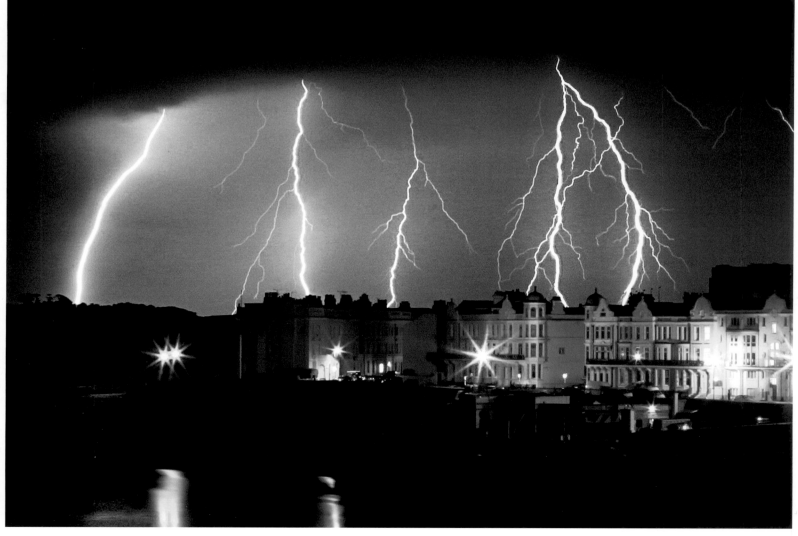

chris young PA

HMS Victory as played by the cutter the "Grand
Turk", takes centre stage during a firework display
which illuminated a re-enactment of the Battle
of Trafalgar, in the Solent to mark the 200th
anniversary of Nelson's defeat of the French.
28th June 2005.

james boardman

Families brave the cold temperatures and snowy
conditions on top of the South Downs at Clayton
in Sussex. The Jack and Jill windmills are seen
in the background. 27th February 2005.

lewis whyld SWNS

A summer lightning storm flashes over Plymouth,
Devon, damaging properties and bringing torrential
rain. 24th June 2005.

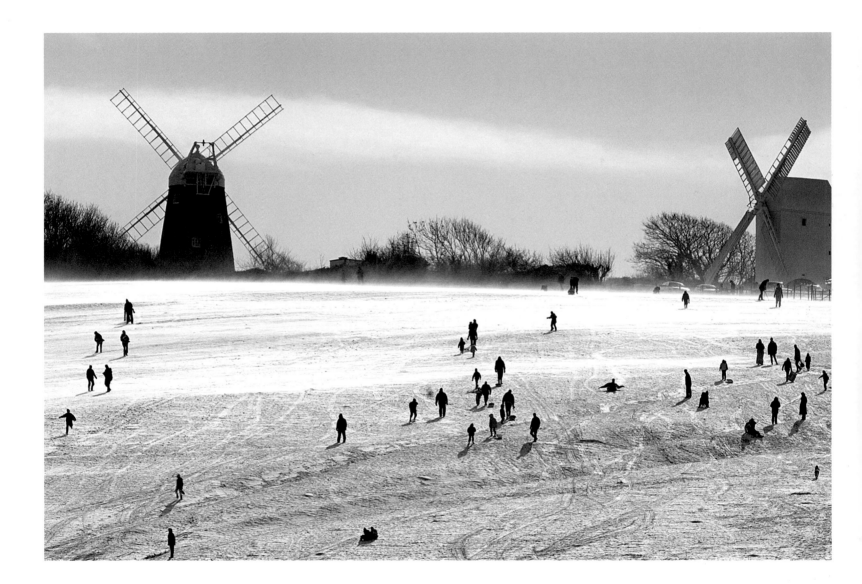

ERTY

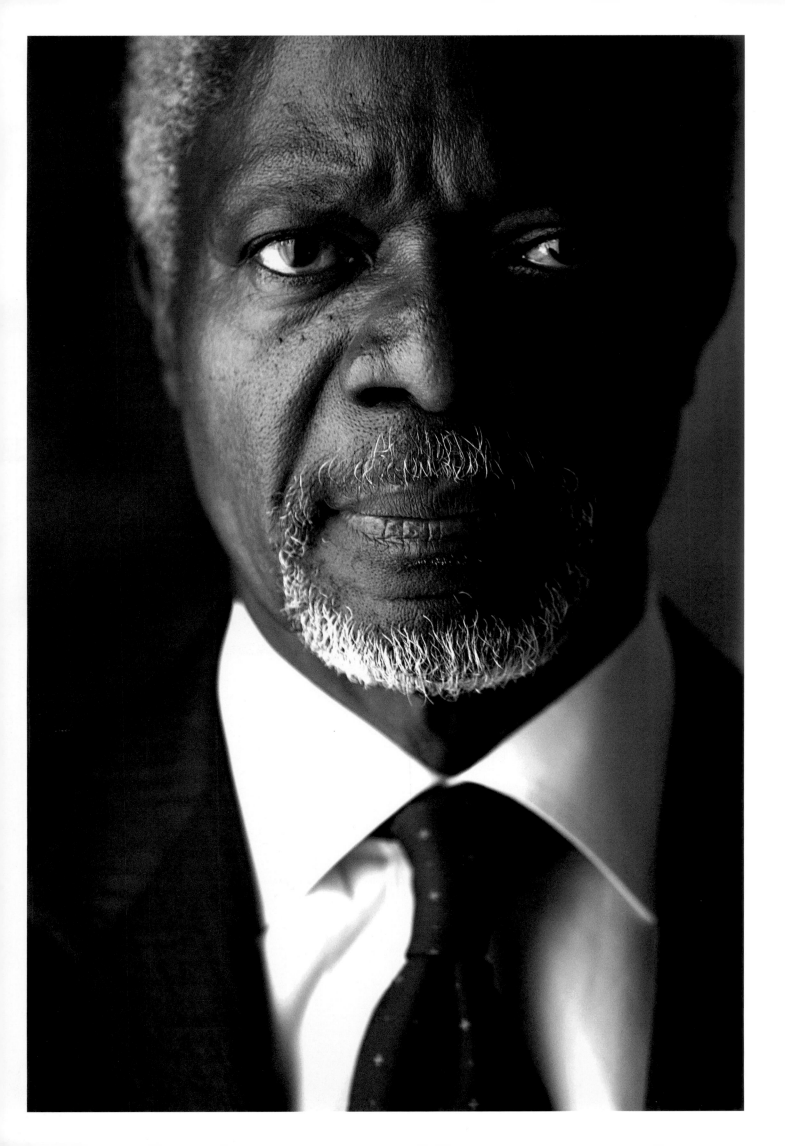

david sandison THE INDEPENDENT
Kofi Annan, the United Nations Secretary General
photographed in London. 5th September 2005.

john angerson
Author and historian Peter Ackroyd on the deck
of HMS Victory Portsmouth. June 2005.

john angerson
Comedian Ken Dodd photographed at Adelphi Hotel
in Liverpool. April 2005.

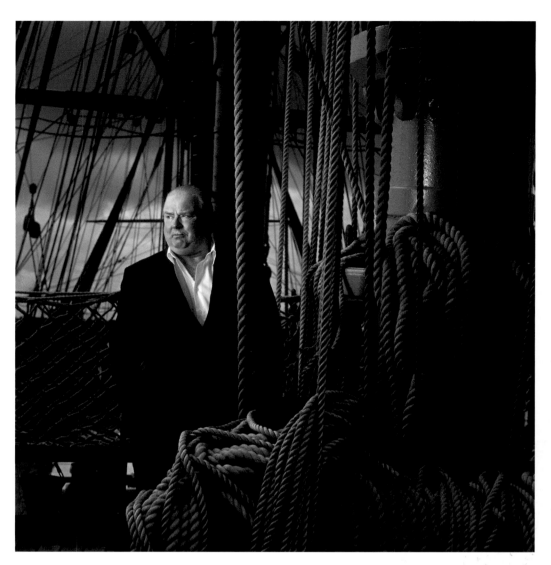

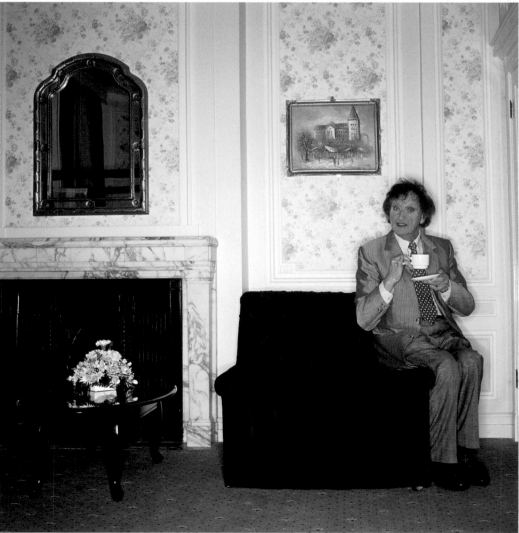

graham trott
Former part-time doorman Phil Selby with Albert, one of his two Rottweilers, at the gates of a country estate near Yeovil, Somerset. Mr. Selby's look was usually enough to keep customers well behaved at the bar where he worked at weekends. Despite appearances, both he and Albert are gentle giants. April 2005.

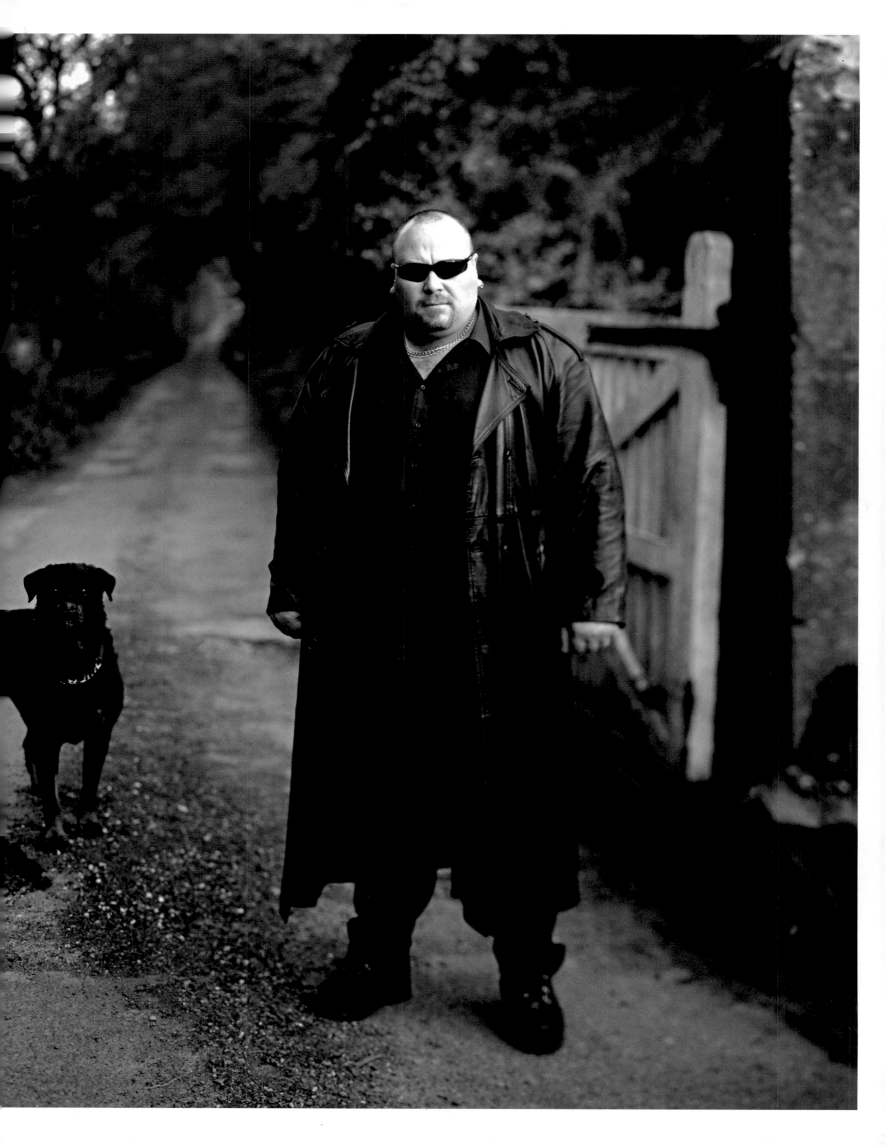

harry borden
Heather Mills McCartney, Adopt-A-Minefield charity
patron and United Nations Goodwill Ambassador,
Spring Studios, London. 22nd December 2005.

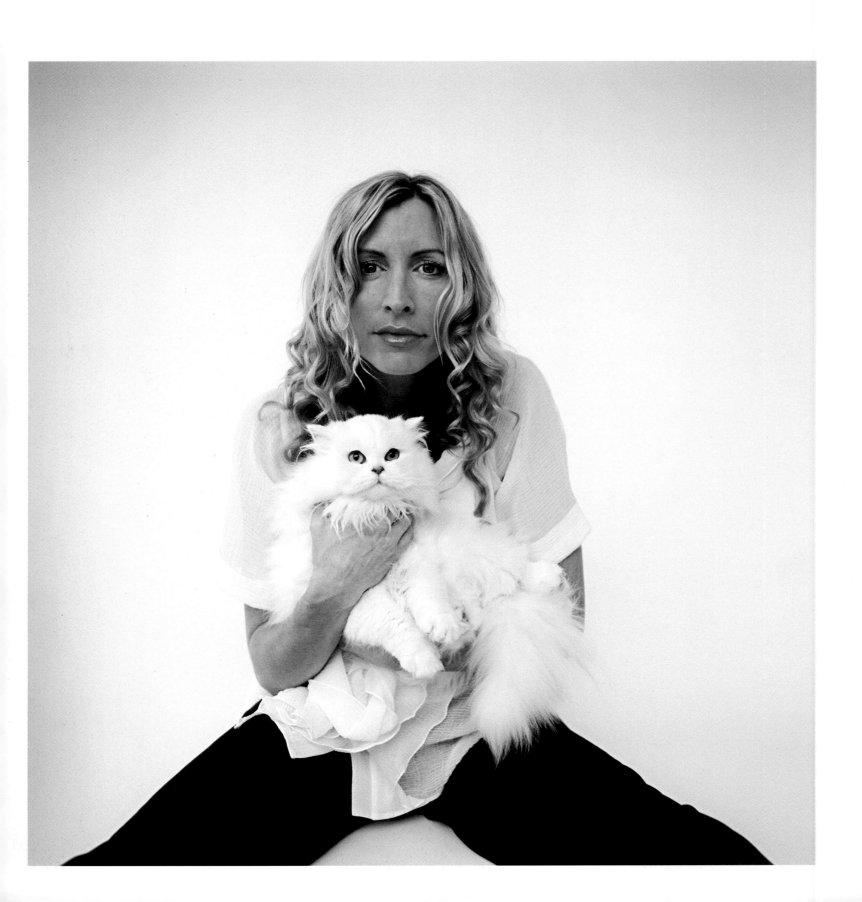

pal hansen
Bob Geldof at the Soho House club in London. Along with the U2 front man Bono, he staged Live 8, the world's biggest rock concert since Live Aid, and was designed to raise awareness of the extreme poverty in Africa, and put pressure on the leaders of the G8 countries who were meeting in Scotland for a summit. The G8 later pledged to spend $25 billion a year on the cause. 12th May 2005.

brian david stevens
Billy Childish, musician, poet, artist and author at his home in Chatham. 20th December 2005.

kieran doherty REUTERS
British playwright Harold Pinter talks to journalists outside his London home. Pinter, 75, whose plays include The Birthday Party and The Caretaker, had just heard he had been awarded the Nobel Prize for Literature. 13th October 2005.

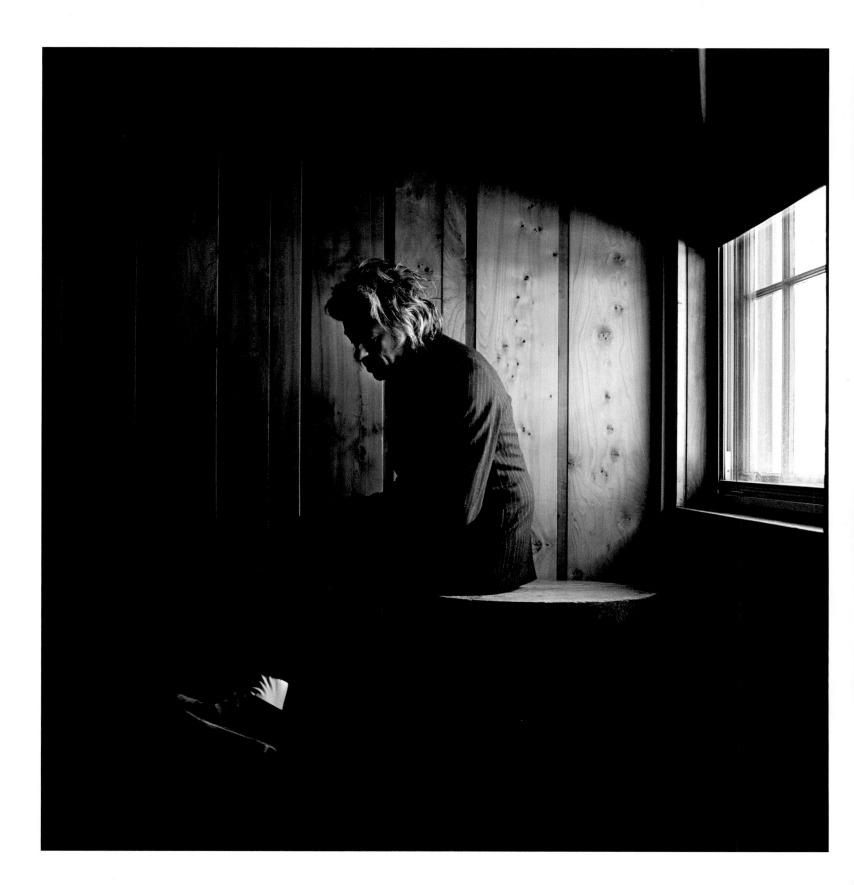

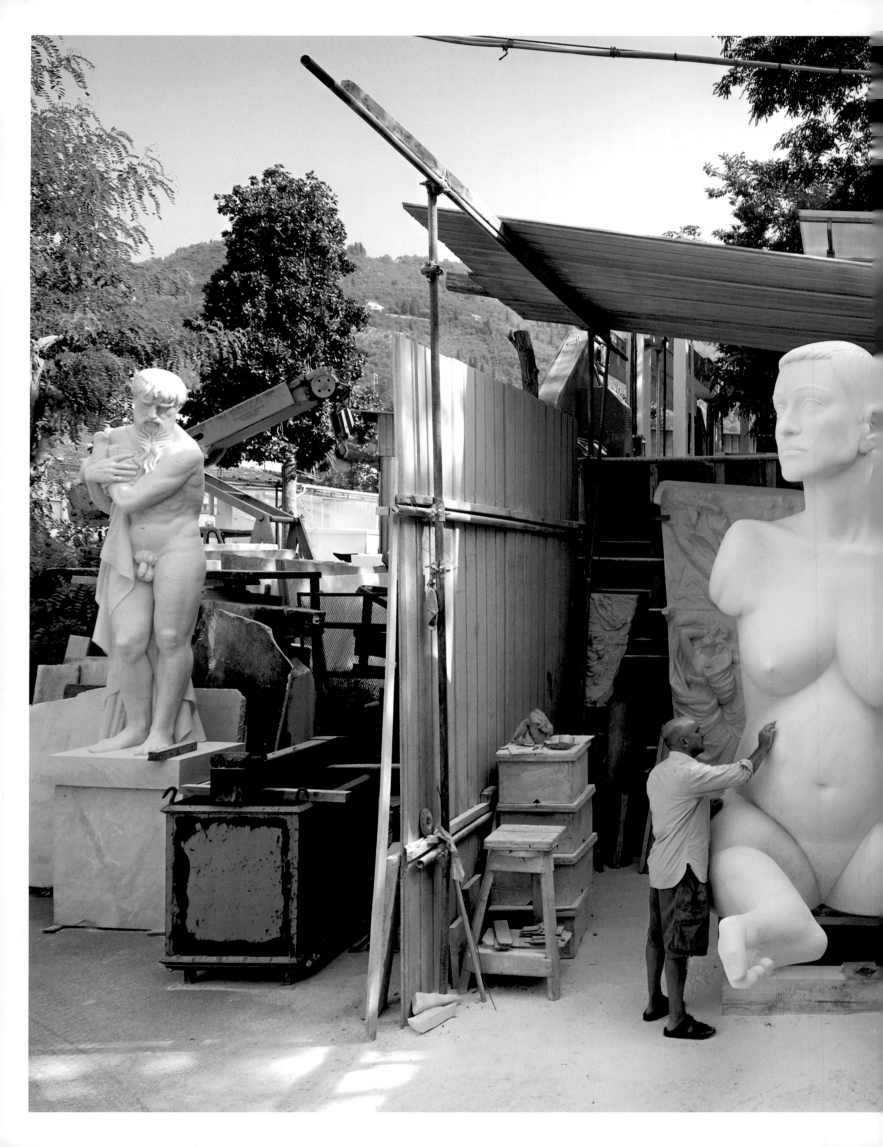

david levene
Marc Quinn attends to his sculpture of
'Alison Lapper' as it nears conpletion at The Cervietti
marble sculpture workshop in Petrasanta, Tuscany,
Italy. The sculpture was then transported to London
to be installed onto Trafalgar Square's empty
'fourth plinth'. 1st September 2005.

dan kitwood SWNS
Mariza performs on stage with Youssou N'Dour at the "Africa Calling" Live8 concert held at the Eden Project, near St. Austell, Cornwall. The concert, to highlight world poverty, featured eighteen different artists from fourteen exclusively African countries. 2nd July 2005.

ken mckay TALKBACK THAMES
Sharon Osbourne soaks Louis Walsh in a
spontanious moment during the live broadcast
of The X Factor, after he insulted her husband Ozzy.
19th November 2005.

dave hogan GETTY IMAGES
Robbie Williams performing at the Live 8 concert
in London's Hyde Park. 2nd July 2005.

david purdie
The re-hanging of the galleries at Tate Britain after
a major clean and repair programme. July 2005.

roger bamber
The shadow of Artist Mark Anstee as draws some
of 10,000, two inch high, $\frac{1}{2}$ scale human figures
for his installation "Early Redemption" The figures
swarm across a vast seven metre high translucent
membrane suspended in the chancel of a former
church that has been converted into an art gallery
screen. 23rd September 2005.

matthew fearn PA
A crowd of 1,600 naked volunteers take part in an art
installation and series of photographs by New York
based artist Spencer Tunick in Gateshead.
17th July 2005.

sean bell
Patricia Convery reflected in a paper silhouette of
"The Managers of the Edinburgh Orphanage" now
better known as the Dean Gallery, made in 1830 by
the artist Augustin Edouart. 2nd December 2005.

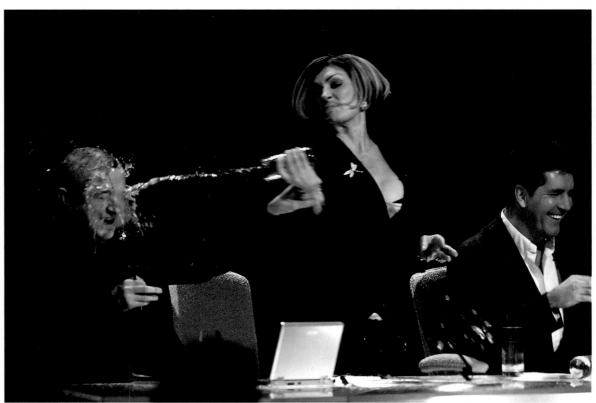

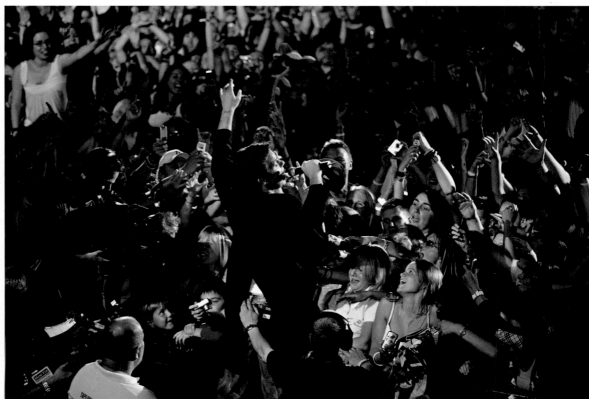

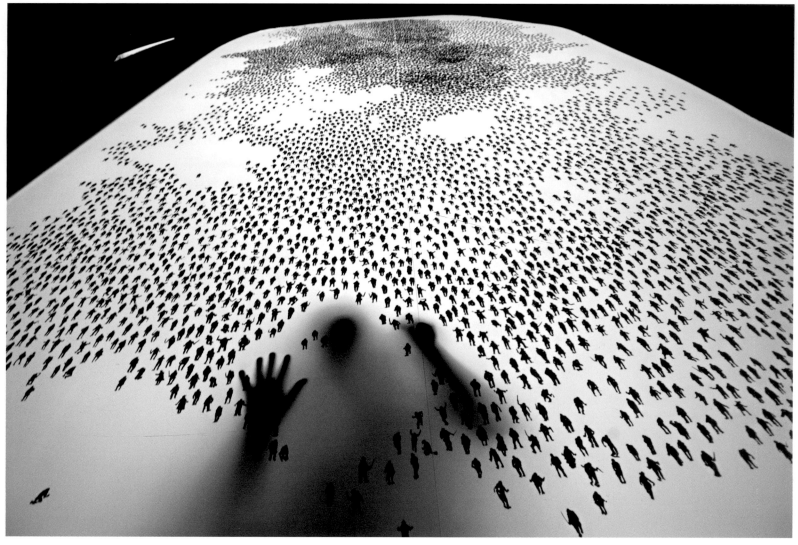

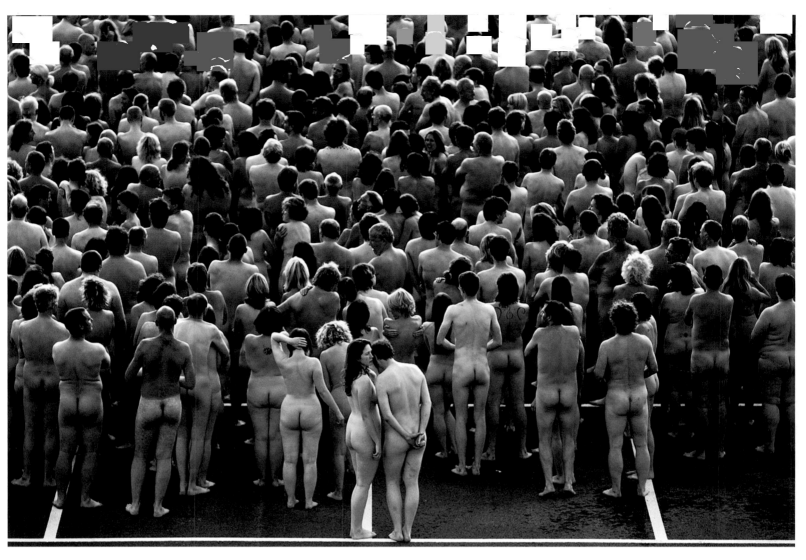

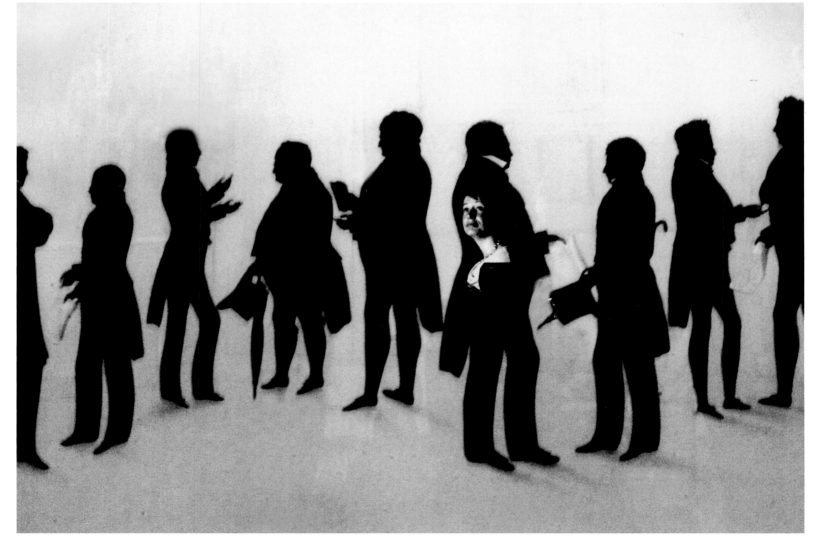

first prize: business, industry & technology

andre camara THE TIMES
During the Confederation of British Industry annual
conference, the panel (from left to right), Archie
Robertson of the Highways Agency, Mayor of London
Ken Livingstone, Sir Digby Jones of the CBI,
John Allan of Exel, Alan Wood of Siemens, and
Justin King of Sainsbury's have to look up to see
the results of an audience vote displayed on rather
awkwardly positioned monitors.
28th November 2005.

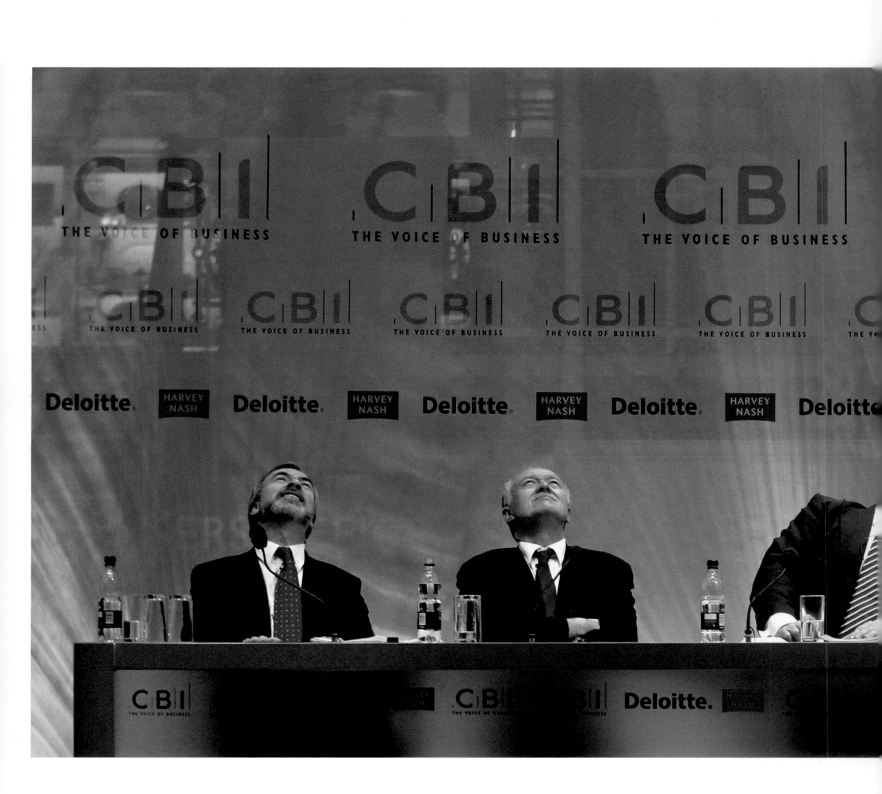

roger bamber
Fishtail Neon Gallery owner Andy Doig, a professional glassblower, arranges his glowing, humming collection of over 80 high voltage neon advertising signs from the 1930s to the present day at his gallery under the arches on Brighton seafront. Neon is becoming sought after by collectors who will pay £1,500 or more for rare examples. 5th January 2006.

chris jackson GETTY IMAGES
Dows load up in Dubai creek. United Arab Emirates. 17th December 2005.

roger bamber
Cleaning up after ourselves means round the clock shifts for sewage treatment operators like this worker carrying out essential cleaning and maintenance work on nitrifying filters. 1,500 litres of waste water pass through these filters every second and 150 million litres per day in total are treated. 24th May 2005.

david levene
An aerial view of the Rover 'Graveyard' in Oxfordshire. Disused airstrips are utilised as dumping grounds for unsold Rover cars following the company's demise. 29th April 2005.

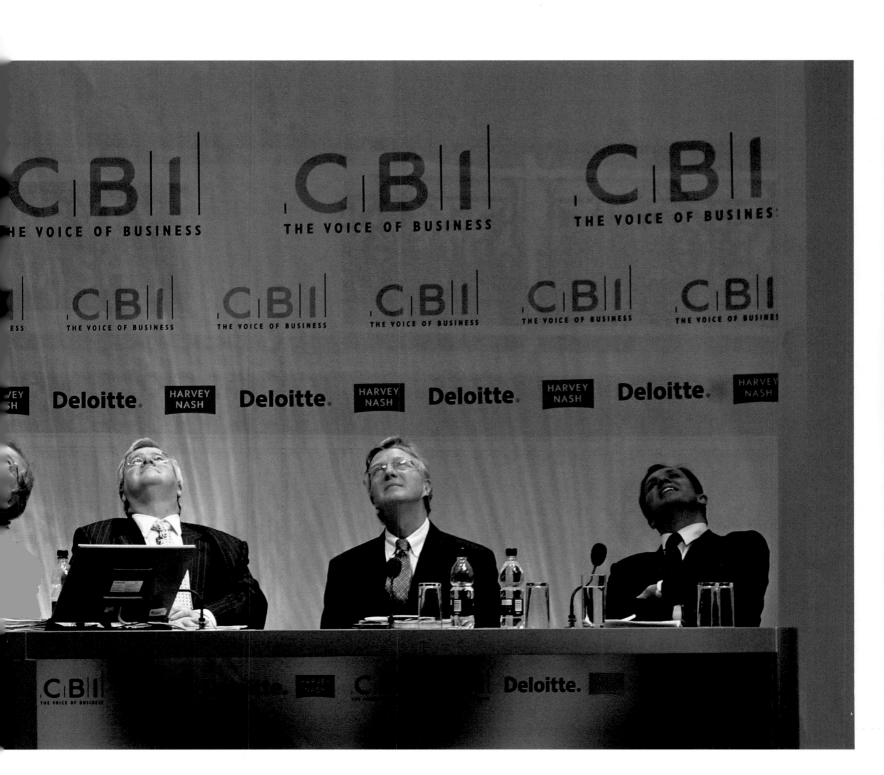

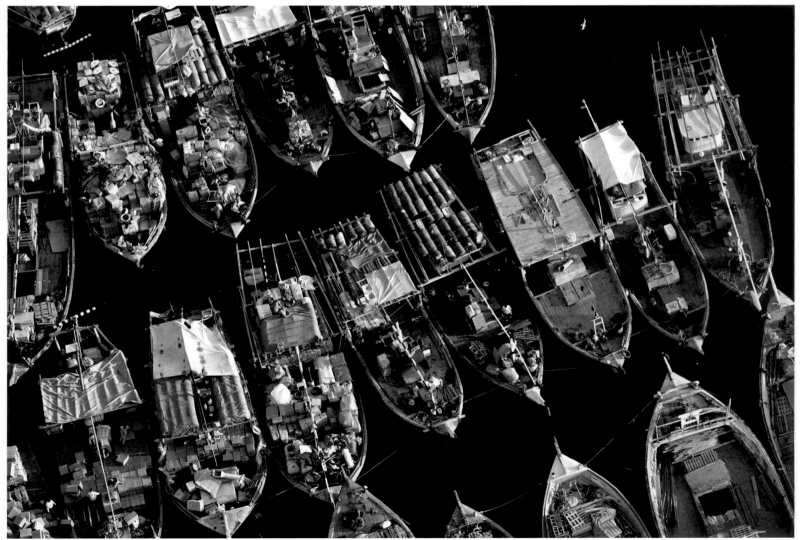

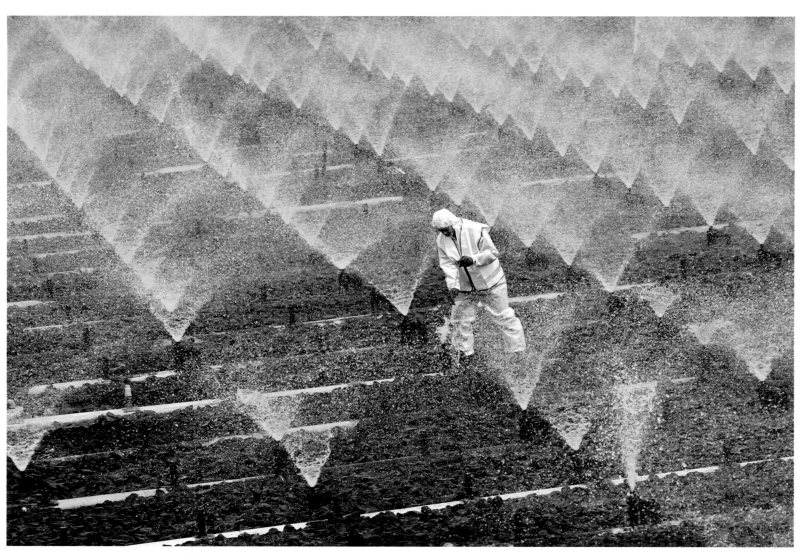

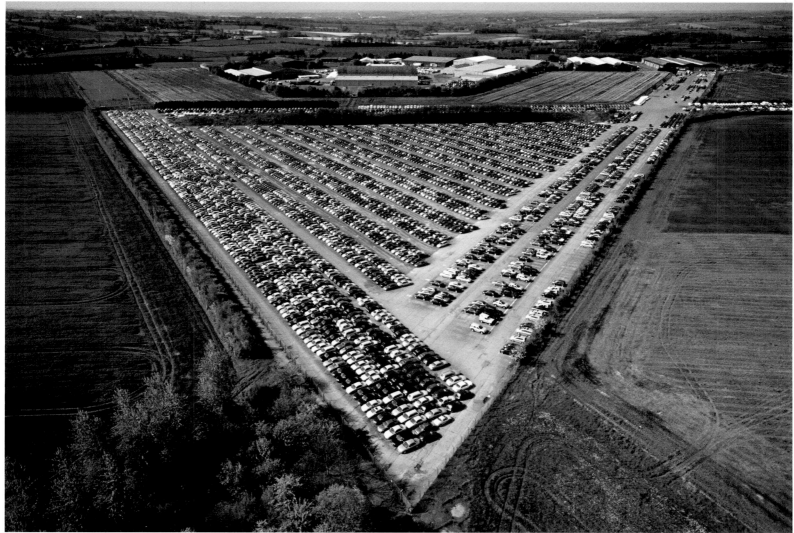

alex macnaughton METRO
The recently completed Kentish Flats wind farm, off
the Kent coast near Whitstable . The wind farm is the
largest yet build in the UK and is comprised of thirty
150m high turbines. The photograph was taken from
a hot air ballon 25 miles away. 6th September 2005.

following spread
phil wilkinson SCOTLAND ON SUNDAY
Trent Jennings, left, and Thomas Marsh from the
design company Blue Marmalade looking through
one of their futuristic furniture designs in their
studio in Leith near Edinburgh. 15th March 2005.

bob johns EXPRESSPICTURES.CO.UK
The staff at Bedfordshire County Council united
behind the new Chief Executive, Andrea Hill who
hopes the council will achieve a three star CPA
rating within 17 months of her taking charge.
23rd November 2005.

scott barbour GETTY IMAGES
Workers make their way to work in the financial
district of London. Many commuters made their
first trip to work since the terrorist attacks of
7th July when 56 people were killed and 700 injured
during morning rush hour terrorist attacks targeted
at London's transport links. 11th July 2005.

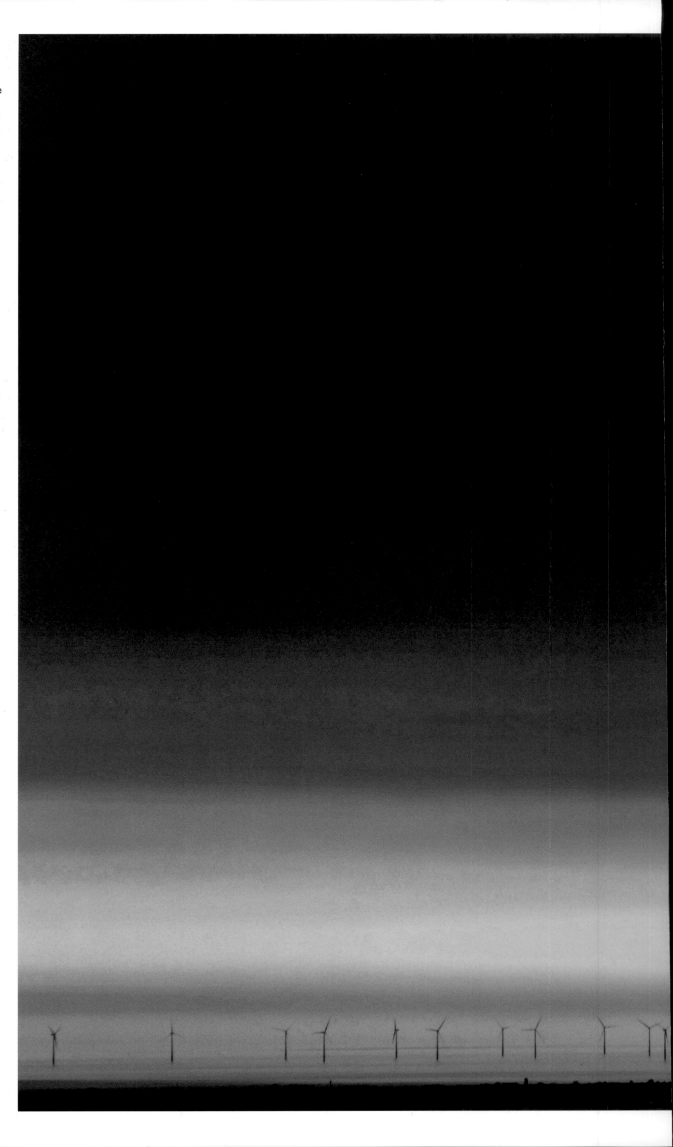

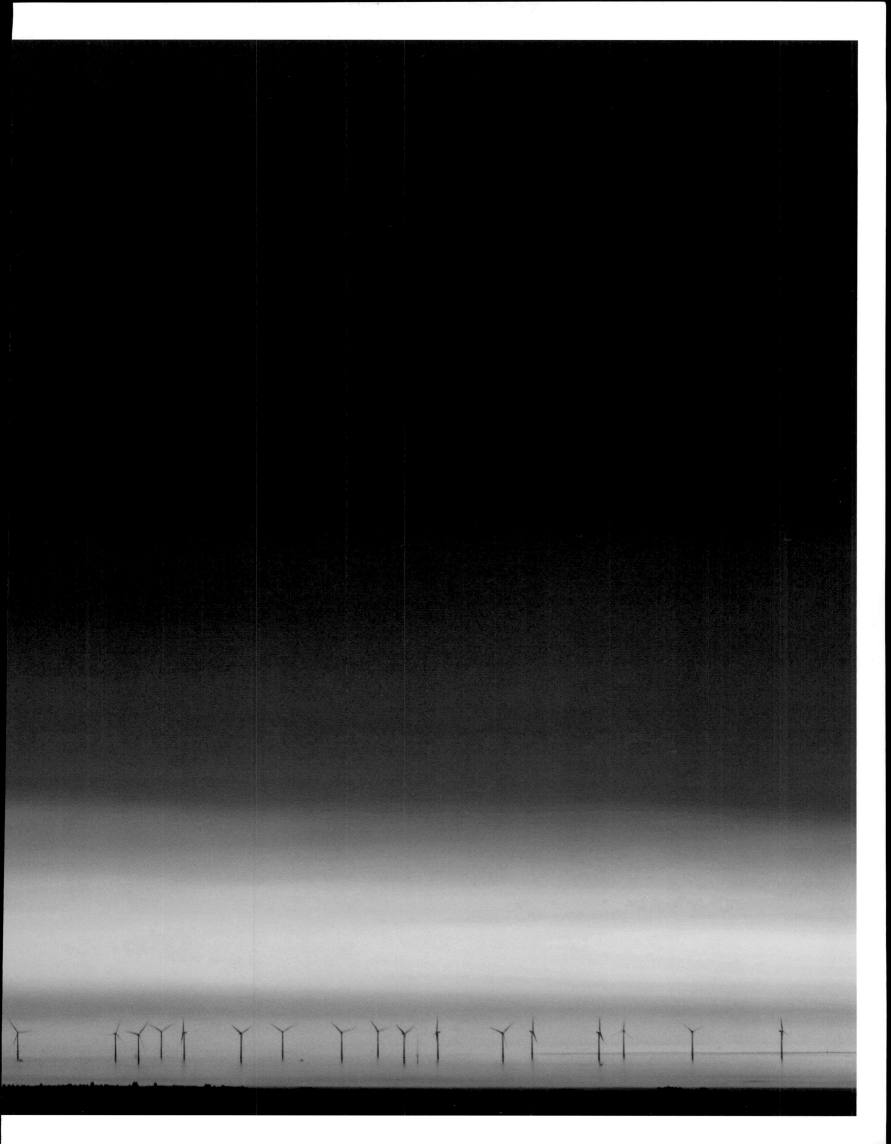

104

julian finney GETTY IMAGES
The Queen looks out of her Land Rover as she
follows Prince Philip competing in the Carriage
Driving Grand Prix Marathon event during
the Royal Windsor Horse Show at Home Park,
Windsor Castle. 14th May 2005.

following spread

**first prize: royals
tom main**
Prince Philip shares a joke with his team during
the Hopetoun House Carriage Driving Trials,
South Queensferry, near Edinburgh. 27th May 2005.

lee thompson SWNS
Prince Harry showing his frustration during a
polo match at Cirencester in Gloucestershire.
21st July 2005.

richard pohle THE TIMES
Prince Harry stands on parade as a junior officer
cadet at Sandhurst Royal Military Academy for the
presentation of new colours to the college by Chief
of the Defence staff General Sir Michael Walker.
21st June 2005.

chris tofalos CTP PHOTO
Prince Charles shakes hands with schoolchildren
at Walton High School in Nelson, Lancashire.
27th October 2005.

jason dawson
Charles and Camilla leave St. Georges Chapel,
Windsor Castle, as the Duke and Dutchess
of Cornwall after the blessing of their marriage.
9th April 2005.

jason dawson
The Queen attends the Aston Martin motorcar
anniversary parade inside Windsor Castle.
23rd April 2005.

peter macdiarmid GETTY IMAGES
Queen Elizabeth II looks out of the window
of her carriage after attending the State
Opening of Parliament in London. In her speech
the Queen outlined 40 bills for the forthcoming
parliament, including controversial legislation
on identity-cards and a new offence of
incitement to religious hatred. 17th May 2005.

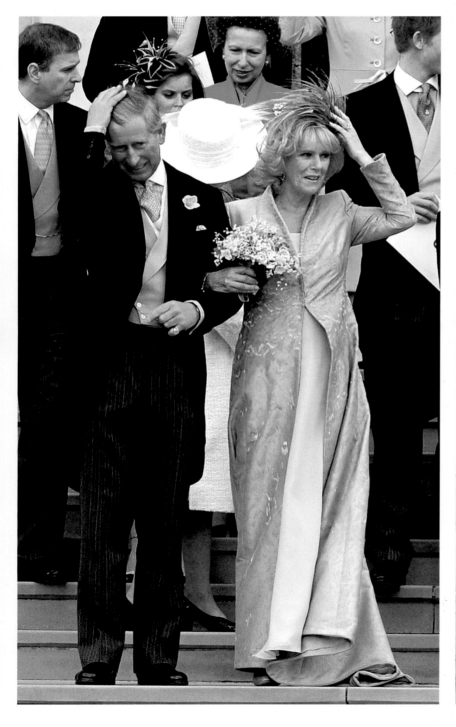

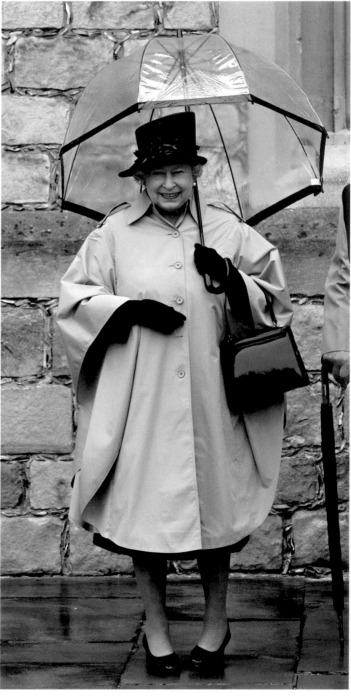

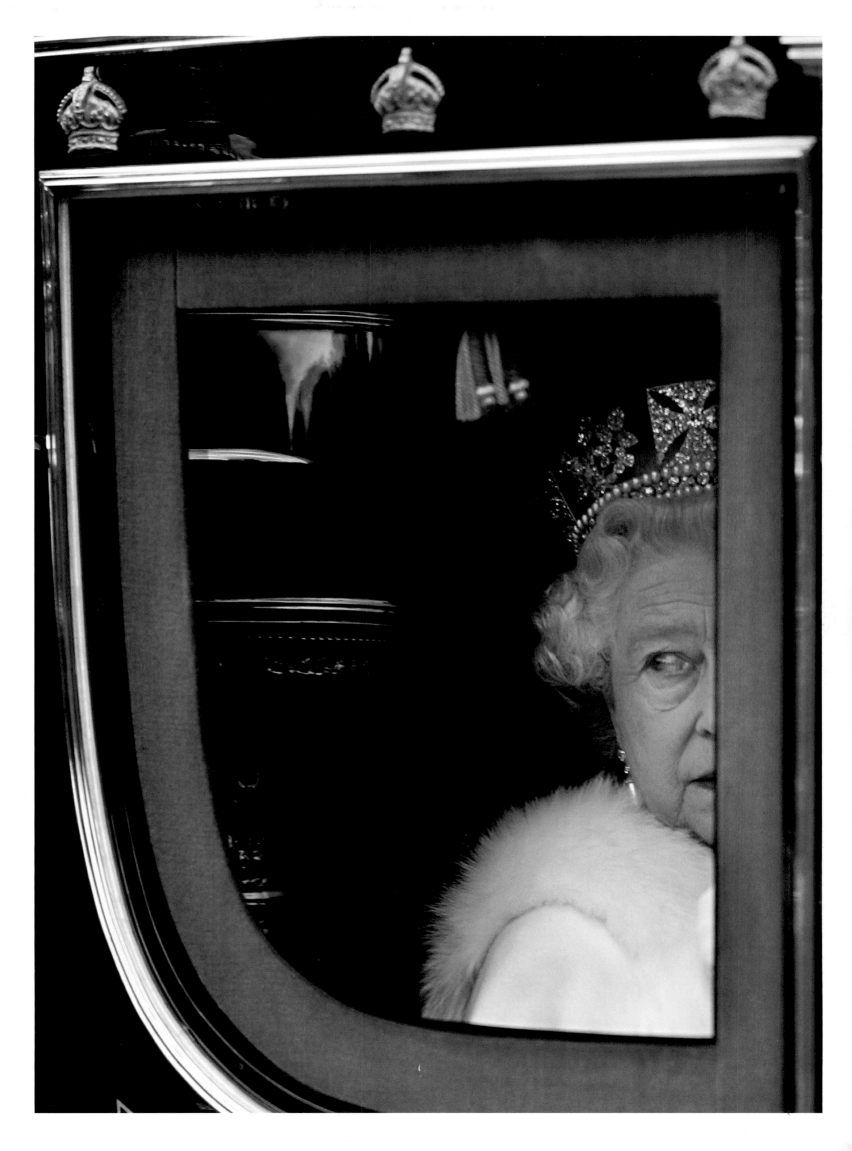

kieran doherty REUTERS
Former Prime Minister Margaret Thatcher,
right, greets the Queen on her arrival at her 80th
birthday celebrations in London. 14th October 2005.

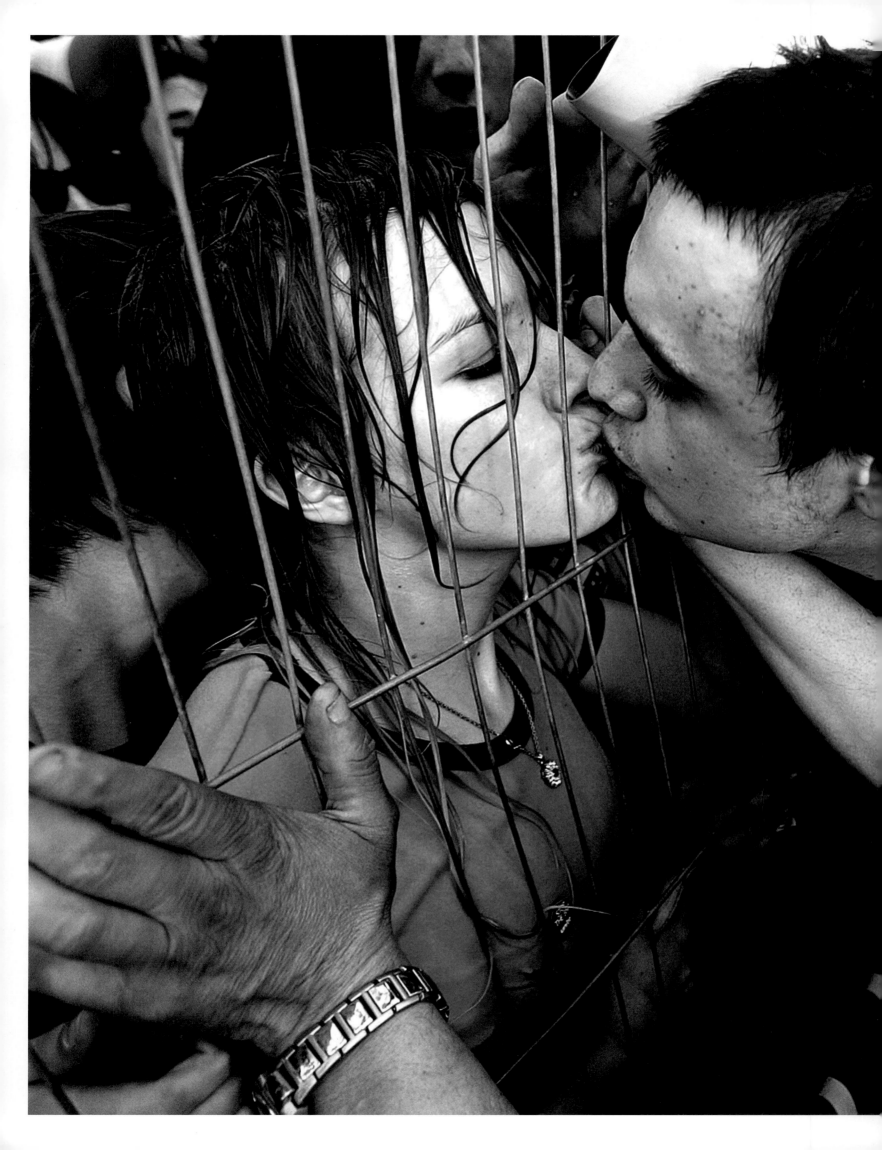

shaun curry
Musician Pete Doherty grees one of his fans through a security fence, after coming of stage from an acoustic set, at the May Day anti-fascist concert in Trafalgar Square, central London. 1st May 2005.

following spread
john ferguson DAILY MIRROR
German tennis star Boris Becker watches from the crowd during the Live8 concert at Hyde Park in London. 2nd July 2005.

alex macnaughton
The motoring writer and broadcaster Jeremy Clarkson, seconds after being hit with a custard pie thrown by environmental protester just after he had been awarded an honorary degree from Oxford Brookes University. 12th September 2005.

chris jackson GETTY IMAGES
The singer Elton John with his long term partner, David Furnish leave Windsor Guildhall after their civil partnership ceremony on the day that same sex couples could legally "marry" in England following The Civil Partnership Act being frought into force. 21st December 2005.

chris jackson GETTY IMAGES
George Clooney signs autographs for fans as he arrives for the Golden Lion Awards at the Palazzo del Cinema on the final day of the 62nd Venice Film Festival in Italy. 10th September 2005.

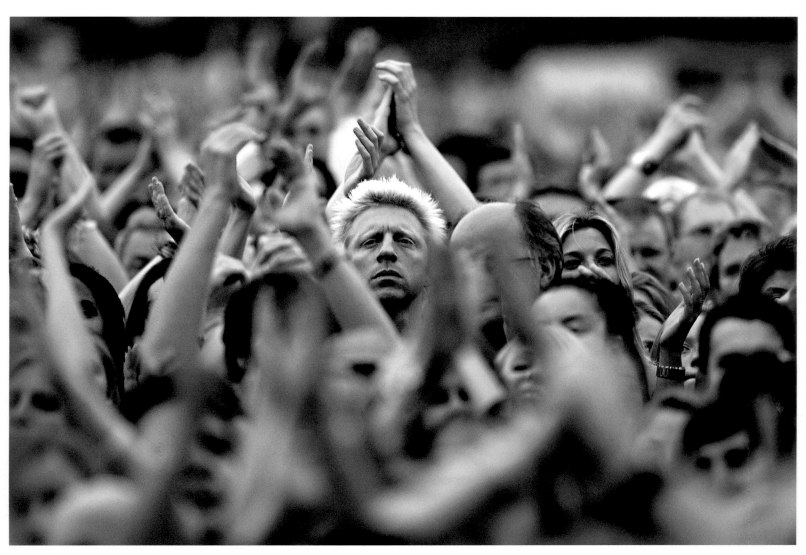

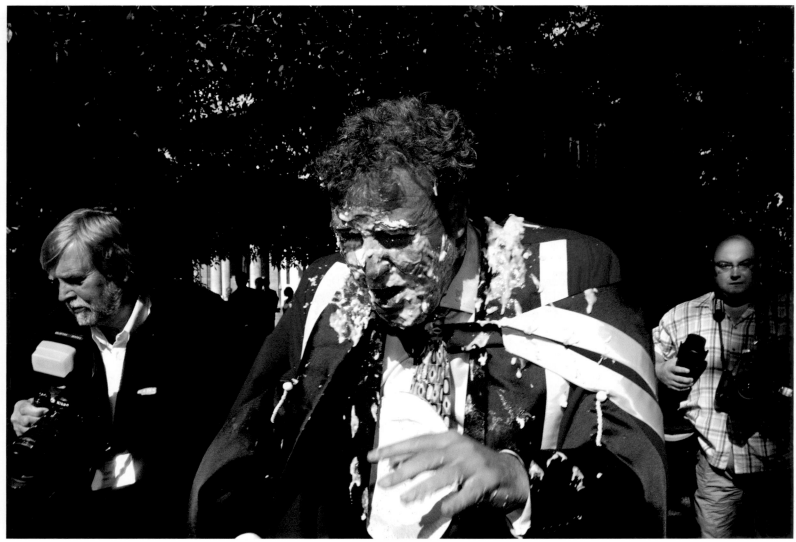

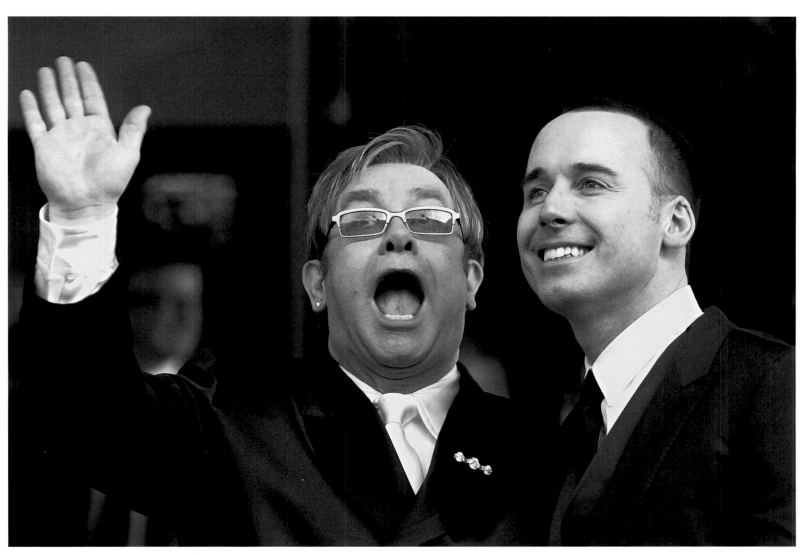

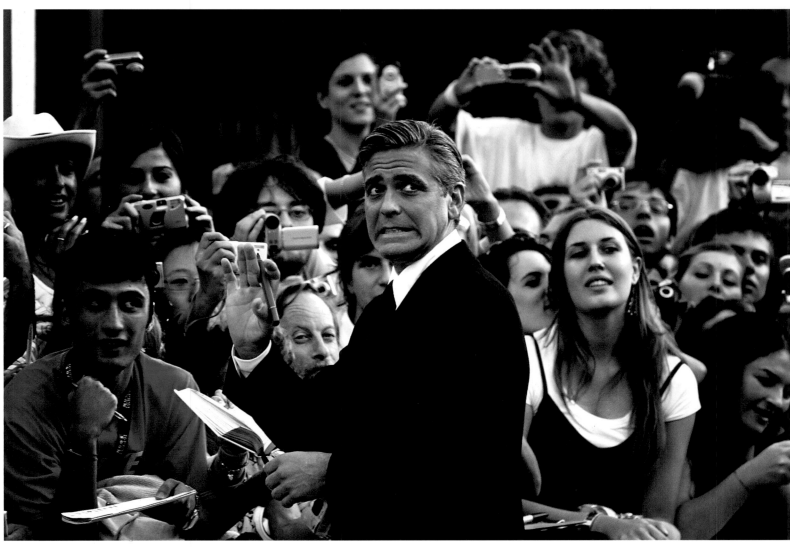

118

chris jackson GETTY IMAGES
Actress Rachel Weisz has problems with her dress
as bad weather strikes while she attends the
photocell of the in competition film "The Constant
Gardener" at the Venice Film Festival.
9th September 2005.

lee thompson SWNS
Catherine Zeta Jones celebrates a successful putt
during the Celtic Manor All Star golf tournament,
Place South Wales. 29th August 2005.

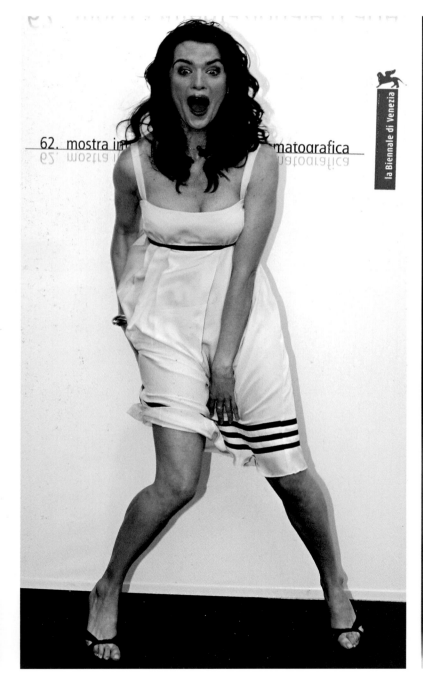

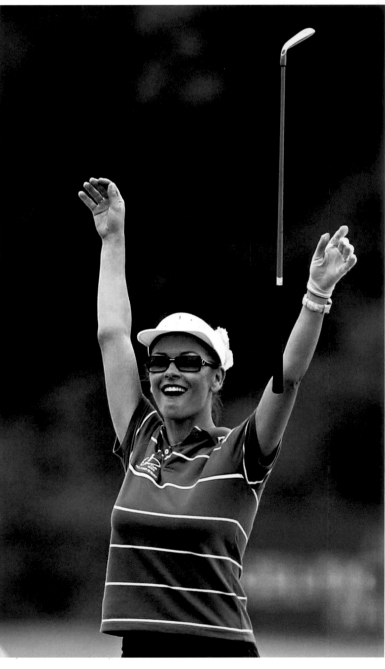

stewart cook REX FEATURES
Dwayne 'The Rock' Johnson shakes hands with a
burning stunt man, Jim Trella, on the red carpet at
the Stunt Awards in Hollywood, California.
25th September 2005.

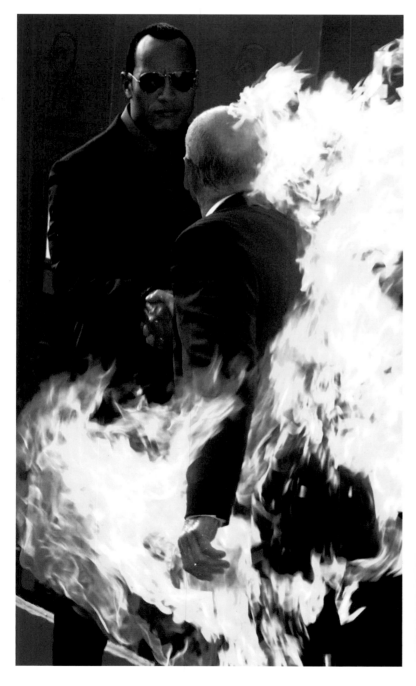

kelvin bruce ENIGMA
A gaunt looking Madonna arriving at the London
Kaballah Centre nursing a broken arm caused by
a fall from a horse whilst riding on her country
estate. 3rd September 2005.

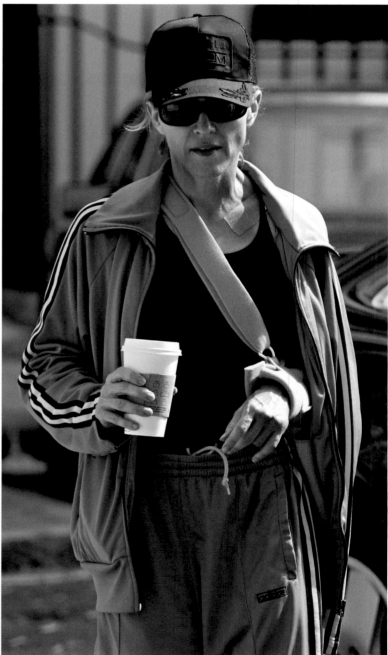

lewis whyld SWNS

Yachtswoman Ellen MacArthur celebrates at Falmouth Harbour in England after successfully completing her solo round the world record attempt. Her time of 71 days, 14 hours, 18 minutes and 33 seconds beat the previous world record set by Francis Joyon. Extreme weather conditions and technical problems challenged Ellen. Mountainous seas, icebergs and gale force winds threatened to capsize her boat - and she narrowly missed a collision with a whale on day 63. Ellen also burnt her arm trying to prevent fumes and heat leaking into her cabin early on in the race and suffered bad bruising after scaling the mast to make repairs on the return Atlantic leg. 8th February 2005.

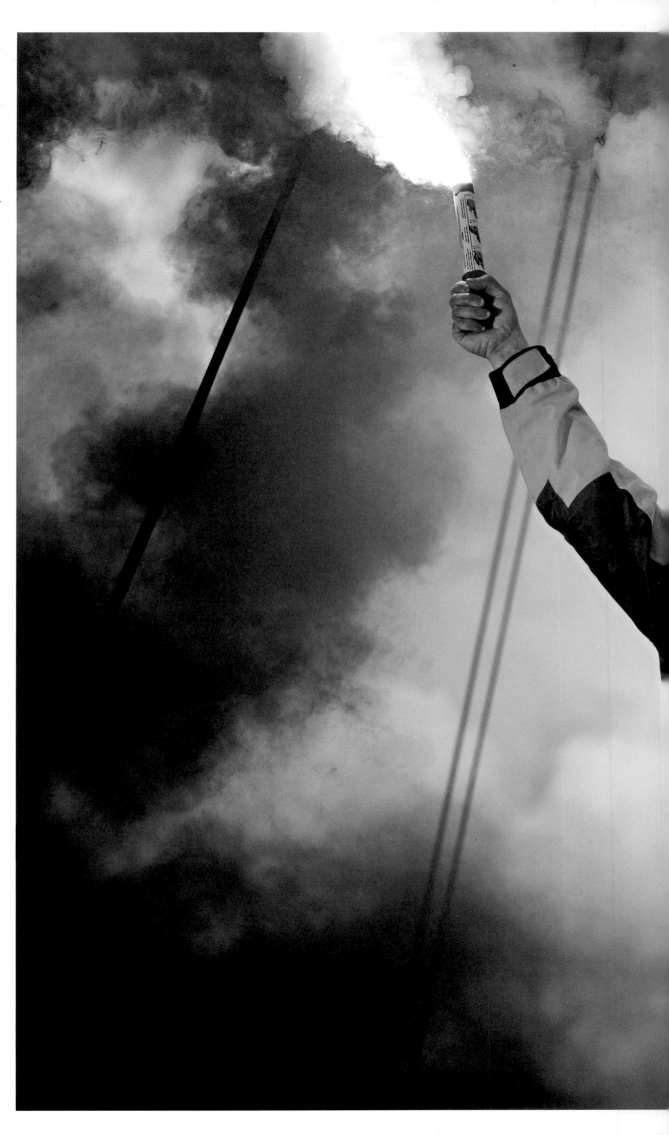

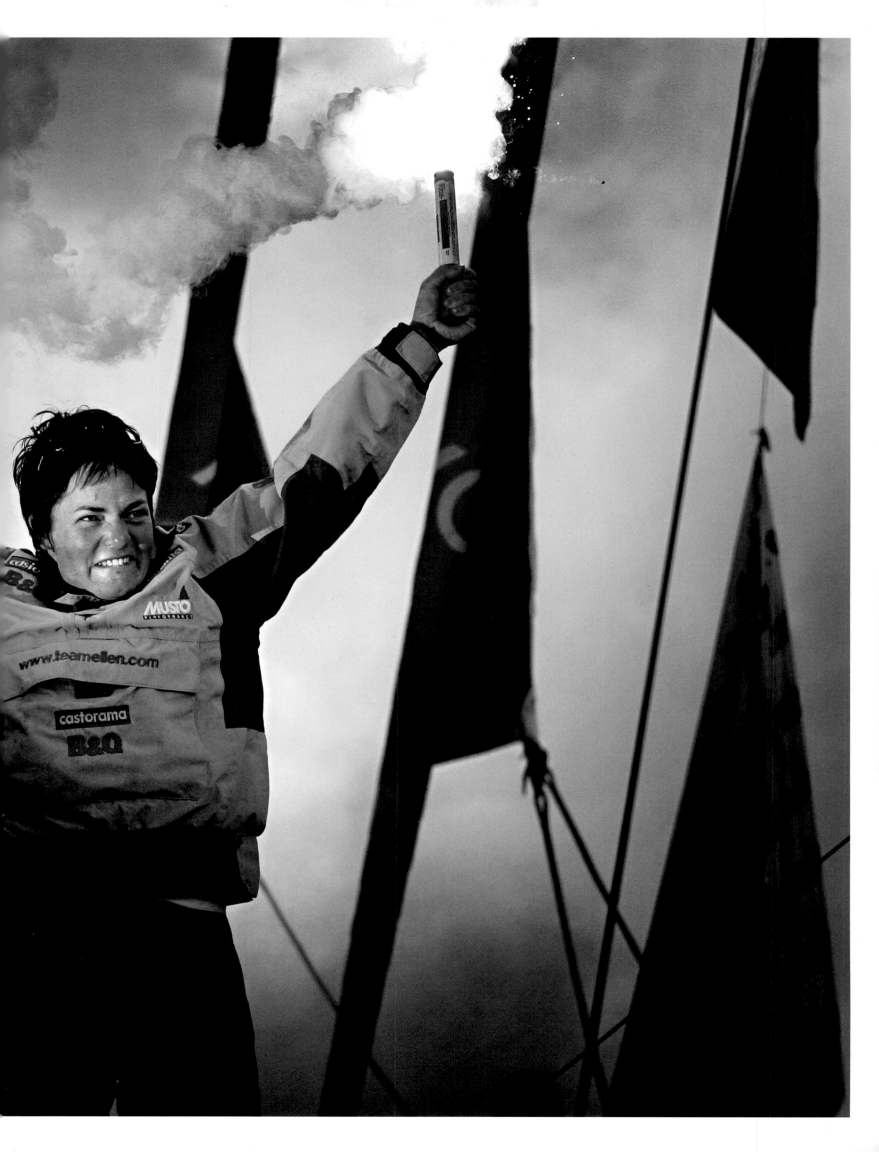

clive mason GETTY IMAGES
Hungarian rider Gabor Talmacsi parts from his Red
Bull KTM GPI25 in difficult conditions during the
British I25cc GP at Donington Park race circuit in
Leicestershire. 24th July 2005.

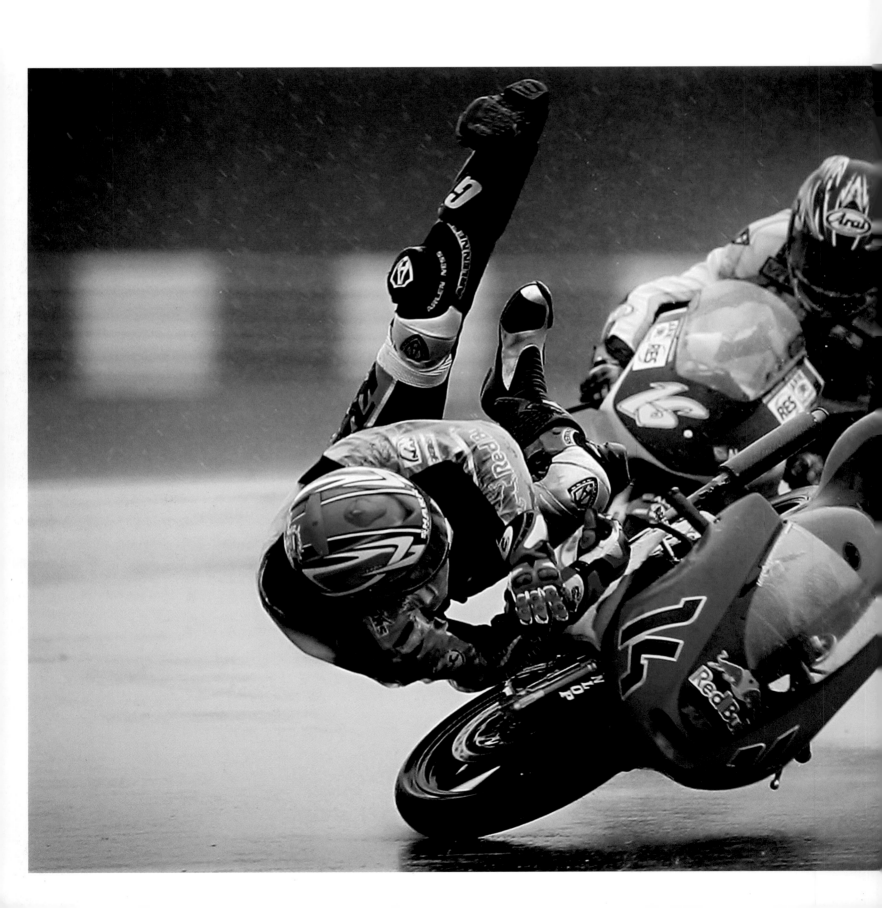

julian finney GETTY IMAGES
Jason Gardener of Great Britain celebrates winning the 60m final during the second day of the European Indoor Athletics Championships at Comunidad de Madrid Indoor Hall, Madrid, Spain. 5th March 2005.

**first prize: sports features
jeff moore**
Unable to get into the ground, fans celebrate from the rooftop of the nearby "The Cricketers" pub, as England reclaim The Ashes from Australia, in the decisive 5th and final Test match at the Oval in London. 12th September 2005.

tom shaw GETTY IMAGES
Andrew Flintoff consoles Brett Lee after England defeated Australia on day four of the second Npower Ashes Test match between England and Australia at Edgbaston, Birmingham. 7th August 2005.

tom shaw GETTY IMAGES
Andrew Flintoff of England celebrates the wicket of Ricky Ponting of Australia during day three of the Second npower Ashes Test match between England and Australia at Edgbaston, Birmingham. 6th August 2005.

tom shaw GETTY IMAGES
Andrew Flintoff celebrates after England regained the Ashes during day five of the Fifth npower Ashes Test match between England and Australia at the Brit Oval, London. 12th September 2005.

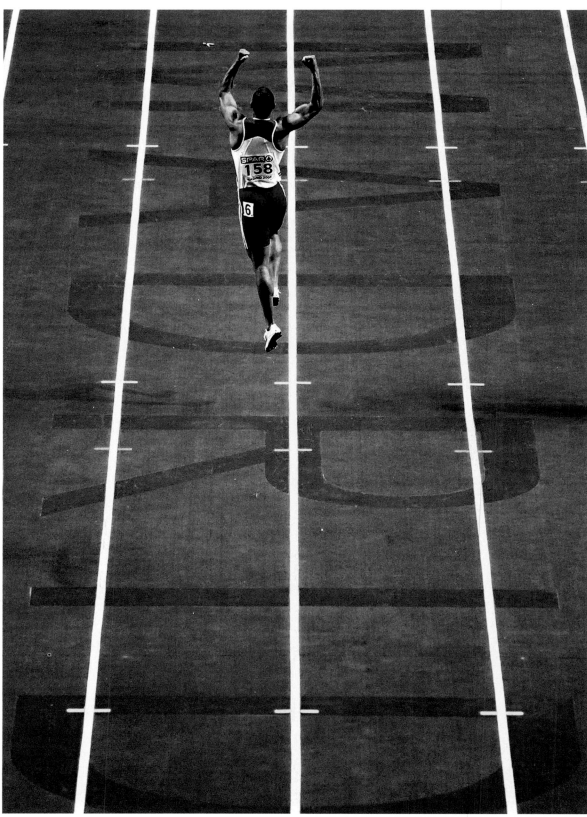

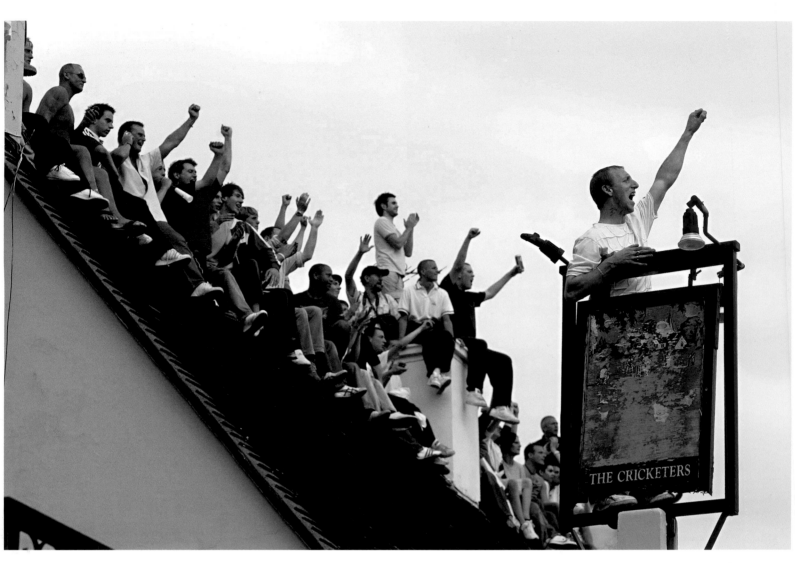

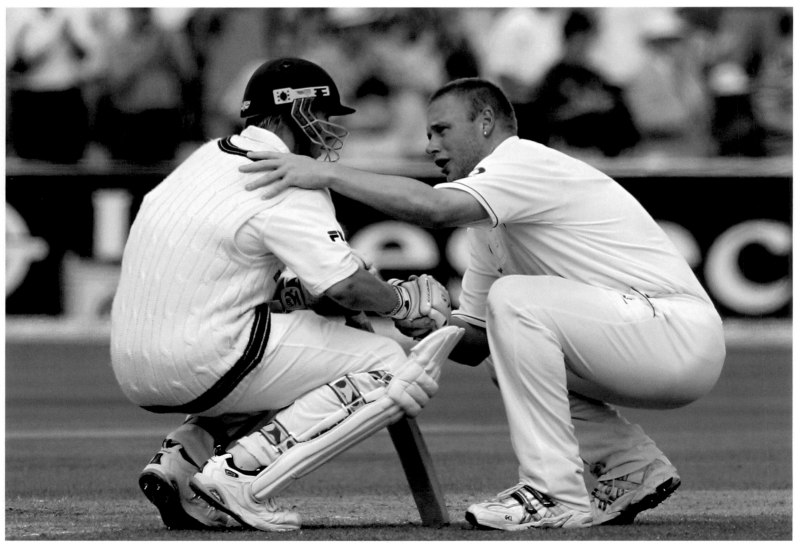

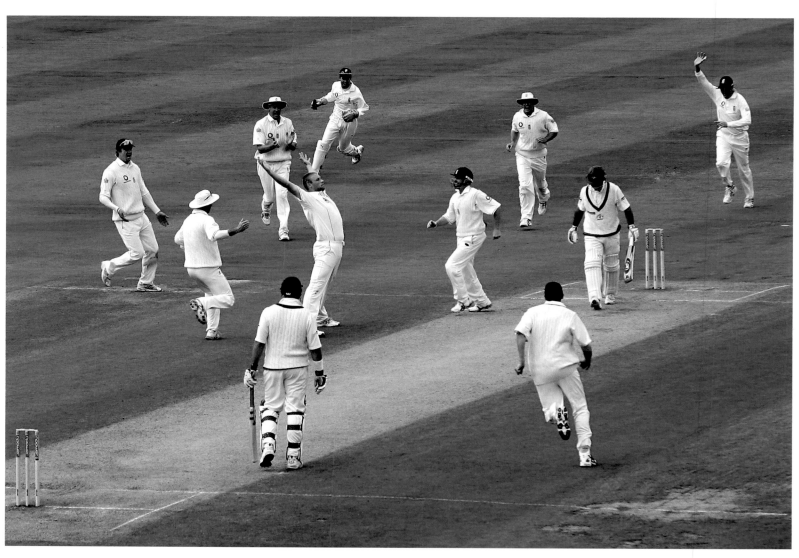

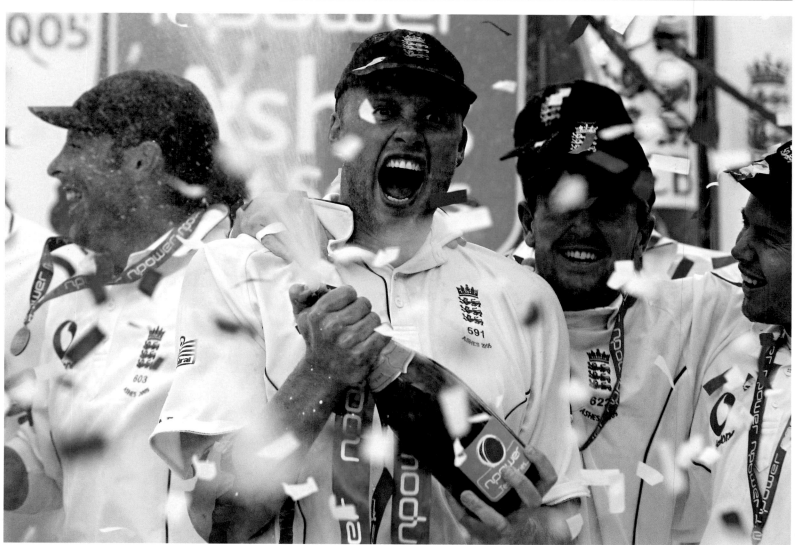

dylan martinez REUTERS
Liverpool's Steven Gerrard celebrates winning the Champions League final soccer final against AC Milan at the Ataturk Olympic stadium in Istanbul 23rd May 2005.

scott barbour GETTY IMAGES
The Liverpool team rides on an open top bus through a mass of fans as they arrive at St. George's Hall during the Liverpool Champions League Victory Parade in Liverpool, England. Over 250,000 cheering fans have lined the roads to celebrate after Liverpool defeated AC Milan in a penalty shoot out 3-2 to win the UEFA Champions League Final. 26th May 2005.

marc aspland THE TIMES
Liverpool's Steven Gerrard celebrates winning the Champions League final soccer final against AC Milan at the Ataturk Olympic stadium in Istanbul 23rd May 2005.

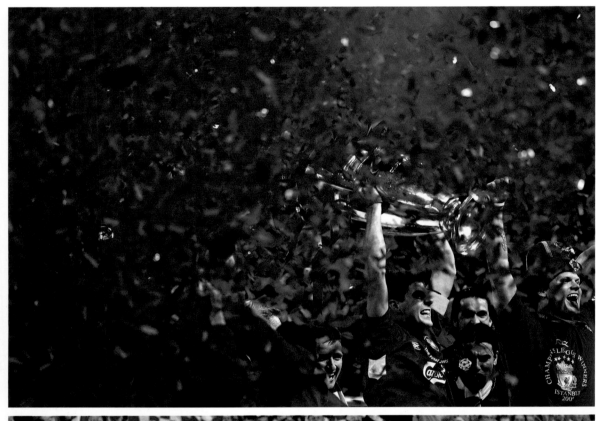

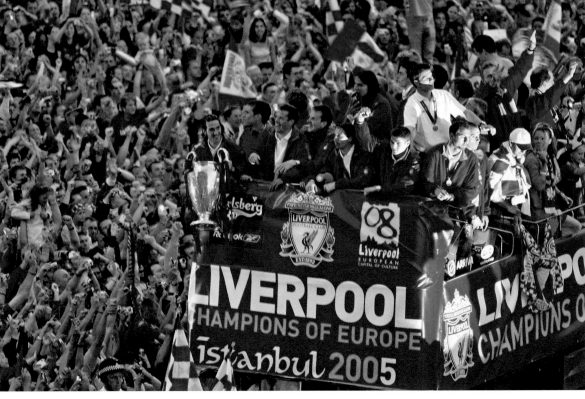

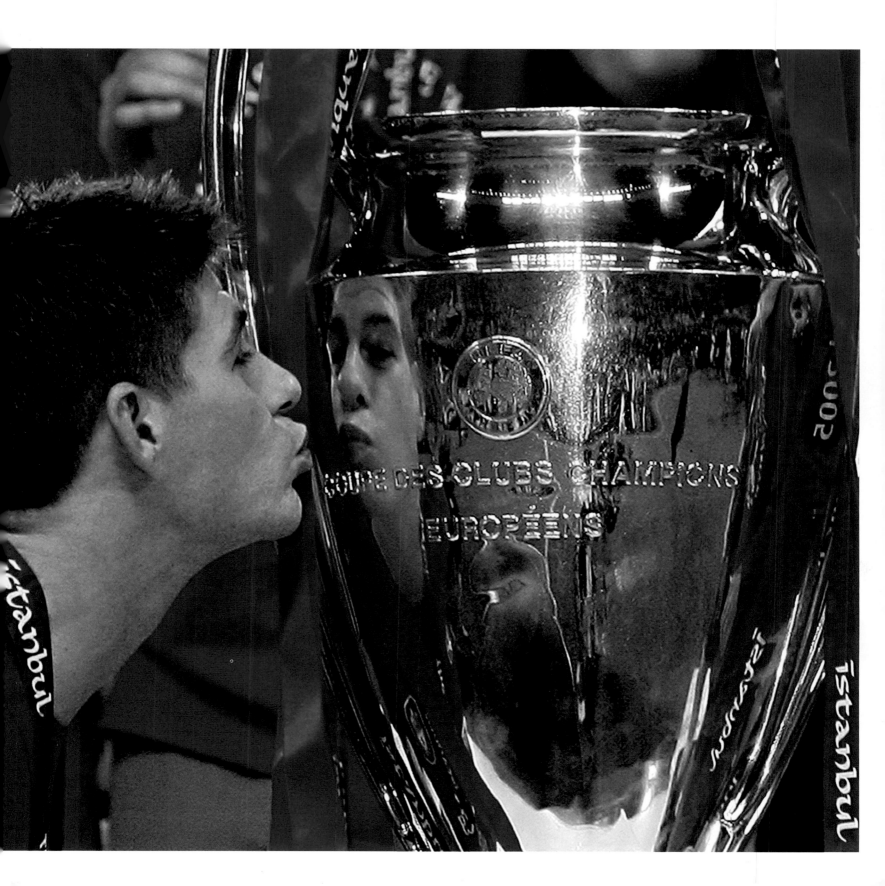

mike hewitt GETTY IMAGES
Ivica Mornar of Portsmouth is brought down
by Santiago Solari of Internazionale during the
pre-season friendly between Portsmouth and
Inter Milan at Fratton Park in Portsmouth.
31st July 2005.

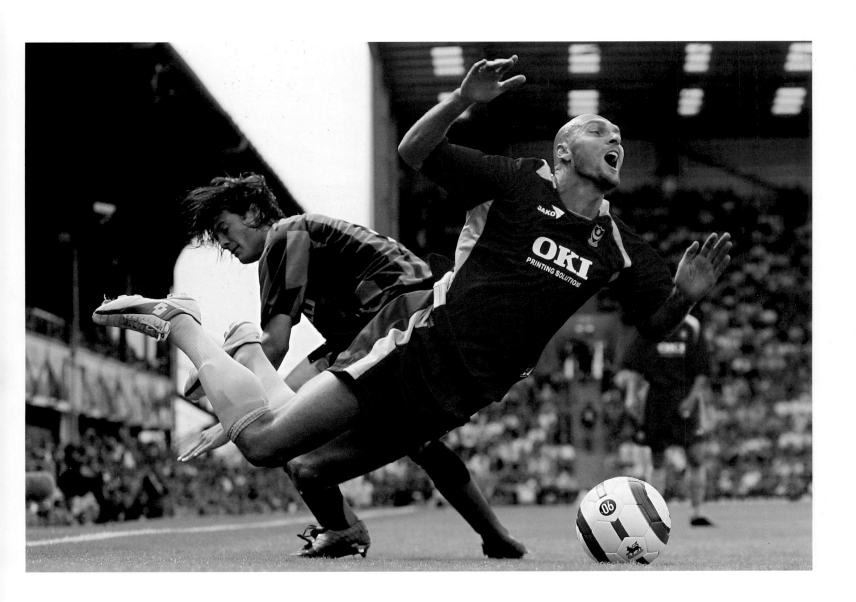

eddie keogh REUTERS
Arsenal player Lauren looks to his team mate, the goal keeper Jens Lehmann, and gives a typically gallic shrug of the shoulders after Bayern Munich had just scored their second goal against them in the Champions League. 22nd February 2005.

clive mason GETTY IMAGES
Michael Schumacher of Ferrari arrives for a team photo prior practice for the Formula One Spanish Grand Prix at the Circuit de Catalunya in Barcelona, Spain. 6th May 2005.

howard walker
Fans hold tributes to the late great Manchester United player George Best before United took on West Bromich Albion in the Forth Round of the Carling Cup. 30th September 2005.

dylan martinez REUTERS
Chelsea fans show their delight as Frank Lampard is airborne as he celebrates with team mate Damien Duff after scoring his second goal against Aston Villa during their English Premier League soccer clash at Stamford Bridge in London. 24th September 2005.

kieran doherty REUTERS
American tennis player Venus Williams celebrates winning the 2005 Wimbledon Tennis Championships. 2nd July 2005.

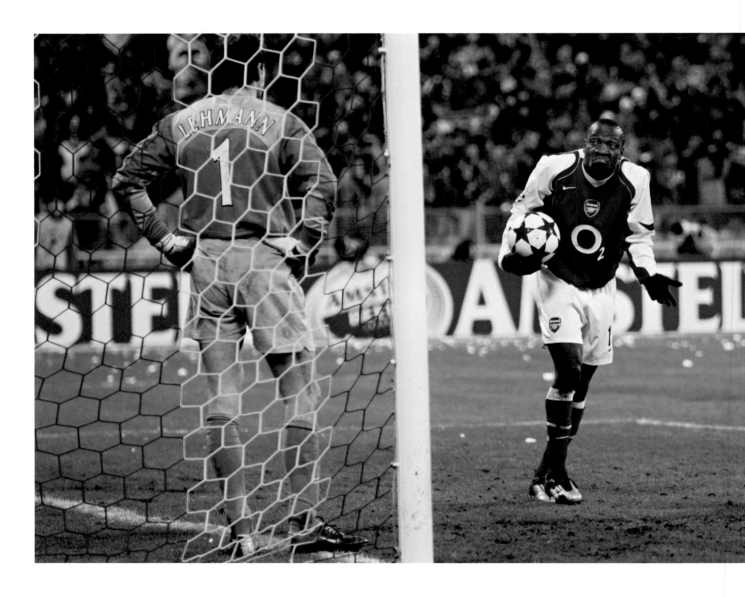

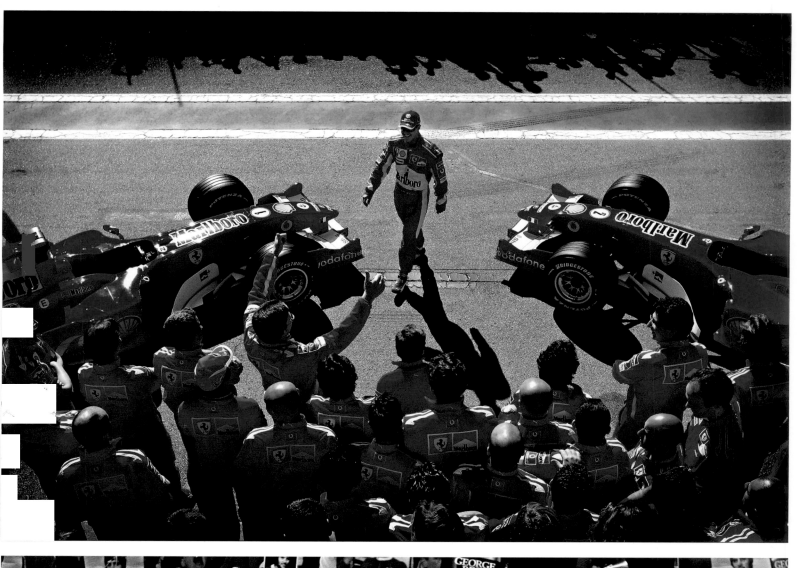

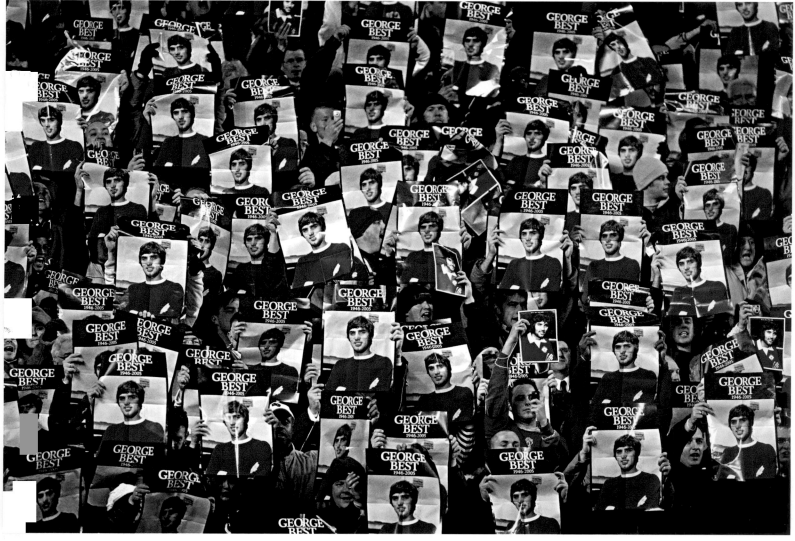

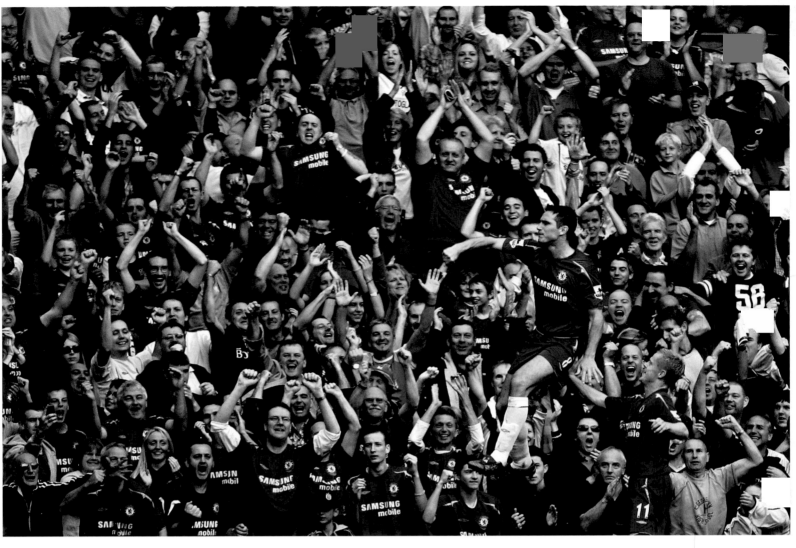

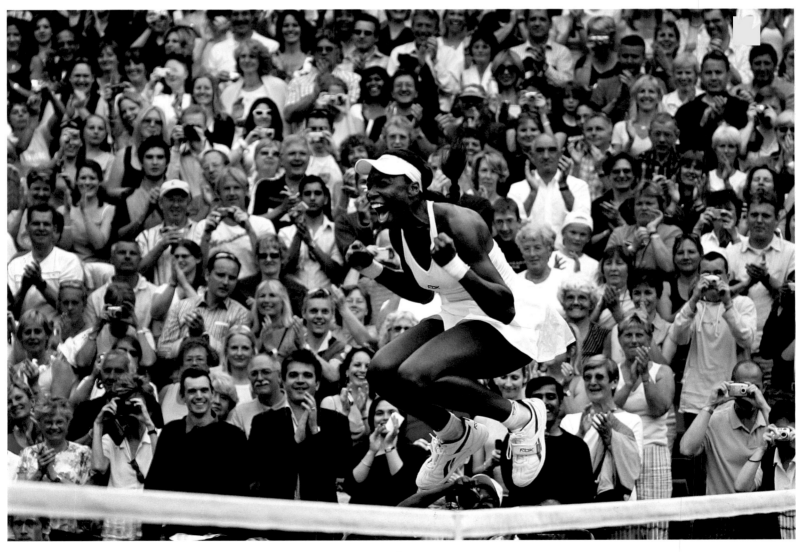

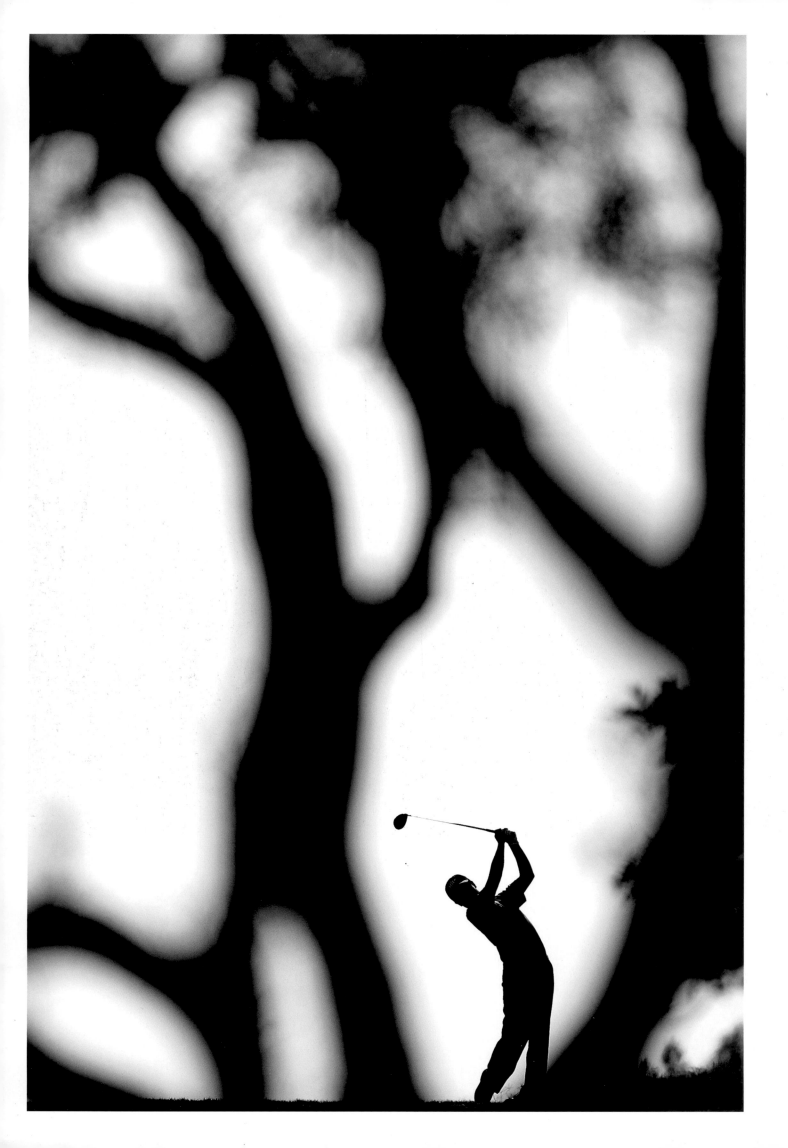

warren little GETTY IMAGES
The silhouette of Ik-Je Jang of Korea teeing off
in the morning light during the first round fourballs
of the World Golf Championships Algarve World Cup
at the Victoria Clube de Golfe in Vilamoura, Portugal.
16th November 2005.

john giles PA
A violent thunderstorm in the Finnish capital
Helsinki halted competition on the fourth day
of the World Athletics Championships. Torrential
rain fell for about 90 minutes and sent athletes
and officials scurrying from the Olympic stadium
delaying many of the events. 9th August 2005.

adrian dennis AFP
People in Trafalgar Square in London celebrate
the announcement that the city has been awarded
the Olympic Games in 2012. 6th July 2005.

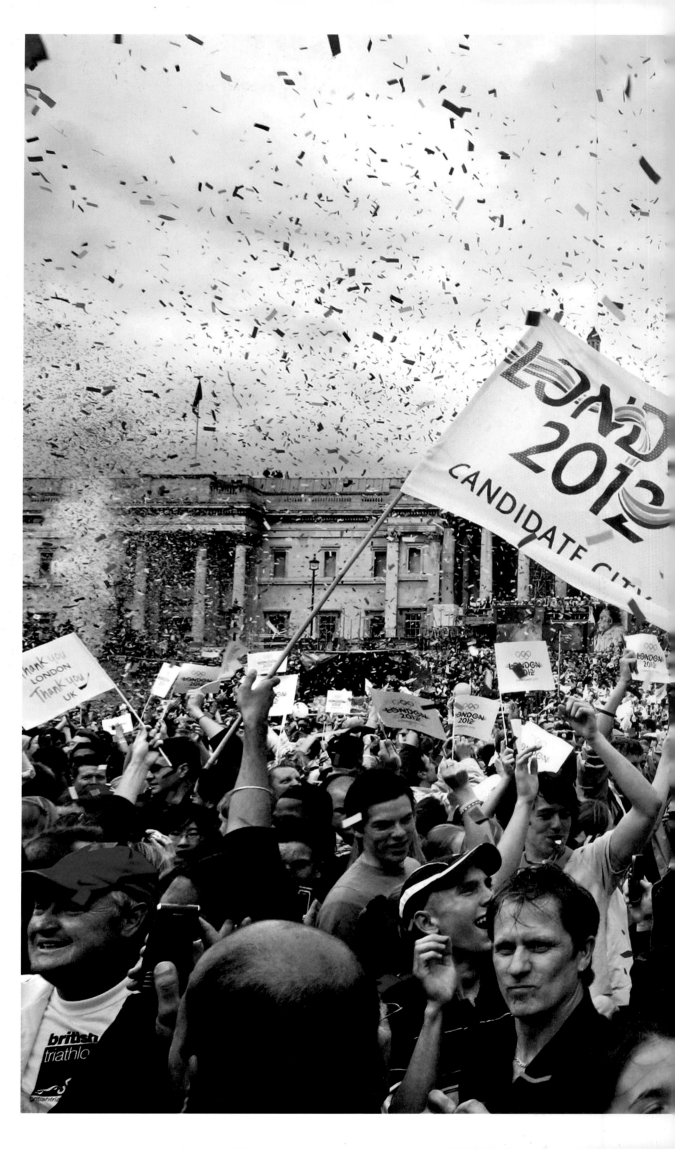